T0065656

Also by Marjorie Costello:

How to Select and Use Home Video Equipment

BREAKING INTO VIDEO

BY MARJORIE COSTELLO
AND CYNTHIA KATZ

A Fireside Book
Published by Simon & Schuster, Inc.
New York

A Fireside Book
Published by Simon & Schuster, Inc.
Simon & Schuster Building
Rockefeller Center
1230 Avenue of the Americas
New York, New York 10020
FIRESIDE and colophon are registered trademarks of
Simon & Schuster, Inc.

Designed by Barbara M. Marks
Manufactured in the United States of America
Printed and bound by Fairfield Graphics

10 9 8 7 6 5 4 3 2 1

Library of Congress Cataloging in Publication Data

Costello, Marjorie.
 Breaking into video.

 "A Fireside Book."
 1. Television supplies industry—Vocational guidance.
2. Video tape industry—Vocational guidance. 3. Video
disc industry—Vocational guidance. 4. Television
industry—Vocational guidance. I. Katz, Cynthia.
II. Title.
HD9696.T462C67 1985 384.55′023′73 85–2104

ISBN: 0-671-50094-2

Acknowledgments

One of the greatest rewards of breaking into video is getting to know the wonderful people who work in the industry.

In the course of preparing this book, we spoke with professionals in all the different areas of the video field. Many we already knew from our years of working in the business; some we had never met personally but knew through their reputations as industry leaders. They were all generous in the extreme with their time, advice, wit, and wisdom. For their help and invaluable contributions we would like to thank: Mal Albaum, Jon Alpert, Len Alphonso, J. C. Anderson, Carolyn Baker, Frank Beacham, Ron Berger, Sue Buske, Peter Caesar, Marty Callner, Maggi Cowlan, Paul Crittenden, Lenny Davidowitz, Sandra Devlin, David Eatwell, Nat Eisenberg, Imero Fiorentino, Susan Geisenheimer, Noel Gimbel, Meg Gottemoeller, David Hall, Christin Hardman, Michael Heiss, Larry Hilford, Bill Hillier, Paul Huhndorff, Doyle Kaniff, Larry Karman, Bill Kelly, Lynn Klugman, Kay Koplovitz, Ken Leddick, Phil Levens, John Lockhart, Nancy Logerfo, Sylvia Marshall, Ralph McDaniel, Dave Miller, Kitty Moon, Stephen Mulligan, Richard Namm, Gil Padilla, Jon Peisinger, R. Laverne Pointer, Stephanie Pressman, Jeff Ross, Nathan Sambul, Angela Schapiro, Allan Schlosser, Bill Silverman, David Small, Jane Strausbaugh, Jeff Tolvin, Ted Turner, Charles Upton, Gene Weed, and the staff of *Videography* magazine.

To our editor, Charles Rue Woods, we want to express our gratitude for his advice and his unfailing enthusiasm and support.

Lastly, a special thank-you to our families and friends, who cheered us on at every step.

Contents

How new technology changed the business and continues to create new jobs. Up close and personnel at the ABC Network. The stations: O&O's, network affiliates, independents, and PBS operations.

Chapter 5: *Cable* 95

The simple idea that spawned an industry. How wiring America improved TV reception and created new programming and production opportunities. Satellite technology transforms the business. The cable networks and an in-depth look at Home Box Office. Special focus on production, marketing, affiliate relations, and sales. MSO's, local origination, and access operations. The alphabet soup of new technologies: STV, MDS, SMATV, DBS, and LPTV.

Also known as private television, industrial or institutional video. How corporations and organizations are using video to improve communications and training. Why corporate video grew and is rapidly expanding. From one-person operation to full-fledged studio setup: how to decide what's best for your company. Videoconferencing and interactive video. The range of job opportunities. Profiles of professionals in corporate video.

The most explosive area in video today. Home video's story: from Betamax technology to blockbuster titles on cassette. How to get a job or make a programming deal with a software company. The distribution end. Entrepreneurial business opportunities in video retailing: The independent store, the affiliate, and the franchise. Mass merchandisers, record and book chains, and small businesses move into video.

An invaluable reference guide to key companies, organizations, trade shows, and publications in all areas of video.

Introduction

What do Merrill Lynch, Jane Fonda, the U.S. House of Representatives, David Bowie, and Mickey Mouse have in common?

They have all broken into video.

Merrill Lynch operates a sophisticated in-house video department. It is only one of hundreds of corporations, organizations, hospitals, and schools now using video.

Jane Fonda is the star of a growing line of home-video exercise tapes. Her programs are just a few of the thousands of home-videocassettes aimed at over 18 million households which already own videocassette recorders.

The proceedings in the House of Representatives are being recorded on videotape and shown to millions of cable-television viewers across the U.S. Video cameras have also moved into state capitols and town council meetings all over the country.

Rock star David Bowie was one of the first to expand his repertoire to include music videos. He has been joined by the rest of the music industry in realizing video's potential as both a creative and marketing tool.

And Mickey Mouse has both his own line of home-videocassettes and a cable network as well. Walt Disney Productions is one of the many companies responding to the great clamor for video programming.

But these are only a few examples of the ways individu-

als and organizations are tapping into the video explosion.

Many people today see the video industry as an exciting new field offering all kinds of opportunities. The technology's magic is all around us. Barely a day goes by without a report in the media about some new venture in the video business.

With the dramatic advances in video technology have come entirely new fields, new forms of creative expression, new companies, and new jobs. And all this is occurring at a time when our national—and, in many cases, our personal—economic growth depends upon making the transition from a "smokestack" to a "high-tech" society.

If you don't want to be left behind, this is a field you should watch. If you are planning to enter the industry, you will want to understand what it is all about. Fortunately, you don't have to be a "technoid" to take advantage of the many business and career opportunities available in video today and tomorrow.

As professionals in the video industry, we are constantly asked, "How can I break into video?" Typically, the person posing the question is either still in school, a recent graduate, or someone who wants to change fields and move into video. Our usual response is to ask what area of the business he or she is interested in. Because the video industry is so new and so fluid, many people are unaware of the possibilities that are open to them. They are often amazed to learn about how many different jobs there actually are today and how many are just over the horizon.

Other people interested in breaking into video are corporate executives and entrepreneurs examining the business opportunities in the video industry. These people have a sound understanding of their own field and its lingo; but they are baffled by "videospeak"—terms such as DBS, MSO, HDTV, LPTV, and ENG—and what it all means.

Another group that wants to break into video today includes those who would like to find out more about private television, the use of video in their companies or organizations. If they work for a corporation, they probably have heard how other firms are successfully applying video technology in sales promotion, training, and internal communications. If they are involved in education, medicine or the

military, they may be examining ways video can help them teach and communicate.

This book is for all these people and for anyone else who wants to explore an exciting and fast-growing industry.

The student, the recent graduate, and the person looking for a career change; the executive and the entrepreneur; the professional pondering private TV: they all need an overview of the video business and career opportunities so they can decide where they fit in.

In the chapters that follow, we'll describe how the video industry functions, what the separate areas of the business are, and the ways in which these areas are interrelated. We'll cover production companies and video facilities, cable and broadcast television, home video, and private (corporate) television. We'll talk about some of the new areas in video such as high-definition television (HDTV), electronic cinematography, direct-broadcast satellites (DBS), low-power television (LPTV), videoconferencing, and interactive video.

We'll explain what the various jobs are in video today, and where the new jobs are likely to come from tomorrow. We'll discuss the skills and experience you'll need in order to get one of these jobs. We'll tell you what the business opportunities are in video, whether you are a corporate executive looking at new investments or an entrepreneur interested in opening your own video store. And we'll point out ways you can make video work for you in your firm or organization.

We'll share with you what we have learned from our own experiences working in the video industry and our years of covering the field for a leading trade magazine. You'll also read advice from industry leaders and professionals from many different areas of the video business.

There are no proven rules for breaking into video. That's both a plus and a minus. We can't tell you that if you follow our advice, you'll get a job or make a fortune overnight. On the other hand, the field is still new and growing, demanding many different skills and talents.

Every video professional today had to break in at some point. Now it's your turn.

Getting the Big Picture

f you watch the popular TV program "Entertainment To-
night," you are treated to daily reports on the business,
creative, technical, social, and political aspects of the en-
tertainment industry. The success of this show makes its
own point about how interested the public has become about
the media.

Mixed in with the celebrity profiles, "ET" presents the
latest news from the video industry. And while the show helps
its audience become increasingly savvy about the video indus-
try, the program itself is a prime example of video technology
at work. It is taped in a video studio built specifically for it
by the program's producer, Paramount Television. "ET" taps
the latest in electronics wizardry, using elaborate video graph-
ics, videotaped reports from all over the world, and satellite
delivery to reach the local TV stations which carry it.

The reports on "ET" often include stories about how one
cable network has merged with another, which rock star has
just released a new music video, and where people in the
video industry are gathering to see the latest in programming
and equipment. Anyone who has followed the field for even
a short time will see the interrelationships among all aspects
of the video business. They soon realize that the day's events,
deals, and developments in one part of the video industry
can have far-reaching effects on other parts.

Going behind the scenes at "ET" also points out another

aspect of the interrelationships in video. Until the move to the Paramount studio, "ET" was produced at a video studio in Hollywood, Trans-American Video. If you visit TAV, you can begin to see what the video business is all about.

TAV is a video facility, a company that provides video equipment and technical personnel to other firms and individuals producing and distributing video programs. By the way, at TAV's entrance at Sunset and Vine, you'll notice the sidewalk star of its owner, talk-show host Merv Griffin.

If you take a look in one of TAV's many rooms you will find a member of the staff sitting behind the console of a state-of-the-art, computerized editing system. This editor is working with an independent producer to finish a show for a national cable network.

Further down the hall, in another editing room, you might find the manager of a corporation's video department putting the final touches on a training tape for the firm's sales force. In a room off to the side, a TAV electronics graphics specialist is meeting with an ad agency producer; they are planning the video special effects for a new TV commercial.

The next stop is at TAV's largest room, which is actually a theater equipped to function as a TV studio. On this particular day, the seats are filled with an audience watching the taping of "The Merv Griffin Show."

A short drive away at a division of TAV, technicians are transferring a movie from film to videotape, to be shown on the broadcast networks. Other staffers are running off thousands of videocassette copies of another film for a major home-video programming company. These cassettes will make their way to retailers around the country for sale or rental to consumers who own videocassette recorders (VCRs).

Take another ride, and you will reach still another part of the TAV operation, this one devoted to the audio aspect of video. Stereo has now arrived in VCRs, cable channels like MTV, and broadcast television. Like TAV, facilities all over the country are providing clients with more sophisticated sound mixing and editing services.

We should also point out that TAV is part of a larger company, Merv Griffin Enterprises, that also includes a production company. The production arm comes up with concepts for new programs and sells the ideas to those companies

that control what does or doesn't make it to your television set.

* * *

As we've seen, the video industry encompasses many aspects that are closely linked to one another. Let's look at it from another angle, focusing on an individual whose career reflects the industry's interrelationships.

Marty Callner is viewed by many as cable's premiere director. But he did not start his career in cable and his current plans are not restricted to that programming medium. He broke into the business at a Cincinnati TV station as a prop man, in 1969. Before he began working in television, he really had no idea what he wanted to do with his life.

After a relatively short time as a prop man—seven weeks to be exact—Callner was directing, albeit in the middle of the night. He moved up in the ranks at the station quickly, immersing himself in the job almost twenty-four hours a day, until he was directing the news. Leaving Cincinnati, Callner went on to Cleveland, where he directed commercials at a production company. Offered a job at a Boston station, he began directing the Celtics and Red Sox games.

With his experience in directing sports, Callner might have soon found himself at a broadcast network like ABC or NBC. As events unfolded, he started freelancing on weekends for a new programming service that was taping sporting events for distribution to cable systems. The company was Home Box Office. Soon Callner was working full time for HBO and had expanded his repertoire to include entertainment programming.

At the same time, Callner was expanding his production experience in set design, lighting, videotape editing, and special effects (not to mention the unique skills often required to work with top-name entertainers). Over the years he has directed more than 130 specials for HBO and worked with such stars as Diana Ross, Robin Williams, Liza Minnelli, and Hall & Oates. In 1982 he directed "Camelot" for HBO, which even today stands as the most elaborate video program produced for cable.

Today, Marty Callner has his own production company and he is producing and directing for HBO and other cable

networks, such as MTV. The difference is that through his own company, Callner Shapiro Productions, he is packaging his own shows and putting together the financing for his productions. In addition, Callner has made agreements with several home-video programming companies, which means that his productions will be showing up on cassettes in the consumer market. He continues to turn to outside video facilities for the more sophisticated equipment his productions require. But Callner, himself, always keeps up on the technical trends and is expanding the range of video equipment he owns.

* * *

As these stories illustrate, the video industry is clearly one of interconnections. In technology, production, marketing, and distribution, the various areas of the industry work together.

Different outlets for video programming, whether broadcast television, cable TV or home video, now overlap. One of the keys to success in breaking into video—and getting ahead once you're in it—is to understand how all of these areas in video are related.

If you are still wondering about our emphasis on interrelationships in video, talk to people who are already working in the industry. The successful ones keep informed of developments in a broad range of areas besides their own. This is not done by choice. It's a necessity.

A producer or a facility manager keeps up with the most recent technical advances, reading trade publications and attending equipment (hardware) shows. A director learns about innovations in editing and special effects. Home-video executives stay abreast of the latest developments in videotape duplication. Virtually everyone keeps tabs on the arrival or demise of cable networks.

When you break into the video industry, you'll soon find you're working with professionals in other parts of the field. As you saw from our tour of TAV, facilities work for broadcast and cable networks, ad agencies, home video, and private TV. Producers are often making deals not just with the traditional distribution channels of broadcasting, but also with cable and home video. Corporate video departments, hospi-

tals, and universities are finding outlets for their video programs beyond their organizations; their productions are showing up on local cable. The list of overlapping fields in video is almost endless, and will continue to grow as new technologies like high-definition television (HDTV), low-power television (LPTV), and direct-broadcast satellite (DBS) reach their potential.

Over time, you may well move from one area to another yourself. Understanding how video operates as a whole, you'll have a clearer picture about where your own talents and experience can best be applied. That way you'll be able to grow and thrive with the video industry.

One of the best pieces of news for those who want to work in video is that the field is wide open; there are few established career paths. It's too new for that. If you're heading up a corporation's video department, you may be the first person in the company to hold that position. The same may be said for many jobs in cable, home video, and production.

If you're entering the video field, chances are you're not going into the family business. Unless your relatives or friends have contacts in the video industry (always helpful), it's unlikely they can advise you about how to get a job in the field.

The professionals working in video today have either worked their way up from entry-level jobs, started their own companies, or moved over to video from different fields altogether. In many cases, there are no formal courses or training grounds for the jobs. The introduction of a sophisticated new piece of hardware can mean that everyone in a particular area is playing in a new ballgame and anyone who can hit the ball is welcome.

Especially in production, video is a hands-on business. Throughout this book we will be sharing advice from video professionals regarding the merits of formal education in helping you break into the industry. We'll tell you right now that the opinions vary. One point everyone agrees on is that, unlike many professions, there are no specific degree requirements for most jobs in video.

Industry veterans feel that while a college course in video can teach you some basics, it will not prepare you for the

realities of a complicated, high-budget video production on a tight schedule. In getting ahead, real-life experience counts the most.

And any video professional will tell you that attitude is also very important. A positive attitude is likely to serve you well in any industry, and it can make the difference in video if you are trying to get your foot in the door. There are always stories circulating about people who got a start in video because they had that "I'll-do-whatever-it-takes-for-as-long-as-it-takes" attitude. Further, many video jobs, particularly production, mean spending long, pressured hours in close quarters with other people, and the tension can run high. It's easy to see why experience alone isn't the only factor in whether or not you get hired a second time.

We should point out that attitude and experience are important factors for more reasons than the demands and often high stakes of the business. Let's face it, there are lots of people who want to work in video, and there's tough competition for jobs in many areas. The video executives doing the hiring can be as selective as they wish in most cases. They may use experience as the deciding factor in the more demanding jobs, and attitude for the entry-level positions.

As in many fields, there's also that element of being in the right place at the right time. For example, when a producer finds he needs an extra hand for an upcoming job, you want to be the person on the other end of the phone at the moment the producer is considering who to hire. Don't think you can't get a job that way. It does happen. But when you are talking with a company, it's not enough to tell them you want to work in video. You should find out as much as you can about the field and that company. Then you'll be able to understand exactly where you might fit into their operation.

To find out more about the field, you can attend local meetings of industry groups, talk to people in the industry and ask questions, go to trade shows in your area, and read trade publications. In the appendix, you'll find lists of trade shows, organizations, and publications associated with the video business.

Once you know what you'd like to do, the most important step is to find a way to get out and start doing it.

Before considering the specifics of the video industry, it's helpful to take a look at the bigger picture. Several major trends that you should know about are affecting the industry. Some are on-going, while others are now taking shape.

We'll be referring to these trends throughout but it's important to understand a few up front. This will start you off with a broader perspective—not to mention valuable information you can use to make a positive impression in a job interview.

1. *Technological Advances Equal New Jobs*

Technological advances in the video industry are usually good news because they often open up new fields and create jobs which never existed before. Careers in cable television and satellite distribution are based on relatively recent technological growth. There are entrepreneurial opportunities in home-video retailing and staff jobs at programming companies because technology has made consumer video equipment affordable for the average person. New, sophisticated production equipment keeps coming, bringing with it a demand for people who can operate it.

As all these fields progress because of advances in technology, some of the jobs created will require entirely new skills. Companies then have to find qualified people to fill these jobs or train some of their current employees. In other cases, firms are looking for people who can transfer more traditional skills to a new business.

There is no better illustration of this last point than the great demand in video production for people with skills honed in film. Another example is at video facilities and broadcast operations where they are looking for artists to operate new electronic graphics systems. Looking at another side of the business, cable and home-video companies are searching for people with marketing and sales backgrounds. Because the career paths aren't yet established, it's possible to move vertically into a new job or laterally from another industry altogether.

2. *Decentralization*

When technology creates new opportunities, more people see a chance to compete for a piece of the action . . . in more places. In the past five years, there has been a surge

of growth in video-related companies across the country.

Video stores, locations where you would go to rent or buy videocassettes, are no longer located just in the large cities. Because over 18 million people all over the country now own VCRs, even small towns can support a local video store.

In production, the trend is the same. Because of the speed and cost-effectiveness of shooting and editing on videotape, more and more TV commercials are shot on tape rather than film. Original programming for cable networks and local systems is often produced on videotape, as well as most corporate TV programs. As a result, there are hundreds of video facilities getting work today all over the country—not just in New York City and Los Angeles, the traditional production centers. Technology has made even high-end video equipment more affordable to those who want to start their own video operations.

This can also be said for production companies specializing in video programming. The increasing demand for programming has put companies across the country in business.

The decentralization trend operates at another level in the video production industry as well. Within the major production centers, facilities are opening up specializing in one or two services. Sophisticated new equipment, such as computerized editing and electronic graphics systems, have put a number of smaller facilities, called boutiques, on the map.

3. *Multiple Avenues of Distribution and Financing for Programming*

Programming (or software) can be distributed to audiences through an increasing number of outlets including broadcast television, cable TV, and home video. It's not unusual for several distribution outlets to share a project's financing. This trend decreases the costs and risks for all involved.

For example, a cable network and a home-video software company might share the cost of taping a rock concert. Both release the concert program through their own distribution. This system makes it possible to get projects on the home screen that might otherwise never get off the ground.

4. *New and Better Technology and Services for the Consumer*

Video will be making further inroads into the home market. VCR sales continue to exceed even industry predictions, and more consumers than ever are renting and buying videocassettes. In the near future, new home-video hardware will be arriving that will expand the use of video equipment for creating home-video movies.

The electronic information services of teletext and videotex offer the opportunity to shop at home, and they promise to be part of the picture.

The picture at home is likely to get much bigger and better with high-definition television, a system that offers major improvements in the sharpness of video images. HDTV will also make it possible for motion pictures to be shot on videotape instead of film, opening up opportunities in a field called electronic cinematography.

More homes will be wired for cable. New cable systems and upgraded older operations will provide dozens of channels. Special new converter boxes, which permit two-way communication between the viewer and the cable company, are now moving into homes. These "addressable" boxes make it possible to shop at home or order up brand-new movies and other types of special programming on a pay-per-view basis.

Other promising new forms of distribution will include direct-broadcast satellite service and low-power television. With DBS, consumers will be able to receive some of the same programming now available on cable simply by installing a small receiving dish on their roofs. Through LPTV, more localized broadcast TV service is now possible in several parts of the country, with more planned for the future.

Although you may have already decided which area of the video industry interests you, don't skip any of the other chapters in this book. By reading all the chapters, you will gain the critical overall perspective required for anyone who wants to succeed in the video business. Besides, people often wind up as great successes in areas of the industry they initially didn't know anything about or hadn't considered.

The same thing may happen to you. . . .

CHAPTER 2

Production Companies

any people have the image of a producer as someone who sits by the pool taking calls and saying things like, "Love your script, babe. Let's do lunch." There may be a few people who fit that stereotype, but it's more likely that if a producer is anywhere near his house, he's catching a night's sleep after working four straight weeks of twenty-hour days to finish a project. Producing requires a range of skills and knowledge. It's hard work, but many people find it to be the most exciting area of video.

Production is the first link in the video chain. Whether a video program comes to you via broadcast television, cable, videocassette, or on closed-circuit TV in your office, someone had to start out by producing it. Production companies have the job of pulling all the elements of a project together and making it happen.

Production can be loosely broken down into two components: the creative and the technical. On the creative side, someone has to come up with the idea, write the script, choose and book the talent, direct the show, and decide what gets left in or taken out of the final version. On the technical end are the trained professionals who operate the cameras and equipment in the studio, control room, or out in the field, set up the lighting, record the audio, create the special effects, edit the show, and make the final copies. All this is really just for starters. The production process is handled

in a great variety of ways and people with many kinds of job functions are involved in it.

Production companies orchestrate all this. They come in every shape and size. A production company might be one person with a business card and a telephone, who hires whatever and whomever is needed on a job-by-job basis. Or, it might be a complex organization employing hundreds of people. They may specialize in videotape only, film only, or a mixture of the two. For our purposes, we're discussing companies who work in tape all or some of the time and whose final products are distributed through a video medium.

Production companies take different approaches in going about their work. Some create and sell their own programming to various markets, such as broadcast television, cable or home video. They may use their own money to finance the project and sell it once it's completed; they may get some funding up front from a buyer such as a cable network; or they may find a partner to share the financial risk—and, if all goes well, the future rewards.

Other companies take on only straight assignments from clients, whether they be to execute show ideas for someone else, tape segments for a news or magazine-format show, produce a TV commercial or music video, and so on.

And then there's every possible combination of approaches in between.

A production company's clients can come from any segment of the video industry or be anyone involved in video. Production companies shoot and deliver broadcast television series, specials, made-for-TV movies, and the like. Much of the original programming on cable (shows shot specifically for cable, such as concerts, specials, made-for-cable comedy series, etc.) are handled by production companies. In these cases, they have either been hired to execute the cable network's idea or have gotten a go-ahead on a project they presented to the network's executives.

Advertising agencies usually turn to production companies to produce TV commercials. Corporations frequently contract with a production company to produce corporate communications and sales tapes, or whatever else they might need. Outside producers are often hired by record companies to create music videos. And home-video programming firms

may work with a production company to create software for the home-videocassette market.

Bear in mind that many clients also have in-house producers, so there are job opportunities for producers in these areas as well. The clients can have a video operation comprised of anything from one producer on staff to an extensive production setup.

Production companies typically call upon the services of other people and companies to help execute a project, and this is where the production terminology can become confusing.

The production company begins a project with the preproduction phase. This covers the organization and preparation before actual shooting starts: development of an idea, scripting, casting of talent, budgeting, and planning of logistics. To carry out the project, they may hire, or have on staff, a director, cameraperson, lighting expert, set and costume designers, and others associated with the creative side.

Most production companies, even the larger ones, do not own video equipment. They may have some type of editing system for rough editing, or keep a camera on hand for simple taping. To shoot a program, they usually go to another company called a video facility or video house (the facilities are sometimes called production houses, but so are production companies, just to make it a little more confusing).

Video facilities own equipment, and maintain (or will assemble) a crew of technicians, camera operators, editors, audio people, etc., all of whom are made available to clients. Some facilities maintain a studio or stage where programs can be taped. Many broadcast television stations double as video facilities for outside clients.

As one of the facility's clients, the production company rents the facility's equipment, possibly the stage or a mobile truck equipped for location shooting, and some or all of the crew members to shoot their production. All planning is coordinated, everyone shows up on the set at the appointed hour, the cameras roll, and the project is now into the production phase.

Once the footage is recorded, the program goes into postproduction. This phase basically covers everything that happens after the show is taped: creating special effects, editing,

audio mixing, and duplicating copies. Again, the companies with the equipment and staff to handle this are the video facilities. The production company may go straight through the project with one facility. Or, they may spread the work around, taking the unedited ("raw") footage to another facility that specializes in electronic graphics for some special effects, or to one that only handles editing and has a particular editor whose work the producers know and like. Postproduction is a segment of the video industry unto itself and is covered in depth in the next chapter.

There are all kinds of variations in the scenario, but this covers the basics of how a project is typically executed. Production companies are the idea people, the creators and organizers. They determine what the final product looks like, and are responsible for every aspect of the program.

Although there are other areas in the industry offering production jobs (which we'll mention later), these companies are among the ones you want to look into if you're interested in producing, directing, or scriptwriting. Production companies often bring along their lighting designers, camera people, and other technical and creative personnel to a shoot, so people with experience in these areas should also look here for job opportunities.

While production companies may keep some of these people on staff, in the majority of cases your arrangement with them is going to be on a freelance, or project-by-project, basis. However, if they like what you do and they're busy with productions, they may hire you so frequently that it works out to be the equivalent of a staff position.

You should know that contacts is the name of the game in this business, and it's not difficult to see why. Everyone hired to work on a production is being entrusted to handle someone else's money. Even if the sum isn't that large, it may be every cent the producer has in this world.

Putting aside the fact that few people are going to be too thrilled about paying to reshoot a botched job, in many cases you're recording a one-time-only situation. You can hardly expect a rock star to go through a second, unscheduled performance just because you didn't get the taping right the first time. Add to that the fact that you may be working on a project that is someone's personal dream, a show they've

wanted to do for years. Who wants to leave their "baby" with a total stranger whose abilities they know nothing about?

The idea is to get out and meet the people in production companies.

Once you've determined what type of production job you want, you'll need to consider what type of production company you want to work for. You might prefer a larger organization that has more structure and security, where there are lots of projects that you can work on and learn from. Or maybe you like the freedom of a smaller firm, which might be on less secure financial footing, but may give you more diverse responsibilities more quickly.

We think the best way to decide what direction to take is by seeing how a range of production companies operate. The companies below run the gamut in size and in the types of projects they handle, and they all operate differently from one another. In this section, seasoned professionals at these companies discuss what the entry-level jobs are, career paths you might follow, and where the job opportunities will be in the future. They also share how they broke into video. They express their opinions (sometimes conflicting) on how to prepare yourself for a job in production. And they offer comments on what they look for in the people they hire— and the best ways to get them to hire you.

Dick Clark Productions

Dick Clark Productions is a large, solidly established production company in Burbank, California. Headed up by television personality Dick Clark, the company and its divisions are involved in producing network TV series and specials, shows for syndication, theatrical films, and radio programming. Included on their very long list of credits are numerous music and variety shows, "The Academy of Country Music Awards," prime-time shows such as "TV's Bloopers and Practical Jokes" for NBC, and that perennial favorite, the thirty-plus-year-old "American Bandstand."

Gene Weed, vice-president of television at the company, explains that there are some thirty-five people employed on the company staff. Depending on production activity and the people brought on board for specific projects, that number can grow to 300 to 400 people. Weed is one of three staff

producers. Other producers, directors, writers, scenic designers, etc., are hired as needed.

The production process gets underway when the company has an idea for a show and tries to generate interest in it from a buyer, possibly a broadcast network or syndicator (a company which sells programs directly to local TV stations). Or, a buyer may come to the production company and describe the type of show they're looking for or a target audience they want to reach; in that case, the program is virtually a made-to-order creation.

Normally, a full pilot is shot only when a buyer has been found (a pilot being the first show aired and the one that determines whether the buyer wants to commit to a series). Occasionally, says Weed, they will tape a mini-pilot to sell an idea, or they may use existing footage from past shows of a similar tone to help illustrate their concept. Shooting a show without a firm commitment and attempting to sell it afterwards is the hardest route, explains Weed; one reason is that sponsors want to have their input reflected in the show.

Once the sale is made, the staff assigned to that show starts to grow. Two months before "The Country Music Awards," the show's staff consisted of five or six people; when show time rolled around, the group had reached roughly 135. The company goes to outside facilities for location or studio shooting and postproduction, and delivers a finished product.

Coming in with an idea is one way to get involved with a company such as Dick Clark Productions. "If it's a saleable idea," remarks Weed, "then you've automatically associated yourself with the company, and you're part of the staff to do that project."

(A word to the wise if you plan to follow Weed's advice on this score. Be sure that any company you approach with an idea accepts unsolicited proposals; you may need an agent to submit your idea through the proper channels. Further, get some copyright protection to avoid any possible ugliness down the line; it's not that every company will steal your ideas, but why not protect them properly? One last point, which may seem obvious but is frequently ignored: make your written presentation as professional-looking as you know how.)

One entry-level job at Dick Clark Productions is that of

runner, the lowest rung on the job ladder, but a point of access for someone without credentials. Runners are "gofers"—they do anything from delivering scripts to the talent and going for sodas to assisting in the editing room. "At least in this company, they usually have an opportunity to get involved. They get to see what makes the production work," states Weed.

One runner at the company moved up to production coordinator in nine months, then became a unit production manager, and is now an associate producer at another production company. Dick Clark's own son paid his dues for over five years, starting as a runner for one year, helping in foreign sales syndication and then working as an associate with Weed. He's now producing a show himself.

Weed didn't break into video until the age of thirty-five. He had been a successful radio disc jockey for over fifteen years. With his own resources, he began by financing a pilot and starting a business in "songfilms," which today would be called music videos.

"For the first four or five productions, I hired the best people I could find, and observed," he recalls. "By the time I got to the fifth one, I was the cameraman. I would spend my time at home between productions taking a camera apart, and playing with it for hours to learn how to make the moves easy and smooth. By the ninth or tenth one, I edited it myself. I was able to pay for my own education.

"I was willing to work in any capacity," Weed says, "so that I could learn the things that would make it possible for me to be at the helm one day—and be able to ask for things so if somebody said 'I can't do it,' I could say 'Move over, I'll show you how.' You can't ask people to give you things if you don't even know what you're asking for."

Just having a college degree won't make you readily employable in the competitive L.A. market, notes Weed, though a degree alone may serve you better in a smaller market. He points out that many successful people in the business don't have a college education, but feels a combination of formal school training and experience is the best mix. School will teach you the industry terminology, and show a potential employer that you have stick-with-it-ness. In general, he adds, "If you have the opportunity for formal education, you'd be

foolish not to take it. But if you don't, it shouldn't be a curtailment to getting into the industry and learning the other way. Like chicken soup, it can't hurt."

Weed has this to say about the kind of person he looks for: "I like to hire people that I think would like to have my job. If they're that ambitious and that willing to work and pay the dues, I sure as hell want them working for me, rather than against me. The runner whose ambition is to be a producer is going to give me 150 percent; somebody just looking for a paycheck is going to give me 60 percent or 80 percent, and that's not enough. [Their ambition] is usually shown more in what they do than what they say. I look for somebody who wants to participate in a project rather than work on it."

And, he adds, for those people dedicated to being in the business, willing to pay their dues and work hard at learning the craft, "this industry offers them as much opportunity for excelling as anything in the world."

Imero Fiorentino Associates

When broadcast television itself was young (with all the shows carried live, and videotape recording barely a gleam in the industry's eye), Imero Fiorentino was a pioneer in the field of TV lighting at the networks. In 1960, he went on his own to found Imero Fiorentino Associates, which started by specializing in lighting, but grew over the years to become a full-service production company.

Headquartered in New York, IFA is now involved in programming and production, lighting design, studio and facilities design, corporate communications, and training. Like other production companies, they do not own production equipment or maintain a studio, but go outside to meet those needs. They do keep on hand some equipment that is unique or hard to find.

IFA may produce their own programs, handle A-to-Z execution of a client's concept, or just take care of parts of a production. Among their many projects have been: lighting the musicals *Camelot* and *Sweeney Todd* during their taping for cable; lighting, set design, and special visual effects for a Barry Manilow concert tour; and the entire production (from staging with scenery and original song-and-dance num-

bers up through videotaping) of Anheuser-Busch's 1982 corporate meeting for 4,000 people, one of the most elaborate corporate meetings ever held.

IFA maintains a staff of roughly eighty people, including directors, producers, lighting and set designers, associate producers, and unit managers. Writers, musical composers and the like come from outside because various projects require different styles.

Imero Fiorentino describes the process of how the firm pursues new projects (and we think it doubles very neatly as perfect advice for the individual who wants to get ahead in video). First, they read the "trades," the industry publications (some of which are listed in the appendix). And, he adds, "we have an ear glued to the pace of the industry and what's happening. You get that information through the trades, having lunch with somebody, going to a cocktail party. I can be reading the [newspaper] and it says so-and-so will be doing a concert in Central Park this summer. That gets cut out and distributed." Even if the work has been given to another company, there may be some aspect of the production where IFA can contribute their services, and they'll check into it.

"That tenacity is crucial to getting jobs," says Fiorentino. "There has to be an aggressive approach; you must literally leave no stone unturned if you want to progress. If you accept the status quo, you're in effect going backwards because the rest of the industry will pass you by."

In Fiorentino's opinion, schools in general don't prepare students for the real world, nor do they help them focus in on the right career path and what they want to be. "Everyone I talk to, with the exception of a very few, has no idea what they want to do," he laments. "What a waste. Nobody takes the time to sit with them. Why? Because those people don't know; they're not in the outside world. The teacher or counselor doesn't sit where I sit, so you can't blame that person either."

Fiorentino doesn't favor the approach of becoming a production assistant on a project in a major market to get your foot in the door. "You'll be forgotten when it's over. What's happened is you've been exploited. You think you've learned a lot; you've learned nothing but where the coffee is."

He advises looking up stations out of town. "Get a job there doing everything. You don't make a lot of money, but you learn. Sweep the floor, help with the graphics, pull the cable, open the window. Little by little, they'll let you light the news, if that's what you want, or be the floor director if someone is sick. Then if you come to me with experience, I say 'oh-ho, different game.' Also, you taught yourself. Go to the boondocks," Fiorentino counsels, "and find out what you know how to do."

Intern programs are another way to break into production companies. IFA has had such programs, but Fiorentino felt people interning at low level jobs weren't learning anything. So, now the company only has such programs on rare occasions. They might put a student from a design school to work in the graphics department. "They work and learn," explains Fiorentino, "and get payment or credit for a month or two. I bring them into staff meetings and talk to them about it afterwards."

Finally, Fiorentino has some food for thought on where the industry is headed: "TV was a quantum leap for the world. We're about to embark on another: use of the medium as a communications medium in industry—teleconferencing, information and data distribution, etc." For one of tomorrow's opportunities in video, he says, look to the industrial (corporate) world.

There's only one way to make it in the video business, sums up Imero Fiorentino: "Devote your life to it. Give it your all and maybe you'll get something out of it. Chances are you'll win a few."

Hillier Productions
A younger company is Hillier Productions in Los Angeles. Bill Hillier started his company in 1979, after a career that included jobs as public affairs director and then executive producer with WBZ-TV in Boston, and program director at Baltimore's WJZ-TV. In 1976, while program director at Group W's KPIX in San Francisco, Hillier developed the concept for "Evening Magazine"; the show went into syndication as "PM Magazine" on over 100 stations, with Hillier as national executive producer setting up the project.

Hillier's production company is busy pitching show ideas

on storyboards (rough scene-by-scene sketches with dialogue written in) or demo tapes to potential buyers. The ideas have come out of weekly brainstorming sessions, from discussions with other producers which led to joint ventures, or ideas that Hillier says simply "walk in the door—and we solicit that." Or they are responding to clients who come to them with an idea and want to know how they would produce it. That's the way they began taping the magazine-format show at Disney's Epcot Center in Florida for cable's Disney Channel. Many of Hillier's programs are magazine-format or documentary shows.

The production process followed by Hillier's company is similar to that of Dick Clark Productions. The company is far smaller, however, with a full-time staff of seven people. Aside from Hillier, they include his assistant; an executive producer, who runs various projects and makes sure they come in on time and within budget; the executive producer's assistant; a director of talent and development, who solicits ideas and manages development of projects; an assistant for her; and their head of production, who oversees their dealings with facilities and crews. Once the freelancers for different projects are counted in, the company may have eighty people employed; when shows are not in production ("on hiatus," as they call it), the number may shrink to twenty.

Bill Hillier offers a useful description of what a producer does in this business. "Our approach," he explains, "is that any show has a single operating idea—we call it the spine—and that's the basic concept, the reason the viewer watches. The producer is the keeper of the concept and makes sure *that* basic idea happens in all regards; that the graphics, directing, editing and casting reflect that basic concept.

"The producer has the vision," Hillier goes on, "and it's his job to translate that to all the people involved. He also has two other tasks. One is to be a terrific executive. There may be sixty-five to one hundred people working on a show, so he must be a good judge of character and team leader. You have to orchestrate all these complex moving parts. The third task is very important to us: the producer has to do it all within budget."

Hillier, too, thinks the job of runner is a good place to get your start. It may, for example, lead to a research job

as the next step. One of their staff members went from runner to researcher to associate producer to field producer. Other entry-level jobs he mentions are production assistant or switchboard operator. His company also has interns who get school credit for their work, and Hillier says several have ended up with permanent jobs there. They must be in school, but anyone from any school can apply for an intern position.

"People with good ideas will rise in this business," asserts Hillier. "It's craving good people. The trick is to get your foot in the door." According to Hillier, a local TV station is not the place to break in for the person who wants to produce entertainment programming. In his view, "If you want to do network programming, particularly entertainment programming, then I think you're much better off coming to work in Los Angeles or New York with a major production company, or going to work directly for the networks. And the reason I say that is that everybody I know who does that kind of [programming]—that's exactly how they started . . . The other side of [it] is that there are very few entertainment programs, if any, at local stations. So it's virtually impossible to build a résumé reel . . . Plus the people who are likely to hire you to produce that network entertainment show really look upon the local stations as the hinterlands."

However, Hillier continues, "None of those rules apply to news. If you're interested in going into news, then, yes, that's a very good way to do it. That pipeline is completely open because the local stations do so much news. You can go from local reporter to network reporter very easily; you can go from local news producer to network news producer. But in the entertainment area, I think you are much better off getting into the Hollywood community right off the bat, because you'll find later on it's very tough to break in from a local station."

When Bill Hillier hires people, he looks for "creativity and a desire for quality and stretching . . . Someone who will do everything they can to make it the best they can. That's number one." Secondly, he points out that "this is a fun business, but it's not really a fun career. One has to look for a commitment, a willingness to work and put in strange hours. You have to understand you may be in an editing room all night, or work twenty days nonstop, or have to run

around the country going from location to location. You have to love it a lot and make that commitment. It's not the best profession if you like to come home and have drinks with your family every night at 5:30."

For those who love it, the best preparation, he says, is learning to understand communications, "the act and art of communicating. The key to the business is ideas. I think some of the best backgrounds are often in English or theater—not necessarily directly in broadcasting, but a good liberal arts background with an emphasis on how do you get messages across. Even people who want to run camera ought to know that. That's half of the preparation and to me the most important part."

The other half is getting that first job. "We don't look at school on a résumé, but I've observed people tend to get jobs through friends, so it's good to be in with a group of people who want jobs in production. When you graduate and one of them gets a job, they can pull you along. It's important to be in the right milieu of people who can help you out professionally. A degree doesn't mean anything. Unless," he laughs, "they went to my alma mater." (He may be joking, but we say take the tip. Look up anybody from your college or high school who is now in the video industry.)

Hillier sees the video business becoming "fractionalized" through all the distribution means, such as cable, home video, and DBS. "As a result, cheap production is becoming very important," he remarks. "You're finding a lot of computerization and experimenting with ¾-inch and ½-inch tape. If I were starting out, I'd look to companies involved in the new technologies and new means of producing programming. Look to new technology and to small-format production. There's no other way to feed all these video outlets. None of them have a big enough share of the market to have the kind of money traditional television had behind it, so they can't afford the same kind of production. They have to be ingenious and do things in different ways."

Bill Hillier has one parting suggestion for people who want to break into his business. "I'm always impressed by their presentation of what they've done. It baffles me when a person who wants to be a producer or director comes in and hands over a very traditional résumé on a piece of paper,

instead of a dynamite tape—even if it's shot on home-video equipment. Since it's so competitive, you need every edge. I'm always impressed when somebody does an imaginative pitch for a job. I think that's one thing people don't pay enough attention to."

NBE Productions

Nat Eisenberg specializes in directing television commercials, working in both tape and film. He founded his New York-based production company, NBE Productions, in 1969. Eisenberg is another television pioneer and a well-known industry figure; he is also famous for directing celebrities and children in TV spots.

Eisenberg directed live TV on local New York stations in television's early days, and began shooting with videotape when it arrived on the scene in the late fifties. He even helped NBC set up their first videotape commercial operation. Eisenberg's career path into the television business included a job as a press agent, working in the mailroom at WMCA radio in New York, and writing and directing quiz and variety shows for radio. He's worked for others on staff, freelanced, and for the past fourteen years has headed up his own shop.

As Nat Eisenberg explains, in the business of producing commercials, ad agencies come to a production company with their idea plotted out on storyboards. The company estimates what the job will cost, typically bidding against two or three other production companies. Eisenberg notes that outside the major commercial production center of New York, video facilities may offer themselves as production companies to ad agencies. That situation doesn't exist in New York, he observes, because production companies wouldn't want to spend their money booking equipment and crews from the same companies that are bidding against them for work.

NBE Productions started out with three people: Eisenberg (the director), his partner, Belinda Cusack (acting as producer, associate director, and editor), and a production manager. To start a company like his, he adds, "You always need a director or a cameraman to go into the business. That's been the fragmentation since the days when the big companies split up. It was always the director that they hired."

Today, NBE's staff is comprised of three directors, the same production manager, a producer/production coordinator, a director of sales who is also a producer, and a part-time bookkeeper. Eisenberg himself has always gotten involved in selling, but that's fairly unusual for a director.

Sales in the video industry is an example of a job where traditional skills can be applied to a new field. It is not, of course, restricted to production companies; everyone has to attract future business. Still, while selling may be selling, there's more to it than that in video. As Eisenberg explains it: "Most companies our size dabble from time to time in sales directors or sales reps. We've had them over the past fourteen years. Only one has really been thoroughly successful; he was with us seven years. Our current director of sales is also a producer, a man who had his own company, who also is selling . . . Selling is a very difficult art because it's very competitive. It would be ideal to get someone to sell who knows the business, not just someone who walks around with a reel. You can hire anybody to walk around and show your sample reel."

There it is again: to make it in one end of the business, you still have to know about all its other aspects.

As Eisenberg sees it, the entry-level jobs in production are secretary or production secretary, positions that people pursue "in the hope that they will work up to become production assistants. Or in the case of a small company, they do everything; they learn the business. When our producer/production coordinator came with us, she didn't know this business at all. She had a long background in executive secretary work. In five or six years she has learned the business where she's now able to produce, coordinate, and knows how to script."

Although you might be doing clerical work as a secretary, Eisenberg points out that "everything is going through the office, and if you're lucky you become part of it . . . You're not sitting and typing a hundred letters a day; it isn't that kind of a job. You may also be keeping track of traffic—tapes that are made and making up cassettes.

"You learn the production business [in these secretarial jobs] and the biggest thing then is to hope that the company you're with will get you out into the studio." However, he

continues, "That's tricky, because who minds the store if you're in the studio? [But] a good company that's trying to break in people and grow would try to do it that way."

To Eisenberg, the bottom line for those who want to break in is that school "doesn't hurt, but they've got to start way down on the bottom again. They've got to be a secretary or production assistant, and do all the dirty work. That's the advice. That's the way I started. You start at the bottom, and if you're bright, you move up."

Downtown Community Television Center

A very different type of producer is Jon Alpert. You may know Alpert's face from seeing him on "The Today Show," where he appears to introduce tapes he's shot in the field. Alpert is an independent producer who heads up the twelve-year-old Downtown Community Television Center in Manhattan, a nonprofit organization that produces issue-oriented programming and provides training in video.

Although all the people we've talked about in this chapter are technically called independent producers, the term "independent" is often used in the industry to describe producers who work on less commercially oriented projects. Video artists also fit into the category. This is the type of independent Jon Alpert is. He and his wife, Keiko Tsuno, have a reputation as people who have "made it" in the tough world of independent production.

Alpert became known to many through his exclusive taped reports for NBC News on the China-Vietnam conflict and the revolution in Nicaragua, and his interviews with Fidel Castro. His documentary work often focuses on subjects that concern the people in local neighborhoods. Alpert's and Tsuno's derring-do in venturing into dangerous situations for a story is also well known.

Alpert was a community activist and taxi driver in 1969 when he met Tsuno, who was then working as a waitress. She introduced him to video equipment—a Sony ½-inch system called the portapak—and they were off and running. Alpert has used video as a means of drawing attention to social problems and community reform. His work has been seen at alternative media centers, in institutions, on PBS and network news, and in the streets.

According to Alpert, government grants and funding cover only 30 percent of DCTC's expenses; the rest comes from earned income. He explains that revenue from places like NBC helps subsidize their community video activity. About two years ago, he started Electric Film, a for-profit company with a top-notch editing facility DCTC can use, and which can be rented to outside clients (more income to subsidize DCTC, adds Alpert).

DCTC owns the equipment it uses. Seven people are on the staff full-time, up to ten more part-time. The organization is very involved in training others to use video (Alpert says they now train some 3,000 students yearly), and will lend equipment to those who know how to use it and are working on a nonprofit venture (presently, that means some 400 artists and community organizations). In addition, anyone can call and get on the list for their free class in basic shooting, lighting, and editing. For a small fee, they can go on to a more advanced class.

From community video to network news as an independent. The question is, can it still be done today by other enterprising producers? "I can't say if it's harder now," reflects Alpert. "We were ready to make sacrifices in the beginning, to live very frugally, and let our work speak for itself. That was the thing which attracted us some funding in the end. We didn't start out with the desire to be successful TV producers. We just put the work first and did the best job we could.

"I imagine that if someone really wanted to do that again today, they could," Alpert speculates. "The people I see always getting into trouble are those who decided they're going to be a producer or famous reporter or something. If they have the job definition in front of the work, these people always seem to get in a lot of trouble."

For anyone starting out in this field, Alpert feels every case will be unique, but advises they "get into an area they're really excited about, and don't mind working on seven days a week, looking at takes over and over. If they can get themselves into a situation like that, I think everything else is going to take care of itself."

Alpert recently took some of the high school students he works with to visit a broadcast network, where the job advice was to come in with four years of college and experience

in a smaller market. But Alpert also suggests "there's another case where you can go out and do your own work, and your work becomes your calling card rather than your experience. There's no clear-cut road for anyone to follow." The hard-nosed truth: "Whether you're working for a company or you're working independently," he notes, "you're basically going to have to give your labor away for a number of years in order to establish yourself."

Improved video technology has clearly played a role in Alpert's success. Being the first or best with new equipment helps give the independents what Alpert calls a needed "leg up" on the competition. He makes the point that "the television networks and the bigger organizations have used the work of the independents as basically a free form of R&D [research and development]. In my observation, the independents went out and pioneered the ENG [electronic news gathering] revolution."

It was the independents like Alpert who were the first to get programs shot with small-format video—portapaks, ¾-inch and the more recent one-piece camera/VCR units—on the air. "We have to do that," relates Alpert, "because we have to try a little bit harder. We have a lack of security and a future we just can't predict. But the other part is we really don't have to take any orders from anyone."

Alpert believes the qualities one should have for this work include wanting "to talk to people and be truly concerned with their lives and the things affecting them. You have to really like people and want to use the camera to get to know people you might normally not get to know."

And you have to know how to tell a good story. Says Alpert: "I've seen a lot of stuff on TV where people were very bad storytellers, not able to focus and get across some major themes in their work. I think one of the things that was very helpful to us was that we were extremely self-critical, especially in the early phases of our work—always dissatisfied with what we'd done and continually looking at it and trying to do a better job. That was one of the major faults of a lot of the other producers who haven't survived: they loved their tapes, and if they ran for a half hour or an hour, they just thought so much the better. Well, other people didn't see that and they're not around anymore."

Professional Video Productions

About the same time Jon Alpert was out in the field experimenting with portable video equipment, Richard Namm was also learning about the possibilities offered by the new small-format video technology. Namm is an independent producer/director/consultant in New York (of the more traditional "independent" sort: clients hire him to produce or direct their show or consult on a project).

Many shows Namm has worked on have been broadcast live and then distributed on cable and/or videocassettes and videodiscs. He frequently works on music video projects. Namm produced and directed a Charlie Daniels Band special which was transmitted to cable systems live via satellite, and an REO Speedwagon concert, the first concert program MTV showed after its launch. He also directed the videotaping of The Who's final concert.

Flashback to 1970. Richard Namm was selling hi-fi equipment after school at Harvey Radio in New York. By reading the manuals, he learned about the industrial video equipment they had just begun selling and became the store's resident expert on video. When Harvey's Professional Audio/Video division expanded in 1972, they "borrowed" Namm. He stayed there until moving on to head up another company's new video-related division at the ripe old age of twenty.

By 1973, Namm and his brother had started their own company with a $10,000 loan from relatives. Using their own modest equipment setup, they did casting sessions on videotape for agents.

Some interesting jobs began to come Namm's way as he built his list of contacts as well as his reputation. In 1976, for example, he spent ten days with a crew taping President Gerald Ford as the candidate made a tour of major cities during the election campaign. Namm's employer on that job was none other than Imero Fiorentino Associates. He was initially hired as an editor on the trip, but by his own account, also wound up acting as an assistant director, engineer, technician, gaffer, and general schlepper.

Over time, Namm and his brother were able to expand their services with funding from an outside source for state-of-the-art hardware. Although the company primarily func-

tioned as a video facility, Namm himself was producing all along. In fact, he has the unique distinction of being one of the nominees for the Grammy's first Video of the Year award, in 1981 (for a jazz program he produced, titled "One Night Stand").

In late 1983, Richard Namm went out on his own and started Professional Video Productions, Inc. He's basically a one-man band, bringing in the business, hiring personnel and equipment as he needs them.

Going it alone as Namm does "is not a nine-to-five mentality," he remarks. "It's feast or famine and everything in between if you work for yourself. You have to hustle, but you'll be independent."

Namm follows all the steps to make sure he stays on top of industry developments and maintains visibility in the business. He attends a string of conventions and trade shows starting with the National Association of Broadcasters (NAB) Convention, the Consumer Electronics Show (CES), Society of Motion Picture and Television Engineers Conference (SMPTE), the Visual Communications Congress (VCC), and other conferences and exhibitions in computers, music video, and computer animation.

Attending conventions, Namm points out, is a way of seeing many products gathered under one roof for comparison, hearing the latest news, getting his questions answered, and making those always-important contacts. In some instances, he participates in panels and seminars at these meetings.

Richard Namm also reads numerous professional and consumer video and computer publications, ranging from *Videography, Cablevision,* and *Variety,* to *Video Review* and *Info World.* Then there are industry newsletters and coverage of the media in newspapers and on television. Namm has also written for video publications, not so much for the money as for the exposure it gives him and the credibility it lends to his name. All of these activities are crucial for the producer who wants to break in or get ahead in this fast-changing business.

Namm studied film and television in college, but believes he got more valuable practical video experience working in early jobs. In his view, "you can line the birdcage with a sheepskin in this industry." Those who want to break into

41

video "shouldn't disregard the college video course," he says, "but they should put less emphasis on that than on real hands-on experience under battlefield conditions—by which I mean that money is at stake."

Production experience at school helps a budding videographer hone skills and make contacts, Namm goes on, but professionals know the tapes produced there are usually done with little money, and "even if they were great, you wouldn't give that person the job of producer on your next big show anyway. Those tapes are only a means of showing someone you have the basic necessary skills. There are other ways to demonstrate that." According to Richard Namm, "The best one is to work your ass off once you're given the chance to show off what you can do."

If you have any contacts to get a job, says Namm, by all means use them. Barring that, he suggests pursuing an entry-level position with a small television or cable station or production company, since smaller organizations may offer the chance to gain experience in a number of areas.

As Namm points out, in a smaller company—where departmental lines are less strict than at a network, for example—you may be a "jack-of-all-trades and show how valuable you are. And if you can work for a production company and do a little camera and editing, and a little lighting and production assistant work, you're much more well rounded than if you just go to a local TV station and work camera all the time for ballgames."

Namm notes that a network or larger station may have more positions and bigger budgets, and therefore might offer more opportunities to move up the ladder. However, he reflects, "the network might be enticing momentarily, but if you're looking for experience, and there's an alternative of working at a local, small-market station where you could possibly do a lot of things, that might be better for you."

For the person interested in getting into production, Namm provides a list of entry-level positions. Aside from researcher or driver for the production crew, he also mentions utility jobs, which may include setting up cameras, carrying equipment, driving vehicles to and from locations, and pulling cable (assisting a cameraperson and keeping the cables—and yourself—out of the shot).

Occasionally, the job of lighting assistant may be a spot for the beginner. Another might be that of audio assistant or second audio person (also called an A-2). That assistant may be in the studio, stringing cable, putting mikes on the talent, and loading the tape machines. "It's an apprentice position," explains Namm, "because you get to work closely with the audio person and ask a lot of questions, learn about the equipment, and how to do emergency repairs.

"A lot of these things," he goes on to explain, "can be learned at home or are known by people who are hobbyists. Any of those skills—building kits, any minor engineering or technical work done at home, carpentry or electrical work—should be included on a résumé when applying for an entry-level technical job. It's valuable [for the prospective employer] to know."

As technology has made higher-quality equipment more affordable, Namm points out that a fledgling producer can use home video equipment to shoot some form of pilot for an idea, and submit it to a potential buyer with a budget and copyright-protected outline. "You can use the equipment at home to practice what you want to do for others," he suggests. "That opportunity didn't exist when I started out. And once you're in the business, you have more access to equipment and can expand on ideas."

Would-be producers, comments Namm, "should be acutely aware of the changing video environment in people's homes. For example, there's now stereo TV, so we have to pay more attention to soundtracks. Also, you have to know that the video quality is as good as it can be going in, so that when the program finally reaches the ½-inch consumer format, the quality is acceptable in comparison to what people are watching on the same box moments before or after your production.

"Television is no longer just a black box," Namm continues, "but more of an output terminal for a host of input devices—like cable, network and syndicated [broadcast] television, VCRs, videodisc machines, teletext, and videotex, DBS, video games, computers, and other devices not even invented yet."

With that in mind, producers "should develop the attitude of being Renaissance people, in the sense of walking into a

production company and not saying 'I want to produce for TV' but 'I'm familiar with all the different uses this box has now.' Be as well-rounded and well-read as possible on all these situations because it will help to stay ahead of the competition," is Namm's advice.

Some specific areas to keep an eye on for the future, says Namm, start with cable TV technology, notably in two-way or one-way interactive television. Then there's the use of computers in production, not only in technical production processes—like editing—but in budgeting, scripting, production management, etc. Namm also advises keeping abreast of the advantages and disadvantages of various tape formats such as Betacam, Recam, 1-inch (and, of course, film), understanding when the need is to shoot on one particular format and edit on another, and all the possible permutations.

Richard Namm has some encouraging final words for those who want to break into the business. "They should not lose track of the entrepreneurial spirit of this industry," he remarks. "Every Tom, Dick, and Harry has the opportunity to come out with a great idea. If they have some experience or can tie in with others who do, and if those ideas are new or innovative and not cost-prohibitive, then more often than not, the ideas can be done. I know people who had little or no experience in the industry, but they had great ideas and were able to write them well. They got together with a distribution company, which assigned a producer to do it. The writer became a co-producer and made a lot of money. That's an exception to the rule, but it's still something to keep in mind. The more VCRs that are out there, the more opportunities there are for people to address a percentage of that population with some new, interesting idea."

Scene Three

Scene Three in Nashville, Tennessee, is still another type of outfit, a hybrid cross of production company and video facility for postproduction and mobile production (shooting outside the studio on location, also called remote production). While they do not currently create their own programs, co-owner Kitty Moon explains that they work on projects for outside clients, and have other customers using their computerized video editing facilities and 45-foot mobile produc-

tion truck. They are also renovating an old theater into a new studio.

Scene Three's clients might be other production companies, ad agencies, corporations or record companies (there is, of course, a large segment of the music business in Nashville). Twenty-seven people are full-time staff, including the key positions of producer, director, writer, lighting designer, art director, cameraperson, and engineer. The company works in both film and tape.

The ten-year-old Scene Three underscores how the video business has spread across the country to support companies such as this one outside the New York and Los Angeles production centers. A key factor encouraging the growth of companies like Scene Three is that they frequently offer lower prices than those on the two coasts.

"I think the whole environment in the South, and Nashville in particular, has been to really promote this industry," Moon comments. "I know the film commission has worked very hard to expand the film and videotape industry here." She agrees that the business opportunities are expanding across the country, and points out that the Tennessee Film Commission calls Nashville "the third coast" for production (Texas has also laid claim to that title—but that just illustrates how much the industry has expanded to other regions). And, "the talent pool has grown considerably here," Moon continues. "That's been a stumbling block in the past, but that's not the case anymore."

Moon's own background includes a college major in radio, television, and film, and jobs in public television. To work on the technical end of video, she reflects, "You have to go to school. For the production end, I think you just need to get in and do it; I don't think that's something that can be taught in school."

At Scene Three, Moon notes, many people have worked their way up through the ranks. "We offer people the flexibility to pursue their interests. Three years ago, we had someone working freelance doing whatever they could—building and designing sets, gripping—who then went on staff and worked his way up. Now he's vice-president of production for the whole company."

Though Scene Three's employees can still wear many hats,

"obviously," she says, "as we expand we'll need to hire people to do specific jobs and nothing else." (Another tip: there can be a benefit in hooking up with a young company before it becomes highly structured.)

"This is the most exciting business in the world," Moon sums up. "There's always something new—a new project or client, or trying to come up with a new way to communicate a specific message. You have to be open to new ideas; anyone who can't think creatively or wants to be pigeonholed in the same routine does not need to be in the production business."

To break in: "I think you just need to roll your sleeves up and do whatever you can to try to get into a good organization and learn your way from the ground floor up."

Final Takes

In Chapter 1 we mentioned the importance of having the right attitude to get ahead in the video industry. Just in case you thought it was only stock or pat advice, consider what these professionals had to say when we asked them what were the qualities they look for in the people they hire:

Gene Weed: "A tremendous willingness to become involved in the project on whatever level it is. And to be a participant in the project and not to say 'I don't do that because that's not my job description.' Any kind of a production is a team effort. A production assistant's job description is someone who's in charge of the scripts and the rundown and paperwork and so forth. But it goes so far beyond that. Without their working with the director and associate producer and everybody else, things fall apart. I look for the attitude of the person and the willingness to learn and work."

Imero Fiorentino: "Attitude is the first thing. How do you relate to people? It's a people business, not a parts business. Before you design anything, you have to talk about it. If you can't accomplish the basic need—communication among people—you fail. If you're a loner, forget it; you belong in some other business. Lighthouse-keeper is good."

Nat Eisenberg: "I personally like people with outgoing personalities. You want people who are not averse to working long hours and who don't want to become directors the first day they work with you, and don't want to be in the studio where all that glamour is the first day they work with you.

And a lot of them—that's what they want. They don't even want to put in a year learning."

Kitty Moon: "A willingness to work, because in the production business you work hard. Our people are hand-picked and they have a [certain kind] of attitude. They're all-business toward doing whatever is possible to get the very best possible job for the client; the client always comes first. I call it professionalism. This is not a nine-to-five job. We've been known to work around the clock and then take the next day off. You have to have that kind of dedication."

Richard Namm: "Attitude is as important, if not more important, than technical experience. Every day is a new experience in production. Except for the old-timers, no one's seen it or done it all."

Enough said.

CHAPTER 3

Video Facilities

ost people who saw the popular movie "Tootsie" probably had no idea that the TV production scenes for the mythical soap opera in the movie were shot at a real-life video facility in New York. Although moviegoers may have seen the name "National Video" in the film, most people focused their attention on the transformation of Dustin into Dorothy, rather than on National Video's temporary identity as a movie location.

But to anyone in the production business, National Video and hundreds of facilities like it across the country are the places where a large percentage of what we see on television is shot and/or edited. From what we know about the video business—and talking to people who want to break into video—facilities are often the most overlooked part of the business for job opportunities.

As we saw from our discussion of production companies, the video facility provides the equipment and staff required by producers to get their projects on tape. Although the major broadcast networks maintain studios, equipment, and crews, most of the prime-time videotape programming seen on TV is shot by outside producers at video facilities. Networks sometimes supplement their news and sports operations by using the services of outside facilities. Similarly, corporate or private TV operations often go to facilities for special services and equipment not available at their in-house facility.

Cable networks, with only a few exceptions, do not maintain either studio or editing operations and turn to facilities for these services. Most TV commercials, whether shot on film or tape, have passed through the doors of a video facility at some point in their production. The same can also be said of the home video program you've bought or rented.

Video facilities or production houses, as they are sometimes known, may provide production services in the studio, the place where the program is shot, and they may be able to take their cameras and videotape recorders outside the studio for mobile (or remote) production. Most facilities today offer postproduction services as well. In postproduction, a program or commercial—which has been shot either on tape or film—is edited and readied for distribution. Video facilities also handle tape duplication for TV commercials, corporate TV programs, or home videocassettes.

Not all facilities do the same things. Some may specialize in postproduction or even in one particular area of post such as editing. Others may only offer remote production and have their equipment and crew constantly on the road. Some do everything, from shooting in the studio or on remote, through editing to videotape duplication.

Working at a video facility can provide opportunities available in no other part of the production field. You can learn about different equipment and jobs, and find out more about the business by working with people from all parts of the video industry. Entry-level jobs can lead to hands-on experience and eventually to a career in the facility world in a job for which you demonstrate talent and interest.

The video facility business has prospered over the years since a handful of companies set up operations after Ampex introduced the first videotape recorder (VTR) in the late '50s. This VTR used 2-inch videotape and recorded in the quadruplex (four-head) format, soon earning the machine the nickname, "the quad." The facility business began in New York where these new "tape houses" concentrated on providing studios for advertising agencies shooting the first commercials on videotape.

Back in those days, and actually until fairly recently, most people working in facilities were engineers or highly trained technicians, because the equipment was very difficult to oper-

ate. Quads and cameras were huge, unwieldy, and often difficult to set up properly. And the only way to edit tape was a laborious process using microscopes and razor blades. (Remember all the fast cuts in the network program "Laugh-In"? All done with razor blades.)

Although facilities still have engineers, many of the other people working in facilities today don't have technical backgrounds because the equipment has become simpler to operate. The 2-inch VTR has been replaced by the smaller, easier-to-handle, and more versatile 1-inch VTR. Cameras have also come down in size with setup almost a snap in many cases. Gone are the razor blades because now videotape is edited electronically.

People who are operating the equipment today have learned some basics of video technology and worked their way up through the ranks of a video facility. Many jobs they hold did not exist a few years ago. And there are many more jobs at facilities today in more parts of the country because of the growing use of video.

The video facility business grew initially because tape was faster and cheaper than film. The business continued to grow during the sixties and seventies, as more production of TV commercials, broadcast shows, and corporate (industrial) programs was done on tape. In the past five years, new distribution channels such as cable and home video has increased the demand for programming, and led to further prosperity in the video facility world.

With the growth of videotape production has come a demand for new developments on the equipment side. Computer technology has become an integral part of the video business, affecting everything from editing to camera setup to graphics, just to name a few areas. With this new electronic wizardry, video has been able to make even more inroads on film.

Special effects that once took days to produce at a film lab can now be created almost instantly at a video facility. New video-based editing systems, that merge electronic technology with many of the tried-and-true techniques of film editing, are bringing the video and film worlds closer together. This has meant more work for the video facilities, as film

people bring more projects to video houses for completion on tape.

The film industry, which maintains a love/hate relationship with video, has seen the business potential offered by tape production. Film laboratory companies have set up video facilities across the country. Kodak is selling professional videotape to video houses. And a major force in motion picture production, George Lucas, has established a division of his company, Lucasfilm, that designed a new computer-based video-editing system that is being marketed to video and film facilities. As the two media merge, thanks to the miracle of microprocessors, there is a growing sensitivity from video professionals to the craft behind film and the talents of professionals in that field.

At the same time that sophisticated and expensive equipment was arriving at the facility, new relatively inexpensive and high-quality cameras and recorders also made the scene. Enterprising people all over the country have used these portable and lightweight devices to start their own remote facility services. With a video-hungry local, regional, and national clientele, these new companies are adding postproduction and other video-related services as they grow and thrive.

A look at the locations on one of the "magazine" shows on broadcast TV (such as "P.M. Magazine"), will show you that crews are busy at work not just in New York or Los Angeles, but in Peoria and Portland as well.

Inside the Studio
National Video, which played host to the cast and crew of "Tootsie," usually finds its studio booked by clients shooting everything from commercials and cable shows to music videos and corporate programs. The twenty-five–year-old company, which began as an audio house in a Manhattan office building, now makes its home in a renovated bus terminal on the West Side in midtown. In addition to its studio, National offers postproduction services in video as well as audio.

According to Bill Kelly, vice-president of sales and marketing at National, "The facility end of the business has overtaken the networks in terms of pushing manufacturers into new directions and coming up with new products." He goes

on to explain that "ten years ago you would assume that networks were on the cutting edge . . . Now it's the facilities."

The range of projects and new equipment arriving at the video facility makes the video house an exciting place to work. "There's a tremendous diversity. You certainly are not doing the same things day after day for the same clientele," remarks Kelly.

At National, that could mean a music video production in the studio one day and a TV commercial the next, perhaps followed by a shoot for a cable network.

National's full-time studio crew consists of about ten people. For the simplest shoots, requiring only one camera, the facility usually assigns a cameraperson, audioperson, and videotape operator, with the lighting handled by the crew.

In larger productions, requiring two or more cameras, a technical director (TD) is required. The TD operates the production switcher (a device that cuts or dissolves to the camera shots selected by the director) and supervises the crew. The crew also includes additional camera operators, a separate lighting director, audio and lighting assistants, and production assistants on the floor moving camera cables.

Another job is studio manager, whose responsibilities include making sure the studio is prepared for the shoot (walls painted if required, sets dressed, and studio stocked with the necessary supplies), and operating the in-house prompting system (a device that displays the script copy read by the talent).

At National and the other facilities which handle more sophisticated studio productions, larger shoots often mean adding personnel hired on a freelance basis. These jobs range from the technical and engineering jobs, where the in-house staff must be supplemented, to the other specialties not available in-house, including wardrobe, make-up, and hair. According to Kelly, National maintains a list of freelancers they know and like to work with, who they call if the client has not made a request for specific outside specialists.

As in the case of most facility studio operations, National doesn't maintain a staff of directors. "The directors come in with the clients," explains Kelly. "We can recommend directors and we usually recommend a minimum of three. We

don't want to give the impression that we have directors working for us."

(You can understand a facility's reluctance to foist a director upon a client by recalling Nat Eisenberg's explanation of the business: Production companies, especially those involved in TV commercials, usually have directors on staff, and they use outside video facilities to shoot their projects. Facilities don't want to compete with their best clients, the production companies.)

To get into the studio at National, people must start at entry-level jobs, such as shipping. Eventually, more desirable positions may open up either in the studio or postproduction. But as Kelly reflects, you may not be able to get into the exact phase of production you planned on. "You may ideally want to do something," he explains, "but if there is an opening that takes you in another direction—and it looks interesting, challenging, and involves a raise—you look at that. And if you move off in that direction and you do it well, you get typed as an expert even though you stumbled into it."

As a seasoned facility professional, Bill Kelly has watched many people start in the business and has some interesting observations to share: "Some people come in and they stand with their hands in their pockets. They're like an empty vessel waiting for you to fill them up. Other people come in and they are running around looking for the source of the water. They jump in and ask questions and are willing to help." Kelly comments, "It's interesting how some people fit in and learn quickly. They put two and two together and figure out the answer is four and they should be doing such-and-such."

Therefore, it should come as no surprise that, to Kelly, "the overriding criterion is basic intelligence, a sense of good judgment, and a willingness and desire to learn." As he sees it, "you get someone with those qualities and there's not too much they can't do. There are people who started as gofers who are now doing camera work and lighting."

Bill Kelly has some thoughts to share on the realities of getting in and getting ahead. "We are not an industry known for training and preparing its people." He goes on to explain that while the facility business may be open to almost everyone, "It's a Darwinian system where only the fittest survive."

As far as formal education goes, Kelly says: "I don't get the impression talking to people who come out of colleges and universities that they are particularly trained to function in this business. They may have absorbed a good deal of theory [in school] but they get reality by working in this business."

One of the realities Kelly cites is "the craziness that goes on." But as he remarks, "That is the nature of the business. People tend to wait until the last minute and then you have to run just to keep in place once that decision is made." So, he concludes, college trained novices find that "in reality, the situation is vastly different from what they are trained to expect."

One for the Road

Have you ever seen one of those enormous trucks parked in front of a sports stadium or theater with forbidding black cables leading to points unknown? Chances are this was a mobile television production truck. Sometimes these semi-trailers will have a familiar broadcast network logo painted on the side. With the growing market for location shooting for broadcasting, cable, and other distribution channels, more video facilities are putting these vehicles on the road.

The new breed of mobile (remote) production trucks can include a dozen cameras and VTRs, an editing system, control room, and even audio mixing equipment. With these larger units, you have a video facility on wheels that can drive almost anywhere to cover a big event. The people working on these trucks are usually seasoned veterans, including full-time and freelance staff.

Video facilities offer remote production services ranging from the portable location unit packed in cases that can be shipped anywhere, to the panel truck specially outfitted for mobile production, to the 45-foot semis. Remote production (also called location shooting) has really taken off in recent years because of the arrival of a new generation of portable and relatively inexpensive cameras and VTRs.

The big breakthroughs began in the late seventies when broadcasters replaced their 16mm cameras with video equipment, and electronic news gathering (ENG) was born. The minicam and the ¾-inch videocassette recorder not only re-

placed 16mm film, but also the commonly used, larger and more cumbersome, 2-inch videotape recorders and unwieldy video cameras. With the demand for more location shooting and the availability of new portable equipment, many enterprising people were able to break into video with their own companies.

Frank Beacham, a partner in Television Matrix, has built his location shooting company on the service's growing demand. In the past year, Television Matrix has expanded from its Miami base to include an operation in Hollywood as well. Beacham does location shooting for "Lifestyles of the Rich and Famous," "Entertainment Tonight," network news operations, comedy and entertainment shows, and some industrials. His work takes him all over the world. Beacham started small with relatively unsophisticated equipment—a Sony ½-inch portapak and camera—specializing in shooting legal depositions.

By 1976, technology and Beacham's business had progressed to the point that it was time to move into higher-end equipment and more challenging and lucrative assignments. So, Beacham went to the professional video industry's main hardware show, the National Association of Broadcasters Convention and bought a $52,000 equipment package of RCA ENG gear.

After forming Television Matrix, Beacham bought more equipment. He started to develop good contacts with the manufacturers, which brought him some interesting assignments. Shortly before Christmas 1977, he got a call from ABC asking him if he could get to Egypt the next day to cover the Begin-Sadat peace talks. ABC had found out about Beacham from Sony, which had recently sold him a new editing system the network needed for the assignment. "So a day later," recalls Beacham, "I was on my way to Cairo, with the whole thing on my American Express card—$8,000: a great investment that got me into broadcasting."

On trips to the NAB in the past few years, Beacham has continued to increase his equipment inventory, sometimes as one of the first facilities to take delivery on new gear. Several years ago, a new video device came along that is now having an impact on location shooting: the one-piece camera/VCR. Beacham bought one of the first offered by

Sony, called the Betacam, and today he rarely leaves town without it.

The beauty of the one-pieces (or camcorders) is that they eliminate the need for two separate and often heavy machines—the camera and the VCR. There are no cables to get tangled in because it's an all-in-one unit. Another big plus is that the quality of the images—delivered through a broadcast-quality ½-inch or ¼-inch recording system—surpasses what is produced shooting with a comparable camera and a ¾-inch VCR. Therefore, video produced by a Betacam and systems like it, such as the Panasonic Recam, RCA Hawkeye, and Bosch Quartercam, can easily meet the standards of even broadcast TV.

However, even the best equipment in the world can't guarantee success in location production, asserts Frank Beacham. The availability of this relatively inexpensive and high-quality gear has created problems for the industry, he believes. "A lot of people go out and buy the equipment, put up a sign and say they are in business," comments Beacham. In reality, "It's very difficult to find a good crew."

Because Beacham relies heavily on freelancers for staffing most assignments, he has developed his own profile for top-notch ENG talent. The big demand, says Beacham, is for people who have a film background. He says he requires it in the people he hires, explaining that most video people "have not developed the sense of craft that film people have insisted on over the years."

Beacham shares some further thoughts on the problems with many people entering through the video side: "Video people are paid by the hour, and film people are paid by the project." This has led to a situation, according to Beacham, in which, "video people tend not to be respected as artists." He adds, "We don't have really trained people in the video profession," suggesting that one reason is most people in ENG came from TV news operations where the pressures of the job and the structure of broadcasting don't allow for learning a craft or exercising much creativity.

Beacham illustrates the problem by recalling what happened after he put an ad for a cameraperson in *Broadcasting* magazine: "I got about 200 cassettes and I started to go

through them. They all looked the same except for maybe three that showed any outstanding creative work."

To start out in this business, Beacham suggests getting hands-on training. You can get that in a college course or at a technical school. Another way is to try to find a company that will let you go on location with them. Says Beacham: "Even offer to work for free and go out into the field and try to learn the business."

He recalls that he started out working in radio for free. "And that's how I finally got a job, because if you're good enough, you become indispensable and they think they have to pay you." Beacham notes that his company has taken people out in the field who want to learn about the business, adding, "there's really no money in the budget for them to go, but they want to learn and they'll help carry equipment."

Another way to start to develop some of skills required for location video work—aside from using 16mm or Super 8 equipment—is to acquaint yourself with 35mm still photography. As Beacham sees it, this way, "you develop a feeling for lighting. You learn what lenses mean. Those things translate quickly into video."

If you want to start your own business, says Beacham, "maybe you should go out and buy an inexpensive video package and try to make it struggling." As he points out, with the new technology available, "there are $6,000 to $7,000 cameras that can make damn good broadcast pictures."

Opportunities are still there and "the industry is wide open for talented people," states Beacham. In the future, he sees areas such as high-definition video opening the way for feature film production on videotape. There will also be a demand for camerapeople who can work with computers as new computer-controlled "robot" cameras are tapped for production work. Some of these units will be able to "fly around," controlled by the camera operator who is really a programmer, notes Beacham.

Frank Beacham remembers when half of his time was spent just making the equipment function properly. But he states, "We are now entering a period where the equipment works very well. Now you have to make it look good." He sums it up when he comments, "You have to try to forget

being a technician a bit and let the creative part open up around you. But at the same time you have to make sure you have enough batteries."

Spoken like a true video veteran.

We'll Fix It in Post

The facility business is not just equipment. It's people and service. Anyone working in the field today knows it's competitive and there's a constant demand to respond to the client's needs. Even if your equipment is the newest on the block and in tip-top working order, if your people "break down" you can be out of business.

The Editel Group is a video facility company that specializes in postproduction, operating post houses in New York, Chicago, and Los Angeles. Employing 350 people, the eleven-year-old operation was recently acquired by ScanLine Communications, and serves clients in advertising, corporations, cable, and home video. Doyle Kaniff was president of Editel for several years and now acts as a consultant to ScanLine.

Kaniff, a veteran of broadcasting as well as the facility business before he joined Editel in Chicago, explains, "Our whole emphasis has been on the people part because the hardware never ends. We want people on staff who can interact with the clients." He doesn't like "technoids," he notes: "It's high tech, but the clients are looking for real people, someone who can explain it in layman's terms. They have to be able to communicate."

At Editel, and other facilities across the country, it's not only the engineers who must understand it's a service business. Even people coming in at entry-level positions, such as in the tape library or shipping, must develop an appreciation for good client rapport and attention to client needs. According to Doyle Kaniff, "If you come in and you ship, you can begin to understand the business. There is no unimportant job in our business. You can edit for five days and ship to Spokane—and the client forgets it was really a good edit because he wanted it shipped to New York."

Before trying to break in at a video facility, it's crucial to do some homework. As Kaniff explains, people have come to him and said they want to direct. They haven't learned that most postproduction facilities don't even have studios,

much less staff directors. If you're still in school, you can start by becoming an intern.

Says Kaniff: "I think the intern programs are terrific. Whether you are doing envelopes or sweeping the floor, if you have any smarts, you're going to go and find out about things [at the facility]." And he adds, "People in this industry are very helpful. They share. Whether the person is the chief engineer, editor, or operations manager, they are very willing to show people."

For people ready for a full-time job at a facility like Editel, the entry-level jobs are in shipping, the tape library—where clients' tapes and blank tape is stored—and scheduling. Scheduling is part of the operations department in many facilities and it's where clients phone in to book rooms for the company's services. It's also where equipment and personnel are assigned for different jobs, and many people regard it as the facility's "nerve center." As Kaniff notes, "Scheduling is an interesting place to break into. You can start as a gofer for the operations manager or scheduling department. But, you can see what the whole game is about. You see that it comes in here and goes out there."

Post houses like Editel are involved in many services directly connected with getting the program ready for distribution. One fast-growing area here is film-to-tape transfers. Devices called telecines, manufactured by companies such as Rank-Cintel and Bosch, make it possible to take the images and sound tracks of films and place them on videotape.

The telecines are often interfaced (connected) to computerized systems that correct any color problems that may be on the film itself or that result from the transfer process.

Highly-trained people called colorists are operating the equipment in color correction. Many have film backgrounds. The colorist's services are highly in demand by the advertising community, which distributes its commercials—even those shot on film—on videotape. After spending thousands of dollars on shooting the spot and buying hundreds of thousands of dollars of time to air the commercial, they want to make sure the red on the package is the same red you see on your TV set at home.

Facilities in Los Angeles, and to a lesser degree New York, get the vast majority of the transfer business for broadcast,

cable, and home video. Syndication companies find it more convenient to ship reruns of "Dallas" to stations on videotape, although satellites are becoming more widely used for program distribution. Cable programming networks also use tape to play back motion pictures for their customers. To get movies to the home market, the films must first be transferred to videotape. With all these traditional and new avenues of distribution, it's easy to understand why there are now post houses that specialize in film-to-tape transfers.

Another area in the facility business that has grown by leaps and bounds is the duplication business. Duplication facilities are doing most of their work for the growing home-video market as well as the corporate, educational, and medical video fields. In addition, general service post houses from coast to coast are also getting a piece of the duplication action.

Running copies of videotapes (dubs) is the way some people have gotten into the business. Today, it's one of the next positions on the job ladder at a facility after serving in the library or shipping.

Videotape Editing

Editing is perhaps the most coveted job in the facility world today. Even though the field is very competitive, industry leaders like Doyle Kaniff believe it is still a growth area where even more opportunities will be created in the future. Editors working at facilities find themselves operating the controls of systems with names like the 340X, Vanguard, ACE, and BVE-5000, built by CMX, Paltex/Datatron, Ampex, and Sony, respectively.

Christin Hardman is products specialist, and formerly staff editor for CMX, a leading manufacturer of computerized editing systems. Hardman has a unique perspective on the editing field. Based in Santa Clara, California, she travels extensively throughout the United States and the world, teaching the computerized editing courses CMX offers to editors-in-the-making. Before joining CMX, she edited "The Barney Miller Show," for a production company in Los Angeles. She paid her dues as an editorial assistant at a production company and later at TAV, where she learned more about editing and the postproduction process.

In her work, Christin Hardman frequently speaks with

editors and other people in the postproduction industry, and has a clear vision of what it takes to be an editor and what the field offers. "There are many opportunities in video editing because it is still a new field," says Hardman. And, "We have more TV than ever. When you get 168 channels, you can only run "Gunsmoke" so many times on so many channels at the same time. There has to be more programming produced."

Although the field has become more competitive, in many ways, comments Hardman, mastering the equipment has been made easier: "A person who understands the video signal and the aesthetics of editing can master the use of the equipment easily now. That wasn't true ten years ago when you almost had to be an engineer to run the equipment."

To hear Hardman describe the qualities of any editor would make them appear to be a breed apart. According to Hardman, "You can tell a good editor because of the way their mind works. I edit my dinner table. I put people in certain places and then tell them to move three or four inches. I am not really nuts. I just have a visual sense of what is right and balanced."

She goes on to explain that an editor is "somebody who has the kind of mind that is organized and also creative. It's somebody who can [translate] what is the chaos of another person's imagination. A director creates and realizes his visualization on tape; then the editor has to go in and get into that person's head and figure out what he saw."

An editor also must be a psychologist of sorts, claims Hardman, because, "You are working with someone who has—through blood, sweat, and tears, and their checkbook— realized and created their dream. You have to be sensitive to that even if what they have created is awful."

Although she herself loved the process of editing, Christin Hardman is wary of the burnout that many editing positions often bring on. But as she also points out, the money is good, especially in New York and Los Angeles, where the going rate is $30 per hour for freelance editors, and staff editors can make $100,000 a year.

Editing is not as glamorous as many people perceive it to be, notes Hardman. "You don't work with actors. You don't work on the set. You work in a videotape editing room, which

usually has no windows. It's very dark and air conditioned to about 65 degrees below zero. It's like being in a spaceship. It's not a place to go if you want a tan. If you don't mind being isolated from the world around you, it's a great place to be."

Christin Hardman also has some interesting comments on the effects that the editing profession can have on the body and the mind: "It's very taxing physically and mentally. But mostly it's the mental stress that turns you into someone who drinks Pepsi and eats Twinkies for breakfast."

Still, Hardman knows that videotape editing can provide many personal rewards. "You have a sense of completion when you finish a project. It's very satisfying. The people can be great and you can develop close working relationships with [them]." And the job does have those financial rewards, although the money outside the major production centers of New York and Los Angeles, "is not the main attraction. You may only make $28,000 as a CMX editor in places like Minneapolis or Phoenix," she explains.

Hardman offers some advice for people who want to break into the field, starting with the most important: gaining experience on the equipment. "At some schools," she notes, "they have equipment the students can get their hands on. It helps when you are applying for an entry-level job in an area such as tape duplication."

Hardman believes that hands-on experience with film can also be an asset in learning the editing process. She makes the point that video equipment at schools—if they have any— is often out of date but, "the film equipment is generally of better quality. You can learn the aesthetics of editing with it."

Like Doyle Kaniff, she sees intern programs for college students as a real plus, explaining they "give you real-life experience, something to put on your résumé instead of faking it and saying you did weddings and Bar Mitzvahs with your own production company for four years." These internships can be at facilities, corporate video departments, local cable operations, and TV stations. Because of budget cuts, relates Hardman, PBS stations often have a need for volunteers. "At a PBS station, you might actually be working on

something that will be on the air. You can't pay for this experience in college."

A trend in postproduction that Christin Hardman believes is important to anyone looking for a job at a facility is a move toward specialization. While most staff editors at major facilities work on full-blown (on-line) editing systems, others are using less complex equipment. The simpler equipment is used to work off-line, a preliminary process in which editing decisions are made, usually on videocassette copies of the original production tapes. The cost to work on these systems is less than the full-blown on-line systems, so clients can save money by off-line editing before going to the final editing step. As a result, off-line editing is becoming its own specialty.

The new video special effects, created by devices with names like the Mirage, ADO, and E-Flex, are also requiring a move toward specialization in job responsibilities, according to Hardman. The same can be said of electronic titling and graphics systems, as well as audio services. Notes Hardman, "There will be people who will specialize in such areas as digital video effects or sound or titles. This is opening up new fields and people are moving into these areas—which will leave their jobs open."

* * *

Once an editor has made it to the top at a facility, they begin to consider their next move. For Lenny Davidowitz it was opening his own editing house, Empire Video, in New York—when he was only twenty-nine. It's not uncommon for top editors and other postproduction specialists to go off on their own taking their clients with them. When Davidowitz opened his first editing room in 1983, it was the culmination of many long years which included first getting his foot in the door, then paying his dues and proving himself as an ace editor. Empire Video now boasts a second editing room, indicating that business is thriving.

Davidowitz started out at what was then called EUE (now Editel/New York) doing per diem work on the night crew, running dubs. After working at WPIX and NBC, mostly as a freelancer, he finally landed a staff job at HBO as a technical director. But what he wanted to do was edit. Managing to

get his hands on some of the older equipment, he started to learn the craft and often worked with the new computerized systems (which were theoretically only for the staff editors to touch) on his own time.

Hearing that EUE was hiring some people for the summer, Davidowitz gave them a call and said he would leave his permanent position at HBO if EUE would make him an assistant in the editing room. He got what he wanted and so impressed management that before long he was on staff as an editor. Davidowitz became a favorite with clients at EUE, sometimes working twenty-four hours straight to complete a project. To Davidowitz, "Editing is not for those nine-to-five guys."

According to Lenny Davidowitz, "working in a post house is the best experience you'll ever get," partially because people at facilities are willing to share their knowledge.

Davidowitz believes that putting in the hours is not the only key to his success. He had to learn the craft of editing. And to learn it the right way it was not simply a case of mastering the video equipment. He decided to learn about film. Recalls Davidowitz, "Many film people don't like coming to a video house. They looked at us as button pushers; they didn't think we were creative."

By learning film lingo, going out on film shoots, visiting film optical houses (the companies that add film effects such as dissolves and titles), and doing actual editing with film, Davidowitz grew to appreciate the craft. He also was able to develop a better rapport with his film-oriented clients at EUE. And he claims, "Learning about film made me a better and faster video editor." He recommends that anyone interested in video editing learn as much about film as possible.

Electronic Graphics and Animation
Up at the top of the list with editing as one of the hottest fields in video production is electronic graphics and animation. Once again, the arrival of the computer has created a new field which is beginning to take off across the country.

The simplest type of electronic graphics (or video graphics) system is a device called the character generator. It arrived in the mid-seventies, and with it letters and numbers could be added to video programs through a typewriter-like

keyboard. Farewell to the old days of cardboard title cards with press-on letters.

Since that time, the character generator (CG) has become more sophisticated in its own right and spawned other microprocessor-based devices that can create pictures. These machines are called electronic graphics or art systems. The people operating these systems can also create many of the effects, such as shading and airbrushing, that are usually done in a traditional art studio. But with devices like the Quantel Paint Box, Dubner CBG-2, Via Video System Two, and Bosch FGS-4000, the artistic effects are created electronically.

Some of these systems can also create animation through computer technology and special software programs written for the particular device. And by accomplishing all this electronically, charts, graphics, logos, and animation sequences that once took days to complete in the lab, can now be produced in a few hours in a video facility.

Because these new devices are closely linked to design and art, they require many skills not readily found at a typical facility. Video houses are responding to the challenge by bringing people with art or animation backgrounds on staff to work with clients on these new electronic graphics systems. Editel, with several different systems in its various facilities, has set up a special three-city computer graphics network, complete with toll-free 800 number for clients. Another New York facility, MTI, established a separate production company to operate its new graphics and animation system when it arrived in 1984.

Electronic graphics and animation are not only expanding the services offered by facilities, they are also creating new types of video houses. These companies are known as stand-alone graphics boutiques. Artronix Northwest in Seattle purchased a Quantel Paint Box and went into business as a video graphics house in 1983. That outfit is one of the few places in the country where there are regular courses on this popular new piece of equipment.

Also operating an electronic graphics boutique is Peter Caesar, owner of Caesar Video Graphics in New York. Caesar has a background in drafting, math, and electronics, and first started working with one of the earliest Chyron CGs at a UHF TV station in New York. During a five-year stint at NBC,

Caesar broadened his expertise in electronic graphics, winning an Emmy for individual achievement in graphics.

When Peter Caesar decided to strike out on his own, several new devices were beginning to earn a reputation in the graphics field. For his stand-alone graphics and animation boutique, Caesar brought together a Dubner CBG-2, Quantel Paint Box, and Chyron 4100. With his own growing reputation, he attracted clients from the major broadcast and cable networks as well as corporations.

To staff his operation, Caesar has been open to people outside the video field. According to Peter Caesar, if you want to pursue a career in the video graphics field, you "should have a basic understanding of print and text and how to manipulate it."

Although people with traditional art backgrounds often make good video graphics artists, Caesar believes that anybody wishing to work with these systems must master the terminology and "get involved with the hardware and software of the real graphics machines, as opposed to just going from painting on a wall to painting in video." Caesar further advises that artists, "know what video is about. Know the keyboards and the texture of video." And because drawing an image electronically is usually not the end of the line in creating the total graphics project, Caesar points out, "If you don't know video, then how can you combine what you have created with something else?"

With some of this hardware, you must keep in mind that "when you are looking at a screen, you are moving your hand on a surface," Caesar points out. "When you make a line, you only see it in video on a TV screen—you don't see it on the surface you are drawing on." It's easy to see why good eye-to-hand coordination is a prime requisite to working with these electronic arts systems.

The ideal video graphics person would be someone with a background in math, electronics, and art, points out Peter Caesar, noting, "you can't just be an artist to become really excellent." Math is helpful in developing the software programs to drive these computer-based systems. Even if you are not a math whiz, an analytical mind is necessary, comments Caesar.

Because he is not an artist, Caesar often calls in outside

designers to work with him on projects. One of his full-time graphics people, Rick Spain, is a former print media artist who has been very successful in making the transition from print to electronic graphics. Recalls Peter Caesar, "He came in and showed me his portfolio. It contained very deco-type drawings. He used forms that would work in video: dots, triangles, hard-edge types of things. I knew this guy's style would work. I started him on the Chyron and then he started running the Paint Box." In Caesar's opinion, Rick Spain is "one of the best Paint Box artists around. He had no technical skill, no video knowledge. He works all the time."

Caesar's company is also very involved with "moving" the electronically generated images to create animation sequences. But he sees some basic problems in finding people who really understand the process, noting, "One of the things that is lacking as far as video animators are concerned is that if they start in video, they are really forgetting the whole background of animation." As is the case with other people in the video field, Caesar believes a knowledge of film—in this case film animation—is very helpful in becoming a top-notch video animator.

To break into video graphics, Peter Caesar suggests getting a job as a tape operator at a facility and learning how to operate a character generator. His own company has been actively involved in providing training courses on the various machines at the company. It's a two-week course and according to Caesar, the people taking it are from the local stations in New York, the networks, and even other cities in the U.S., as well as Europe. Notes Caesar, "We push the ones we believe have some future in the business. They can come in and use the equipment at no cost if they are very good. We train them and send them on their way."

Sales and Engineering

Let's go back for one more look at Trans-American Video in Los Angeles, the video facility owned by Merv Griffin. We have yet to consider two other important parts of the operation that are integral to the business: sales and engineering. Both areas offer career opportunities in the fast-growing facility business.

Jeff Ross is vice-president for sales at TAV. Like many

others involved in sales at facilities, Ross "was looking into getting into production and almost accidentally took this path." Like salespeople in any other business, those working in a video facility should be self-motivated, have good common sense, be able to work with numbers, and remain adaptable to adverse circumstances, says Ross. But there are some other requirements.

Because of the sophisticated equipment and constant change, not only in hardware but in distribution, salespeople in facilities, states Ross, "must stay abreast of what's happening in the industry: the new developments, new technology, and new applications."

One of the other unique aspects of the facility business that impacts on sales, explains Ross, "is that while it's a service business, the client is also an active participant in the actual process utilized to create the final project. There's an interaction of the sophisticated technology, the editors, the operators, and the client, who is actually in the session directing the activity."

Because the client is so closely linked to the process at the facility, salespeople like Ross must make sure that the client is getting what he wants from the facility, and that "the people are oriented to quality and supporting his efforts to get the final product." And the big push is for clients who will come back regularly. As Jeff Ross explains, "A one-time sale is OK but that's certainly not what's going to make your business." Therefore, it's only logical that at TAV, at least, "the emphasis is focused on creating an environment that allows for repeated or extended business."

Although Ross's own background is production, he notes that salespeople often come out of scheduling, "where there is a great deal of interaction with clients and everything that goes together for a client." Ross is quick to point out that although salespeople don't have to know how to operate the equipment, "they have to have an overall perspective on how the people and parts work together to create a final product."

One of the parts of the operation that people with Ross's responsibilities must stay in touch with is engineering. Although it may be an editor who calls engineering on the intercom when there's a problem, in facilities, the sales people are often just as concerned. Because many facilities have the

same type of equipment, only those that maintain it in good working order will attract the kind of repeat business Jeff Ross knows his company needs to grow.

Ralph McDaniel is the vice-president of engineering at TAV, and is a veteran of network television. He oversees the purchase, installation, and maintenance of all those high-tech marvels filling the rooms at TAV. In addition, McDaniel must hire the engineering staff at the facility and make sure they are adequately trained. Finding qualified engineers is one of the major challenges at facilities across the country.

McDaniel says the first thing he looks for "is a good American work ethic. I want someone who's going to come to work on time and wants to learn." As he explains, "the paths to get into engineering are so diverse it's ridiculous." McDaniel, in fact, "gravitated toward it by accident. I enjoyed being in plays and directing in high school and college, but I realized I wasn't going to make a living acting. I found that my talents lay in engineering. Today, I'm still fascinated by the television industry and how dynamic it is."

To learn the basics of video engineering, there are several paths McDaniel suggests, depending on where you are located. If you are in a small town where there is no TV production, he advises that "it's probably better to go to school and get your degree." If you are in a place like California (or other production center), and you can meet people and hang around equipment, McDaniel suggests taking advantage of that fact and enrolling in a two-year trade school.

Ralph McDaniel also points out that many engineers working in video received training while serving in the armed forces, where television operations have existed for years. That's where McDaniel himself first was exposed to the technical end of video. He emphasizes that in most facilities, a degree is not required; instead "there's a lot more weight given to experience."

Unlike college courses in production, trade-school training in the more technical areas appears to carry more weight during the hiring process. McDaniel has advised people to go to schools which offer courses in engineering and operations. He also thinks it's a good idea to volunteer at a UHF station, for example, "a place that doesn't have a large budget, but has equipment you can put your hands on and become

familiar with." According to TAV's chief engineer, "when you graduate from school at that point, you can walk into a network or post house and say, 'Look, I've got this piece of paper and hands-on experience.' "

For those with a BA or Masters in electrical engineering (EE degree), McDaniels mentions some other opportunities. "Go to a company like Ampex or RCA and get involved in the [equipment manufacturing] portion of it." The next thing you know you've jumped ship and you are working at a network or post house. A lot of people have come from that background. People work for companies like CMX developing editing systems, get enthralled with it, and want to practically apply [what they know] by working on the equipment [in a video facility or network]."

HDTV and Electronic Cinematography

During the past ten years, video has replaced film in many aspects of production and postproduction. More location assignments are being shot with portable video cameras and VCRs than ever before. Many programs shot on film are now transferred to tape for editing on video-based computerized systems. And, an increasing number of special effects, graphic, and animation segments are now created with electronic systems instead of with film.

However, there are still many producers and directors who prefer the look of film. They point out that the resolution, among other factors, is superior with 35mm film than is possible with our present TV standard. The higher resolution offered by 35mm film has been one of the primary reasons why video is not yet accepted as the production medium for feature film production as well as many TV commercials. But recent technological advances have opened the way for the expansion of an area called electronic cinematography (EC), which is the use of video-based systems to create movies.

High-definition television is the hottest issue in the debate on electronic cinematography. HDTV is the technology relating to improved video image resolution provided by increasing the number of lines in the TV picture. Several systems for HDTV have been proposed and some even demonstrated. They all claim to be vast improvements over the resolution and picture quality of the 525-line TV picture standard used

in the United States. The one that has received the most attention, and the only one offering equipment for sale as of 1984 was the 1,125-line system developed by NHK (Japan Broadcasting), and marketed by Sony.

In addition to increasing the number of lines, the NHK-developed system includes other technical enhancements that further improve picture resolution. According to Sony, this HDTV system offers resolution vastly superior to what is delivered with the 525-line system and a picture quality comparable to 35mm film.

To help make HDTV the equal of motion picture film in other areas, the Sony-backed system offers stereo sound and a new set of proportions for the TV picture. Tradition video pictures use a three-by-four proportion, or aspect ratio. The aspect ratio of the Sony-endorsed system is wider at three-by-five, comparable to the proportions of screens in many motion picture theaters.

Although Sony introduced a HDTV hardware production system for sale at the 1984 NAB Show, it remains to be seen where this equipment will find a home. A number of filmmakers, including Francis Coppola, would like to see the gear used to shoot feature films. Coppola, who is using video extensively for editing his films, believes that HDTV will increase the efficiency of motion picture production, cut costs, and at the same time offer images comparable to 35mm.

Until a dramatic change occurs in motion picture distribution, these HDTV movies will have to be transferred to celluloid so they can be shown on the film projectors in theaters throughout the country. Although a HDTV-to-film transfer system has been developed, it has yet to be used in a commercial application. But that could change.

More blue-sky predictions call for transmission of these electronic movies via satellite to the theaters across the country. For that to happen, the motion picture studios first would have to accept the comparability of HDTV to 35mm film. And even if they did, Hollywood would have to contend with theater operators across the country resistant to the massive investment they would have to make in receiving dishes and large-screen video projection systems.

If the challenge facing HDTV proponents is great in motion picture production and distribution, it is even more

profound in broadcasting. The Sony system cannot be transmitted over the frequencies currently used in commercial broadcasting in America. The most viable way of reaching the home screen would be through cable or direct broadcast satellite.

Even if the frequency space could be provided for HDTV, the technology would mean discarding current cameras, videotape recorders, and other hardware for the special HDTV equipment. And no company involved in program distribution is likely to make such a huge investment unless consumers are willing to pay the extra money for high-definition TV sets or projection systems.

There are other complex issues and standards that would have to be worked out before HDTV could become a reality for the home screen. But, to anyone who has seen the pictures delivered by the system advanced by Sony, the markedly improved quality may well prove worth it.

On the other hand, there are engineers who have argued that all that's needed is an overall improvement in our present 525-line system. This upgrade could take place through an improvement in transmission equipment, and the introduction of digital technology in TV sets. Another way is available on the production end. Many of the newer cameras and VTRs are providing viewers with cleaner and crisper pictures, with improved color, than was possible in the past.

There are new cameras now on the market giving film a run for its money by tapping some of the techniques used in motion picture production. Although they still use the 525-line system, these new electronic cinematography (EC) cameras have been tackling the challenge of approaching the film look.

These cameras, from companies such as Panavision and Ikegami, use the fixed-focal lenses that are part of motion picture production, instead of the zoom lenses that are standard in traditional TV cameras. With these fixed lenses, and other external modifications, EC cameras have begun to deliver some of the depth, sharpness, and quality of film that had previously eluded video. Ikegami's camera even alters the internal electronics of the unit so the camera can produce better images in a range of lighting situations.

Many producers would like to see the electronic cinema-

tography features of these cameras offered with the one-piece camera/VCR systems, such as the Betacam, Recam, Hawkeye, and Quartercam. These camcorders, which merge the benefits of videotape's efficiency and instant production with the convenience and light weight of film cameras, are making converts of many diehard filmmakers.

But perhaps the ultimate shooting system would be a camcorder complete with all the bells, whistles, and internal electronics of an EC camera that records a high-definition TV picture. Dreaming, are we? Visit an NAB Show and talk to people. They'll tell you that many of yesterday's dream machines are today's realities.

Closing Credits

Just as the closing credits on a TV program can't cover all the people involved, we haven't been able to touch on every job in a video facility that may interest you.

We've covered the areas we have found to be of greatest interest and those which are critical in a facility's operation.

To learn more about this field, start by watching the credits on TV and cable shows, examining the job functions and the names of companies listed.

Pay special attention to the publications mentioned in the appendix. Many of these magazines provide directories during the year that list the names, services, and phone numbers of video facilities across the country. Studying the advertising in these publications will also provide you with valuable information about such companies. And, don't forget to read the articles, too. Also, in the appendix you will find a list of equipment manufacturers which provide hands-on training, or can direct you to other companies and organizations that offer courses.

CHAPTER 4

Broadcasting

ntil recently, when people thought of video, it was the broadcast industry that came to mind as the place to look for a job. Although it remains the area that many check out first, broadcasting is no longer the only game in town. Today, cable, video facilities, production companies, corporate television, and home video beckon with promise.

But broadcasting offers more hands-on production jobs than any other segment of the video industry. And even though broadcasting has been around longer than areas such as cable and home video, it continues to expand and change, creating jobs in areas that did not exist a short time ago.

Back in the early days, broadcast television was either live or relied on film for everything, from news to entertainment and sports programming. The videotape recorder, introduced in 1956, made it possible to send delayed broadcasts of network news shows to the West Coast. But that was just the beginning of videotape and electronic technology's effect on broadcasting. Soon, entertainment programming such as specials and soaps were videotaped for later playback.

In the mid-seventies, broadcast news operations began the transition from film to videotape for covering stories. Today, electronic news gathering (ENG), complete with lightweight VCRs and cameras, is standard in virtually all broadcast news operations.

Broadcasting has turned to many of the new video devices that are also found in video facilities, such as computerized editing and graphics systems. These new pieces of equipment, and the spread of ENG, have meant thousands of new video-related jobs at both the local stations and networks.

At ABC's network operation in New York alone, there are over ninety graphics-system operators holding relatively new positions. New jobs are showing up at the local station level as well. Since Chicago's WBBM-TV went ENG ten years ago, they have been expanding their video-based news operation, and today it includes eleven camera crews and ten videotape editors.

Currently, there are about 1,200 broadcast TV stations in the U.S. Of these, 900 are commercial operations, privately owned and supported by advertising. Another 300 stations are noncommercial—educational or public—stations which are nonprofit operations.

Commercial and noncommercial stations broadcast on either VHF (Very High Frequency, channels 2–13) or UHF (Ultra High Frequency, channels 14–83). Most commercial stations are VHF, while most noncommercial stations are UHF.

The most powerful forces in broadcasting are the networks, which are involved in the programming end of television and also in some station ownership. Their shows are either purchased from outside producers or produced by the network itself. The three major commercial networks are NBC, CBS, and ABC, and the leading noncommercial network is the Public Broadcasting Service. Depending on their relationship with a network, local stations carry all, most, or none of the network's programming.

In mid-1984, CBS, NBC, and ABC each owned and operated five VHF stations, known as O&O's. Up until then, a thirty-one–year-old rule had limited companies and individuals to owning five VHF and two UHF stations. (In July 1984, the Federal Communications Commission moved to repeal this ownership rule. However, that charge was met by broad opposition and, as of now, the matter is still unresolved.)

Network O&O's carry all of the programming their parent network offers and supplement the schedule with their own locally produced shows or programs bought through syndica-

tion. O&O's are important profit centers for the networks because of their reach in the major markets. Each of the commercial networks owns stations in New York, Los Angeles, and Chicago, the three biggest markets.

Most commercial stations come under the category of network affiliate. Affiliates make an agreement to carry the programming of a particular network and they also produce their own shows locally, as well as buying from the syndication market. Because they are not owned by the network, affiliates can maintain more autonomy than O&O's in deciding when to decline the network's offerings.

But the relationship allows the networks to expand their reach beyond their O&O's. It provides local stations with national news, sports, and entertainment programming that would be impossible for them to produce themselves. Both the network and the affiliate profit from selling time on the network's shows. The network affiliation helps the local station build an audience for its channel throughout the day, which also enhances the station's ad sales.

A third type of commercial station is the independent. They must program everything themselves because they are not tied into the big three's programming operation. In addition to their own local production, independents rely heavily on syndication, especially reruns of TV shows and old movies. They also enhance their schedules by taking satellite-delivered news, entertainment, and religious programming.

With the stiff competition in broadcast TV, an independent can usually only survive in an area where there is a large population. That's because commercial stations can only make it if there is enough advertising to go around.

Obviously, networks are not the only ones that own stations. A range of ownership patterns exist with both affiliates and independents. Some are owned by large station groups such as Westinghouse, Metromedia, Cox, or Capital Cities, companies that may also be involved in radio or even cable. Many station groups produce or purchase programming for their stations.

Local stations may be the property of a newspaper or publishing chain such as Scripps-Howard, Gannett, Hearst, or Post-Newsweek. And they can even be owned by private individuals who may have gotten into the game early on and

become rich, or were already wealthy enough to buy in when the prices started to climb into the millions.

* * *

The greatest concentration of jobs in broadcasting is in the major cities—either at network O&O's or affiliates—or at the broadcast networks.

The three major commercial networks maintain production facilities in New York and Los Angeles. They employ thousands of people in jobs ranging from producer, director, videotape operator, cameraperson, and engineer, to tape librarian, unit manager, technical director, editor, and electronic graphics operator.

Local stations with the biggest audiences are the ones who require and can afford the people and equipment to keep them competitive, especially in the news area. In addition to news, these local stations also produce public affairs and religious programming. Some provide crews and equipment to broadcast the home-town professional sports teams. Many stations shoot commercials for their advertising clients. And, there is also a move by a number of stations to cash in on the overall increase in video production by offering their hardware and staff to outside clients.

Another production surge at stations across the country has been in on-air promotion work. As competition becomes more fierce with each new ratings report, stations are upgrading their equipment and assigning more staff to produce commercials promoting the station itself.

Where are the opportunities at networks? At stations? What kind of jobs exist today and what types of positions will open up in the future? Where is the best place to break in?

We went to the people who know, broadcasters representing the spectrum of local station and network operations: the network, the O&O, the affiliate, the PBS station, and the independent.

ABC Television Network

It happens every four years. America sets out to elect a new President, and athletes from around the world gather at the Winter and Summer Olympics. Elections alone have always

led the networks to beef up their staffing and hardware capabilities. But in 1984, ABC covered not only the elections, but also the Winter and Summer Olympics.

Add to that the network's normal responsibilities for news, regular sports programming, soaps, and other entertainment shows, and it's easy to understand why in New York alone, ABC hired 400 additional technicians for the summer.

Whether or not there are elections or Olympics to cover, ABC and other networks bring many of their new people in during the spring and summer to relieve regular employees going on vacation. (The hiring situation is called either summer or vacation relief.) Through vacation relief, many professionals working as videotape operators, camerapeople, editors, and graphics system operators first got their feet in the door at a network.

These entry-level jobs are available in New York and, to a lesser degree, in Los Angeles, the places where the major networks maintain production facilities. At ABC, summer relief begins in April and lasts until October.

The division of the ABC Network that hires the operators and engineers is called BO&E, Broadcast Operations and Engineering. In New York, Phillip Levens, as Vice-President and General Manager, Broadcast Operations, East Coast, heads up the "O" part of BO&E. Levens' division includes several areas covering everything from carpenters and lighting directors, to videotape and graphics system operators, to unit managers and technical directors.

A total of 2,000 people are employed in the operations end at ABC in New York. Explains Levens, "ABC has three production arms: news, sports, and entertainment. Operations services all three with facilities and personnel." While the producers and directors are hired by the individual shows within each production arm, the technicians and engineers at ABC report to BO&E; they are moved around among news, sports, and entertainment.

The New York–produced programming includes national news and shows like "20/20," sports, soaps, and other entertainment shows like "Good Morning America." However, most of the entertainment shows offered by the network come out of Los Angeles, many done by outside producers. In addi-

tion, Levens' group hires the technicians who work at the ABC O&O in New York, WABC-TV.

Within East Coast operations at ABC, there are several areas including Production Services, Production Planning, and the biggest, Television Operations. Production Services includes scenery, props, wardrobe, and electrical work. In Production Planning are the unit managers who "are the liaisons between the producers and BO&E," explains Levens. There are 113 unit managers at ABC in New York, who are assigned to each show or event, he relates, and "they tell BO&E what personnel and machines are needed and keep track of the finances."

Most video production jobs at ABC are in Television Operations. In 1984, this department swelled to 1,400 technicians in New York, according to Levens. He explains that the number dropped down to 1,000 after the Olympics and conventions. At its peak, Television Operations at ABC included 200 videotape operators (which also covers editors), 50 technical directors, and 225 camerapeople working in the studio or on location. In addition, there were 46 editors working on nothing but the news, with small-format ¾-inch equipment.

An area that has been developing rapidly at ABC has been electronic graphics. For their Olympics and elections coverage the network invested heavily in the state-of-the-art to enhance the network's look on the air.

With electronic paint and animation systems, ABC was able to drastically reduce the amount of film used in animation and other special effects. In 1984, the network employed ninety people working on electronic graphics devices such as the Dubner, the Chyron, and the Paint Box. (ABC, which has been instrumental in pioneering the use of electronic graphics in television, even helped finance the development of the Dubner.)

Phil Levens offers some advice on landing a job in his division. He says that for entry-level production-oriented positions, "What we look for is some experience at a small station. We [also] want some kind of education, which they can usually get in a good communications course in college."

Since Levens' division must maintain the equipment, they hire engineers. For those jobs, according to Levens, "We want

something more heavily technical, at least an associate degree or better in electronics." Because so much of the equipment is computerized, networks like ABC are looking for engineers with computer maintenance skills, notes Levens, as well as a background in digital electronics.

Within Television Operations at ABC is a subgroup called Technical Operations where you will find most of the hands-on video jobs. Heading up one part of that operation is Len Alphonso, Manager of Videotape Operations. In the videotape rooms, there are operators recording, editing, and playing back all ABC programming.

There is also a tape library, and as Alphonso notes, "it is a big operation at a place like ABC because we are talking about an inventory of 40,000 pieces of tape. We handle about 1,500 pieces of tape a day in and around the complex." He relates that there are "thirty people just to catalogue, ship, and move tape around the building."

A third area where people work, aside from the library and tape rooms, is postproduction, where the more sophisticated editing takes place. This is where you'll find the high-end editing systems, special switchers, and digital video effects (DVE) devices. With these DVE's, which have names like the ADO and Mirage, video images can be zoomed around the screen, flipped, rotated and even turned inside out virtually in an instant.

Some people will start out as tape operators and develop an expertise in editing, eventually moving into the more complex postproduction rooms, notes Alphonso.

Working in Tape Operations are about 200 people, who all belong to a union. But, as the system works at ABC, belonging to the union is not a prerequisite for getting a job. Once a person is hired, they are given a certain period of time in which to join, something that is required as part of the contract with the unions for all operators, technicians, and most engineers.

During a usual summer, Tape Operations brings in about thirty people for vacation relief. The interviewing takes place in February or March. Although they look for people with some experience for these positions, "once in a while," Alphonso relates, "there are inexperienced people hired for vacation relief if we can't find enough people with experience."

Although summer relief jobs are not permanent positions, they can be an entrée into the network. "We work them through one, two, or three summers, depending on what our needs are," Alphonso explains. "Some are hired from June to September and some April to October. We hold off whatever permanent jobs we have until fall. Then it gives us a choice of the best of the summer crop to make permanent."

He suggests that people think about getting technical training, and mentions that production experience at a local station can always help. "We have gotten to the point where so much of the equipment is sophisticated—which you really can't get into until you have a background in other areas," he asserts.

Len Alphonso sums up his thoughts on preparing for a career in a network's video operation when he says, "The reality is that the more and better background you have the better off you are. The lesser jobs are [disappearing]. We don't have cable pullers anymore. You really need a decent background to expect any kind of longevity in this business."

Another important link in the video operation at ABC is engineering. R. Laverne Pointer, Vice-President, Broadcast Engineering, heads up this part of BO&E for the entire network. When a new studio is required for a show or soap opera, it is Pointer's department that designs and builds the new facility. Engineering also constructs new editing and tape rooms, coordinating closely with the requirements of the operations end at ABC.

ABC recently built two new studios in Manhattan, and they are constantly upgrading their present facilities near Lincoln Center. In addition, Pointer's division builds the transmitters for both the network and its O&O's.

The engineers in this division are people who hold an electrical engineering degree, either a B.A. or M.S. There are fifty-five engineers under Pointer. (ABC also has engineers working in the Operations division along with technicians who perform engineering functions, such as setting up cameras.)

As one of the top execs in BO&E, Pointer offers his views on how to become an operator: "Make contacts. Learn about the new equipment and what it looks like so that when you are interviewed you know the difference between 1-inch, ¾-

inch and ½-inch." As others have advised, Pointer says go to a local station. "You'll get more experience in two or three years than you'll get in a network in ten years. If you are at a network, then you might be assigned to one function and you'll never know how the rest of the facility operates."

Once you've determined that you have the qualifications and marked the month of February on your calendar, the next piece of advice you should keep in mind is this: at networks like ABC, you apply for a job through Personnel. Although things might have been less formal until a short time ago, everyone we spoke to emphasized that it is now Personnel that screens résumés and applications for operator, technician, and engineering jobs at ABC.

Personnel will consider your qualifications. And, if there is an opening for which you are suited, you may then be referred to the particular department's manager for an interview.

A Network O&O

At the time of the proposed FCC rule change in 1984, each commercial network owned five broadcast stations in various parts of the United States. Because these operations are all in the larger markets, they have more video-related positions than smaller stations.

WBBM-TV is the CBS O&O in the third largest broadcast market, Chicago, and was one of the first stations to go all video in its newsgathering operation, back in 1973. There are about 300 people employed at WBBM, and Charles Upton, Director of Technical Operations, heads up a staff of 105 technicians at the station.

"Our main product is news at an O&O," Upton explains. The station does a half-hour news show at 5:00 P.M., then an hour at 6:00 P.M., and finally another half hour at 10:30 P.M. The other types of in-house production are public affairs, religious shows, and local entertainment. (The station for many years was also the home of "The Phil Donahue Show," for which they provided facilities and crew, like a production house.)

WBBM, like other O&O's, carries the parent network's prime time and other fare during the course of a day, supplementing programming with syndicated shows they purchase.

As an O&O, WBBM is called upon by the network to provide additional equipment and crew for special events and football games.

The location of the station in Chicago, a top market, and, as Upton puts it, "a tough news market," means they need a large staff. Because they are an O&O, says Upton, the pay is better because they are unionized. Working at an O&O "may be more structured because it is part of a network," he notes. However, he adds, "You can't say that all the O&O's have better equipment. Many times you find that the affiliates in the larger cities probably have much better equipment than we do." But according to Upton, because his station is in a major market, "you find the caliber of production and people higher."

A unique aspect of WBBM has been its early and, today, full-fledged commitment to ENG. "We have eleven crews in the field and there are about ten editors and one supervisor," notes Upton. The fact that WBBM was the first major station to go all-video is no accident. Its parent company, CBS, developed the small, relatively lightweight Minicam back in the early seventies. And local news at stations like WBBM has never been the same since.

WBBM also has about six people a day operating the cameras in the studios, but there are about fifty or sixty people in the station capable of operating them, says Upton. Also in the technical area are technical directors, supervisors, and assistant directors. Keeping up with the changes in TV's look, WBBM has six graphic artists and a number of technicians working with the station's electronic graphics systems.

In addition to the smaller editing systems used for ENG work, WBBM maintains several more sophisticated postproduction setups, complete with full-blown computerized editing, digital video effects, Chyron character generator, and audio sweetening capabilities. There are three editors operating these systems, working mainly on promos, an area Upton sees expanding.

Another part of the operation that may be revved up in the future is in offering their facilities and personnel for booking by outside clients. As Charles Upton sees it, despite the new technologies like cable, "the broadcasters will continue to be a leader in the field . . . What's going to happen is

that your TV stations are going to become production houses. They can produce things more reasonably and easily than new start-up houses can. We will be furnishing programming for cable and other forms of entertainment that is becoming available." Therefore, "There should be a lot more jobs for technical and production people."

As far as hiring practices go at WBBM, "We expect them [our technicians] to have a rather rounded knowledge of the broadcast skills," he says. School is important to Upton, who notes that 95 percent of the people he hires have college degrees and quite a few have Masters. He prefers a degree in radio and TV or journalism, with a minor in electrical technology. And if a person has that kind of education, he or she may be considered for an entry-level position. For those who don't, Upton, like others in broadcasting, says go to a smaller station to pick up skills.

As a big believer in education, a point of view that is by no means the rule with many other managers in broadcasting, Charles Upton emphasizes that "coming in and saying 'I want to be trained as a technician' is like going into a hospital and saying 'train me to be a brain surgeon.' There's a lot of education that precedes that experience." Upton notes that several women at WBBM started out as desk assistants with journalism degrees and later succeeded in making it as technicians. "They didn't have technical educations so they went back to school—took correspondence courses—and today they are excellent technicians."

WBBM hires college interns who have in some cases gone on to jobs in production. They also bring a few college students in during the summer as part of vacation relief. In addition, there are vacation relief positions at the station for more experienced people.

Charles Upton has noticed that one of the reasons many people are looking for operator, editor, and other technical spots "is that they found out that being a technician is a very lucrative job." However, he warns, "you work awful hours and there's a lot of overtime and the [scheduling of] days off is terrible." But, on the other hand, notes Upton, "It's a fun occupation. There is never a dull moment. I've been in it for thirty-six years and I don't think I've ever become tired

of it. There's always something new. You also get good pay and fringes."

An Affiliate in a Top Ten Market

Maybe it's that infectious Texas optimism or perhaps just the way it is at KPRC-TV in Houston, but according to Paul Huhndorff, Vice-President of Operations, "Because of the market and type of station we are, the opportunities are golden here."

KPRC is an NBC affiliate in the number ten market in the country, and according to Huhndorff is "almost called the NBC O&O of the South." The property of H&R Communications, which owns several other stations, KPRC has enjoyed a unique position as a major market station located in a region where there were no O&O's. This situation has undoubtedly contributed to the growth of KPRC over the years, not to mention the employment opportunities.

There are certain advantages, according to Huhndorff, to their position as an affiliate: "If you are a network O&O, you are governed by what the network says you have to do." Whereas at an affiliate like KPRC, "We can do things a network can't do—and we've done most of them." Continues Huhndorff, "We did all those Apollo space shots. [The networks and their O&O's] have so many unions and rules. We can cut costs and do as good a job."

And, they enjoy a special relationship with NBC, as one of the network's prime affiliates. NBC even built their news bureau right next door to KPRC and runs cables connecting the two operations. Says Huhndorff, "We are like another control room and studio. They used us for all their satellite experimentation." Because they are not owned by a network, and are located in as important a place as Houston, KPRC has been able to provide coverage for all the networks at one time or another.

There are about 225 people at the station, including forty-five technicians and engineers, but even members of the sixty-person news department operate equipment too. Most of the programming produced at the station is news or news-oriented but "a lot of time is devoted to promos," notes Huhndorff. KPRC does the usual mix of public affairs and local shows as well as remote work for the networks, including

USFL football games for ABC. However, the station is not doing as much work for outside clients as they once did, Huhndorff relates.

Still, news is what requires most of the time and effort. Along with its regular newscasts, the station also does news-oriented shows geared toward women, blacks, and Hispanics in Houston. Notes Huhndorff with some humor, "We have umpteen million news shows."

Huhndorff gives a realistic appraisal of the kind of experience needed to break in at his station: "You have to have the correct type of training. If you want to be an engineer, you need two years of electronics. For production, you need a degree in radio or TV from a recognized university. If you want to get into the news department, you need a degree in journalism. Once you have those, it gives you a foot in the door."

But, he is quick to note, "In a market like this, you are going to need some experience on top of that." Without that experience, but with the educational training, Huhndorff's advice is (here we go again) go to a smaller station, starting with the fiftieth market.

Some of the editing and camera jobs are in the program department at KPRC but as Huhndorff mentions, "That's different in other stations. In some stations those jobs are in engineering." His department includes videotape operators who also edit, using 2-inch and 1-inch machines. It's the tape operators in Huhndorff's domain who do the promos, spending the balance of their time doing playback of prerecorded programs.

However, most of the editing jobs at this station are in the news department, where there are fifteen ¾-inch editing systems and about thirteen editors. Huhndorff estimates that there are some twenty cameras and a cameraperson for every camera in news.

Keeping up with the times, KPRC has also expanded into electronic graphics, recently purchasing a Quantel Paint Box. The camerapeople in the program department also operate the less sophisticated graphics systems—the character generators—as well as handle floor managing and lighting assignments in the studio.

There is no vacation relief program at KPRC; during vaca-

tions, says Huhndorff, "we double up." There are, however, intern programs at the station and each department hires its own.

According to Paul Huhndorff, "You are not going to find very many new people in this market. You might be able to find them in camera work or floor managing, which are sort of entry-level jobs. Once you get above that, you need skilled people. In a small market you can take people who have no experience and get away with it. [Here] it's not going to be that easily done. It's too bad but that's the way it is."

A Public Broadcasting Operation

Up until now we have focused on commercial television stations that sell air time and are run as profit-making businesses. There are also about 300 noncommercial— educational or public—stations throughout the country, supported by government and institutional funding as well as corporate and individual contributions.

These stations produce their own programming or purchase it from outside producers. Many also receive programming from the Public Broadcasting Service, which functions as a "network" for noncommercial stations.

Throughout their existence, America's noncommercial TV stations have been hampered by budget restrictions, a situation that has become more serious in the past few years with federal cutbacks. Lower operating budgets at these stations have led a number of them to rely for some of their less technical video jobs on either industry newcomers or volunteers. And because they are closely connected to their communities and educational institutions, these stations have demonstrated a greater awareness of the need to give beginners a chance.

In addition, because their programming is offered in many cases as an alternative to commercial TV, public stations have been the places where quite a number of independent videographers have been able to get their work on the air.

One of America's leading noncommercial television operations is WGBH in Boston. In addition to operating two channels—2 and 44—in the sixth largest TV market, WGBH functions as a national production center for PBS. According

to J. C. Anderson, Manager of Production Services at WGBH, and head of the production arm, GBH Productions, they produce about one-third of the programming offered by PBS. "Our nearest competitor is WNET in New York," he says. "GBH and NET have the biggest volume of business."

Among the programs that have come out WGBH, either through production or acquisition, have been "Masterpiece Theatre," "Julia Child's Kitchen," "Nova," and "Zoom."

There are 450 people employed full time at WGBH, a number that is often augmented by freelancers. "Because we are a production center," explains Anderson, "our hiring practices more resemble the production centers in L.A. than they do broadcasting stations." The production arm works on series that "have their own lifetime. There are many contract hires. [The programs] are done by a staff which is brought in for a specific project. When that project ends, those people leave and another project begins with other people."

Although there's a constant turnover on the production side, there is more consistency on the technical end, notes Anderson, but there's extensive use of freelance talent as editors and camerapeople. Whereas film is dying out in most other areas of broadcasting, at WGBH film is thriving.

As in the case of many other public stations, WGBH has a for-profit operation that offers its facilities and staff for booking by outside clients. The station has mobile video and audio vans, a studio, and postproduction rooms they make available as a facility service. Because PBS stations across the country are linked by an excellent satellite interconnection system, WGBH is able to offer videoconferencing services as well.

As a national production center, WGBH looks for people with experience. States Anderson, "We want editors and producers who have track records. The same thing with assistant producers." But WGBH does promote from within and there is recruitment from other parts of the operation. People working in traffic, the mail room, or secretarial positions do move up into production. Comments Anderson, "That's probably the main way to get a break at WGBH if people don't have prior experience." And, he goes on to note, "We have many producers and unit managers who started as secretaries."

Although there are no summer relief programs at WGBH,

the station does bring on interns to work on news and local programs. But, mentions Anderson, interns work on the production side, not on the technical end. Interns are drawn from a number of colleges and cultural institutions in Boston.

There are several positions where there is special need for the right people at WGBH. Anderson cites video grip (whose job on a large shoot is to run cable and lug equipment), assistant film editors, and managers.

Anderson makes a major point that, "the greatest shortage of talent, not just at WGBH but in the broadcasting industry, is good managers. Good unit managers, good production managers. These are solid people who should know the creative and financial side—know how to produce and know how to manage."

Although it's the noncommercial stations that must be especially aware of the money crunch, it would be wise for anyone interested in working at a local station to keep some of J. C. Anderson's other insights in mind: "One has to make the most of the resources available. That requires managing the skills of all concerned; how to get the most production for the buck and make the money show up on the screen."

Independent Stations

There are 250 independent commercial TV stations. One such example is KSTW-TV, a dual-city operation serving Seattle and Tacoma. Part of Gaylord Broadcasting, a station group owner, KSTW competes with several other independents in its market (the 15th in the nation) in addition to network affiliates.

As an independent, or "indie," KSTW does not take any network shows and must instead program the channel themselves. Like most independents, they buy heavily from the syndication market, especially reruns of network shows.

According to the station's chief engineer Paul Crittenden, indies are different because, "We run leaner. Everyone has a prime responsibility but they have to be able to cover many areas." He points out that the affiliates in KSTW's market, "have three times the personnel we do. We have about 110 people." Although there are fewer jobs at indies like KSTW, comments Crittenden, "it is a good training ground."

Independent stations tend to be in larger markets because

of economics, explains KSTW's chief engineer. In smaller markets, where there are fewer stations and all are affiliated with a network, "you couldn't have a fourth station." Although indies were for many years concentrated in the top twenty-five markets, "they are now building them down in the top fifty," says Crittendon.

At operations like KSTW, in-house production includes news, public affairs, and some religious programming. The station relies heavily on ENG-style production for its hour of news and its public affairs shows. In addition, KSTW shoots commercials for clients who buy air time on their channel.

One other production assignment that keeps independents like KSTW busy is televising baseball games. Carrying baseball games, which occurs during the evening time period when affiliates and O&O's are in prime time, is frequently part of the schedules of the independents in markets where there is a team.

At KSTW, taking a program from the syndication market is not simply a case of putting the show on the air as is. There is some production and editing required. As Crittenden tells it, "We do 'wraparounds.' That's an intro and extro and the breaks. We package it and dress it up and run it with the commercials."

Crittenden says the employees' educational background is mixed at KSTW, explaining, "Some people don't have degrees. Usually the ones with the degrees have them in communications, and they are more inclined to be operators. They want to go into the creative end, and become producers and directors, not maintenance."

As far as getting in without experience goes, here's what Crittenden has to say: "In this market, we don't hire people at entry-level positions [for video jobs]. Occasionally we will promote someone from a clerical job and train them because we know them and we know they are good."

But the station sometimes brings in beginners as gofers and pages. "Pages can move into the production area as a VTR operator, floor assistant, or CG operator," says Crittenden. "Those three areas are the ones people start moving into in our station. They become part of the studio crew and get exposed to a little bit of everything."

To get the more skilled jobs right off the bat at his station,

Crittenden believes people should pay their dues in a smaller market, adding, "They make their mistakes where it doesn't cost that much." Or, he suggests, get the technical background by working for manufacturers like RCA or Ampex.

As to what the future may hold for new jobs at independent stations like KSTW, Paul Crittenden has these words of guarded optimism to share: "Indies have come a long way, although we are still lean. The more equipment we have, the more operators and maintenance people we need. It's slow but continual growth."

* * *

As you well know by now, many video professionals, and particularly broadcasters, advise going to a small local station to break into the business. So we talked to one to find out if this is really the way to go.

KAIL in Fresno, California, qualifies as a small station because of the size of its operation and its market. There are only twenty-three people working at this independent station in the sixty-fifth market. In terms of the broadcast industry, KAIL is still very young, having gone on the air in 1976.

Like the other stations in Fresno, KAIL is a UHF channel in the first all-UHF market in the country. The fact that the sixty-fifth market—one known more for its farming than broadcast activity—can support three indies as well as three network affiliates says something about the fertile fortunes of the broadcasting business.

KAIL is run by John Lockhart, the General Manager who has been with the station since it went on the air. It's owned by a single individual whose only other broadcast properties are in radio. Since it is not affiliated with a network nor owned by a station group, the KAIL operation is truly independent.

According to Lockhart, the main form of in-house production at the station is public affairs and TV commercials. To KAIL's General Manager, "News is the kiss of death for a small station because it's a very costly thing in terms of people, hardware, and money." And, he explains, "We don't think we can compete with the three major stations in the market."

For most of their programming, KAIL runs shows acquired from a combination of outside sources. There are pro-

grams bought from the syndication market, satellite-delivered programming from sources such as Biznet (produced by the U.S. Chamber of Commerce), and religious shows that organizations pay to air on Sundays.

The small staff in production and engineering includes a production manager, who doubles as a public affairs director; someone who handles shipping and receiving, and film editing; three videotape operators, who run the programming; and a production person. There's also a chief engineer and three technicians who maintain the transmitter.

Operators must know how to do many jobs at a station like KAIL. As Lockhart tells it, "It's a one-man on-air operation. There is one person running the tapes and running master control, keeping the logs and recording from the satellite." That one person may also have to run the camera and operate the CG as well. The people working at KAIL, therefore, notes Lockhart, "have to be multitalented individuals."

Although they have hired beginners, because the staff is so small (often doubling up shifts during a production), Lockhart says he "shies away from people with no experience." So where does someone get the training to break in at a small station like KAIL? John Lockhart suggests working first at a cable system or volunteering at an educational station. He also points to radio as a "good thing for people to get involved in. I have a lot of respect for people who have gone through radio because a lot of the concepts and ingredients are the same."

But once you have been hired at KAIL, John Lockhart asserts that "it's an excellent learning opportunity." Because of the size of the operation and the fact employees must be jacks-of-all-trades, "they get a good broad look at what it takes to operate a station," not to mention experience in a range of production jobs.

He comments that most people who apply for jobs "want to be producers, directors, and production people." To Lockhart's thinking, "they should be thrown into the tank and learn how a station operates before they have such lofty ideas."

Because it is a small operation and people must do a variety of jobs, it should come as no shock that Lockhart looks for a combination of common sense, education, atti-

tude, and experience. And prima donnas need not apply because each person "must fit into the group," states KAIL's General Manager.

John Lockhart wishes schools would do a better job of giving people the skills they need to make it in broadcasting. In addition, he would like to see a more realistic picture of television presented to those who may be majoring or taking courses in the field. In his mind, "Most people who are trained to go into it don't realize that what pays the bills are the commercials. They think commercials are horrible. I love commercials."

Lockhart admits that there is a Catch-22 operating in his industry in advising people to go to a small station like KAIL. As he states, "One of the ironies is that in the larger stations, they have the more unique positions where there isn't that much demanded in each position." Because KAIL people must do everything, more is required, notes Lockhart, and therefore experience should be more of a premium at a smaller station. But as Lockhart succinctly puts it, "the larger stations won't hire people either unless they have experience."

Editorial Reply

Although broadcasting is no longer the only game in town in terms of video, it is the richest and best financed, oldest and most frequently watched part of the industry. As a result, broadcasting has established its own set of procedures and standards (and some would say prejudices) for the people it hires. And like any other industry watching thousands of recent graduates clamoring to get in, broadcasting has been able to pick and choose.

Everyone talks about the small station as the place to break into broadcasting. But it has been our observation that many people at networks and TV stations have gotten their positions because of experience gained at video facilities and production companies. And it certainly doesn't hurt to have contacts.

You might also keep in mind that many professionals in broadcasting today have been with the industry since it started after World War II. They have been through the transitions from live TV to tape and from film to ENG. They have watched times change from the days of huge cameras and

VTRs manned by specially trained technicians, to the present when a remote operation may be "womanned" by a crew carrying lightweight cameras and VCRs.

Many of television's pioneers will be turning over their jobs in the next few years to a new generation who will become the broadcasters of tomorrow. Although we don't expect the basic attitudes toward ratings and market share to change, we do believe that the people going into the field as operators, editors, and producers are different today. They see themselves first as video people and second as people in broadcasting.

Many video professionals working at TV stations and networks are excited by the new equipment and technology. They keep up on new areas of video and are anxious to get their hands on the latest gear. Because they are turned on by video, they realize that although broadcasting might be the highest paying game in town, it is no longer the only one looking for players.

CHAPTER 5

Cable

n 1982, a song was recorded in Atlanta by a man better known for his talents as a communications entrepreneur and yachtsman than for his singing. While Ted Turner's single never made it to the top of the music charts, the words of the chorus, "He was cable when cable wasn't cool," neatly summed up Turner's position as one of the visionaries in cable TV.

Ted Turner is the man who originated the "superstation" concept in 1976 when the signal of the Atlanta TV station he owned was beamed via satellite to homes wired for cable. And, in 1980, he started Cable News Network, the twenty-four-hour-a-day news channel that dared to take on the broadcast networks' formidable news operations.

Cable has undergone many changes since the days when Turner made his initial bold moves in it. We asked him why someone might choose to work in cable today, rather than picking a more established route, such as broadcasting.

In Turner's view: "Cable is growing more rapidly than broadcasting because there is still a good bit of the country yet to be wired." And that means "there will be more employment and opportunity in cable . . . Someone who goes into cable might advance more quickly than in broadcasting because the field is advancing faster."

"Cable television has changed the viewing patterns and the business of television," says Kay Koplovitz, President and

Chief Executive Officer of cable's USA Network. "The question that we ask ourselves is [what is] the size of the business? What should the level of investment be and what returns should we expect?"

When it comes to contemplating a career move, Koplovitz comments that cable is a "good opportunity if you choose the right company to align with. It's a realistic career. It's not like ten years ago when it was a shot-in-the-dark business. There are some very good growth opportunities."

Challenging, entrepreneurial in spirit, still developing and growing. It's easy to see why those considering a career in video often have cable at the top of the list.

* * *

Cable television technology has been around since the late 1940's, but when Ted Turner made his first major contribution to the programming area in 1976, we would have to agree that cable still "wasn't cool." For most of its history, cable did not receive much public attention.

All that changed at the beginning of the eighties. The public was bombarded on a daily basis with news stories focusing on major communications companies that were getting into cable. And, those Americans whose towns and cities were wired for cable frequently found their mailboxes filled and their phones ringing with offers for special hookup deals.

The news reports about cable often promised a range of programming that would turn us away from broadcasting toward a more specialized approach called narrowcasting. With narrowcasting, all types of material could be directed toward smaller groups with special interests. It was predicted that thousands of new jobs would be created by this burgeoning industry.

Developments were unfolding rapidly. Even today, many people considering a career in video are as confused about what jobs cable offers as they are about selecting a mix of programming to watch on their local cable system.

You may know what HBO and MTV are, but you may not know what the MSO and LOP stand for. If you want to work in cable, an understanding of the industry, its history and lingo, is the place to start. That's part of developing an appreciation of the interrelationships among the key parts

of the business and its players. And the knowledge is vital in helping you decide if breaking in through cable is for you. After all, Ted Turner had to learn it too. . . .

The Birth of Cable

Although most people today associate cable with programming services like HBO, Showtime, CNN, ESPN, and MTV, these services are relatively new additions to the cable TV story. Cable actually began over thirty-five years ago as a utility, not unlike the telephone company.

As we've explained, regular broadcast television transmission began in the United States after World War II. The broadcast signals were transmitted through the air from giant TV towers owned by the local broadcast stations. However, there were people around the country who had poor reception because of obstructions, either natural (such as mountains) or man-made (tall buildings).

In the late 1940's, appliance dealers in Pennsylvania wanted to sell TV sets to the communities of Landsford and Mahanoy City. But the areas were surrounded by mountains, making it impossible to receive signals transmitted by stations in Philadelphia, less than 90 miles away.

So both groups erected antennas on high ground, and connected local customers' homes to the antennas with cables. The customers paid an installation and monthly service fee, and could then receive crisp TV pictures on the sets they had purchased from the local appliance dealers. The system became known as CATV (Community Antenna Television) and soon other communities afflicted with reception problems began investigating cable television.

By 1968, there were 2,000 cable systems in the United States, offering service to almost three million subscribers. The individual cable systems were built after the community had awarded a franchise to a company; that company was responsible for building and maintaining the cable system. Subscribers would receive the broadcast stations through special coaxial cables, which permitted a number of channels to be sent into the home on one wire.

Because cable was a local operation, communities found that they could use their cable system to transmit programs and information which were of interest only to the people

in their area. Small studios were set up at the cable station (also known as the head-end). This was the beginning of local origination programming, or LOP. In addition to local origination programming, which covered everything from community news to local sporting events, cable stations started to offer channel access to groups in the community.

As cable subscribers began to demand more diversified programming, cable operators started to import "distant signals," programming relayed by microwave from distant broadcast TV transmitters. The broadcasting industry, which had up to then looked at cable television as a way to increase its reach, began to see cable an as economic threat. Viewers might be lured away from the local broadcast channels by the other programming available to them on cable.

Pressure from broadcasters was largely responsible for strict guidelines governing cable TV's growth, which were implemented in 1968 by the Federal Communications Commission. For several years, these restrictions limited cable's development to areas outside major cities.

In 1972, the FCC began a gradual deregulation of cable. By this time, many of the original mom-and-pop operations had been acquired by corporations. These companies, which were known as multiple system operators (MSOs), specialized in building and running cable systems. Aside from buying up existing cable operations, they began to compete with each other to win new franchises.

Because of the growing cost of wiring a town or city (especially those that were densely populated), both the stakes and possible rewards of winning a franchise increased. MSOs were attracting Wall Street and other financing sources. With their growing financial resources, MSOs were soon winning virtually all of the new franchises.

Satellites Expand the Business

Over the years, cable operators had been experimenting by offering recently released movies on their systems. Subscribers, who were charged a basic fee for their monthly service, could pay an additional sum for these movies. The films were either played back on videotape at the local head-end or sent to the cable system via regional microwave networks. What this distribution arrangement lacked was economies of scale,

and a continuous and easily accessible source of movie programming.

In 1975, a company named Home Box Office made a startling announcement. Although HBO had used microwave up until then to transmit its programming, it was now going to distribute the service via satellite to the cable systems. To receive the programming, cable operators installed a satellite earth station, also known as a TVRO (TV-receive-only) dish.

HBO, part of the Time Inc. communications empire, had contracted with the movie studios to show films on cable. The "network" also had arrangements with local cable operators around the country. The network and cable operators shared the additional pay-TV fee paid by subscribers who wished to receive HBO on their cable. HBO's decision to use a satellite (or bird, as it's called) to transmit programming was the event that transformed cable from a utility to a true programming service.

Also looking toward the skies around then was an owner of an independent local broadcast station in Atlanta. With satellite technology, Ted Turner could expand the reach of his station, then called WTCG, plus gain more exposure for the team he owned, the Atlanta Braves (he also purchased the Atlanta Hawks in 1977). A separate company, Southern Satellite Systems, distributed the station on satellite for him (since legalities barred him from doing it himself).

Using the same bird as HBO, Turner's humble local UHF station began its march out of Atlanta as America's first superstation.

With a national reach for his channel, Ted Turner was able to increase the advertising rates charged to companies buying time on the Atlanta station. Now known as WTBS, the superstation reaches more than 32 million cable homes, making it one of the largest satellite-delivered cable services. Because of the success of WTBS, several other local broadcast stations have joined the ranks of superstations, including New York's WPIX and WOR, and Chicago's WGN.

With his position established in the cable world, Turner next charted a different course by building a network from the ground up. He launched one of cable's most ambitious ventures with Cable News Network, which went on the bird in June 1980. Like WTBS, CNN is advertiser-supported. It

is offered to subscribers as part of the basic cable fee by cable operators who have signed to receive the service. Today, CNN is seen by over 25 million cable homes.

The MSOs

While people like Ted Turner were building new empires in cable, other well-established companies were feverishly looking for ways either to get into the cable business or expand their fortunes in the industry. For a number of companies, the ownership of cable systems offered the most attractive rewards.

Time Inc., the owner of HBO and one of the Manhattan cable franchises, became a major player in the systems game when it acquired American Television & Communications (ATC), a leading MSO. Group W, a company known for its broadcast interests, acquired a major MSO, Teleprompter. Warner Communications, which already had established itself as an MSO, joined forces with American Express to form the more financially powerful Warner Amex Cable Communications. This alliance enabled Warner to expand its innovative interactive Qube service into more cable systems.

Other MSOs continued to buy out smaller operations and join in the increasingly competitive franchise "wars." Today, companies such as Tele-Communications, Inc., Cox Cable, Storer Cable, Times Mirror Cable, and Viacom stand in the top ranks of MSOs with ATC, Group W, and Warner Amex.

The financial rewards of cable system ownership were closely linked to subscriber satisfaction. If customers were dissatisfied, they could cancel their service at a moment's notice. To attract those Americans who were interested in more than just better reception, cable had to offer programming not available on broadcast television.

It was the MSOs that had the greatest stake in providing programming. Therefore, it should come as no surprise that many early national programming services were launched by corporations also active in cable system ownership. They had a guaranteed base of systems (their own) to carry their services and could keep the customers satisfied with more programming. And particularly in the case of pay services, they found a major new source of revenue to boot.

Time Inc., which now owned ATC, already had HBO, the

first national programming service. Viacom and Teleprompter (before it was bought by Group W) launched Showtime, a second pay channel, in 1976. Nickelodeon, a service geared toward children, and initially begun without advertising in 1979, was offered by the programming end of Warner Amex, called Warner Amex Satellite Entertainment Company (WASEC).

The Programming Services

Even the broadcasters wanted to get in on the action and began renting satellite transponders, the pathways for signal transmission. They all chose to channel their energies into cultural programming. ABC launched an advertiser-supported service, ARTS, in April 1981. CBS also started up an advertiser-supported channel, CBS Cable, in October 1981. NBC's parent company, RCA, went into a joint venture with the Rockefellers for a pay cultural channel, which became known as The Entertainment Channel.

Meanwhile, out in Hollywood, some of the movie studios saw that cable "had legs" and felt they were not being paid enough for their films by the major pay services. In 1980, Columbia, Paramount, MCA-Universal, and 20th Century-Fox joined with Getty Oil to create their own pay cable service, called Premiere. But the show never got on the road because the Justice Department said the combination violated antitrust laws.

But Paramount and MCA managed to get into the cable programming business when they joined cable "veteran" Time Inc. in purchasing the already-established USA Network.

And the services kept coming. Daytime, a joint venture of ABC and Hearst, directed its programming toward women. WASEC thrilled music fans when Music Television (MTV) started rocking in the summer of 1981. There was a fitness channel, Cable Health Network, and an all-sports service, ESPN. You could watch the political scene on the House floor and in committee on C-SPAN.

CNN, and the later Satellite News Channel from Group W and ABC, offered news twenty-four hours a day. HBO started Cinemax, another pay service often sold in conjunction with HBO in a "tier" sales strategy. Playboy bunnies came alive on The Playboy Channel, and the sound of the "Grand

Ole Opry" went on the bird with The Nashville Network. Even Mickey Mouse and Donald Duck had their own cable network when The Disney Channel paraded down Main Street, Cable USA, in 1983.

Still other networks appeared, many started by people relatively new to the television programming business. These services were often targeted to special-interest segments of the population or those with backgrounds not addressed by the least-common-denominator demands of broadcasting.

Such narrowcasting services (which included religion-oriented channels such as the Christian Broadcasting Network, the Eternal Word Network, and Trinity Broadcasting Network) soon found themselves on a growing number of cable systems. Hispanic and black-oriented channels were also narrowcasting to their audiences with services like Spanish International Network, GalaVision, and Black Entertainment Network.

Basic and Pay
The frenzied activity of cable development has still left many people confused. What it means to the consumer is that once a community is wired to receive cable and an individual chooses to hook up, he or she gets a certain package for their dollars.

Cable systems are required to carry the broadcast channels the customer had been getting all along over the air. The systems then choose which "basic" programming services they will make available to subscribers (such as CNN, USA, and so on). When MTV advertised to viewers to demand, "I want my MTV!" they were encouraging people to persuade their local cable operators to give the basic service a channel on that system. Since these services come to the consumer as part of the cable package with little or no extra charge, the programmers make their money primarily through commercials.

Then there are the local origination and public access channels, the number of which is dictated by the particular franchise agreement. Some of these channels sell advertising. Local programming is produced by the cable system or a local organization, school district, or the like.

Public access channels are available to individuals who

wish to take advantage of them. Most groups producing shows for public access use the time so community or public issues can be addressed. Because of the freedom in public access programming, this is where you find the more wacky stuff that has undoubtedly come as a surprise to many new cable subscribers over the years.

Finally, cable systems decide which pay, or "premium," services (HBO, Showtime, The Disney Channel, etc.) they will offer the subscribers who wish to pay an additional fee for them. However, if a subscriber's system isn't set up to receive a particular service's signals and doesn't want to offer it, the customer can't receive the service, no matter how much he is willing to pay for it.

The Industry Matures

The rapid and costly expansion of cable had not been without its perils. As the cable market was taking shape, advertiser-supported services were having difficulty finding viable audience-measurement statistics to convince Madison Avenue to purchase advertising time on cable. And, suddenly, there were simply too many cable services to be handled by cable operators. Older systems only had a handful of channels available for cable networks, and the operators were going with those they believed would be most popular.

The start-ups couldn't go on forever. Several players joined forces while others folded up their tents and went home. CBS Cable left the game in late 1982. The Entertainment Channel went out of business in March 1983; ARTS bought some of that channel's programming and was reborn the next year as the Arts & Entertainment Network. Ted Turner bought out and folded his competitor, the Satellite News Channel, in the fall of 1983. A year later, Turner found himself in the reverse situation: his brand new Cable Music Channel was bought by competitor MTV and promptly disappeared from the home screen. Cable Health Network merged with Daytime to re-emerge as Lifetime, in 1984.

After buying out Group W's share in Showtime, Viacom found some new partners in Warner Communications and American Express. These last two corporations owned another pay service, The Movie Channel, and they brought that service into the deal to form a joint venture called Showtime/

The Movie Channel (both are still available as separate pay-TV services).

The cable system side was also experiencing some economic quandaries. The cost of building new cable systems and wiring communities, particularly cities, was skyrocketing (not to mention the price of simply mounting a franchise bid). Even a heavy hitter like Warner Amex decided to sell off a major franchise and scale down the Qube operation.

Some of the trailblazers had dropped away, but that didn't stop cable's progress. As of November 1984, according to information supplied by the National Cable Television Association, 43.7 percent of America's households with TV sets were wired for cable. The NCTA reports that there were 6,400 operating cable systems in the U.S., serving about 17,675 communities, and estimates the number of cable subscribers at 37.3 million, representing close to 100 million viewers. And, the NCTA notes, over half of all cable subscribers also receive pay services (such as HBO and Showtime).

Of the remaining U.S. TV homes not yet wired for cable, an estimated 15 to 20 percent will probably never have the chance to sign up for cable because they live in such sparsely populated areas. But among the rest, some communities have awarded franchises which are not yet constructed. Others have franchise proposals still under consideration by a community-appointed board. And then there are some towns and cities which have yet to get the ball rolling.

Cable Careers
With the dramatic changes that took place in the cable industry in the late 1970's, job opportunities in the field had exploded. Hundreds of positions were newly created, and on the programming side, there was virtually no such thing as an employee with cable experience. People were moving into cable from a variety of other industries.

Cable has had some time to mature now, and the fact is there aren't as many new jobs as there once were. But it still offers exciting possibilities to newcomers and those who are interested in switching over from a different field. According to the National Cable Television Association, there were close to 7,000 new jobs in cable in 1983. That figure doesn't include the cable programming services or companies with

fewer than five employees, a category that covers nearly half of the cable systems.

To present a picture of the cable industry today, we asked professionals in the field to explain how they do what they do and what kind of personnel they are searching for. For starters, let's take a close-up look at Home Box Office, the country's leading pay-cable programming service.

Home Box Office

HBO employs nearly 1,500 people to program, market, and deliver its service. Like the majority of cable programming services, HBO is headquartered in New York; there is also a West Coast office as well as regional sales offices. The service launched on November 8, 1972, with a hockey game and a film shown for the benefit of 365 subscribers in Wilkes-Barre, Pennsylvania. At last count, HBO had 14.5 million subscribers. Cinemax, the second pay-cable service HBO operates, has 3.3 million subscribers. Five thousand four hundred cable systems offer HBO (and 2,100 of them also carry Cinemax).

HBO's structure can be roughly broken down into five categories: general management, which includes finance, legal, administration, and planning; marketing; affiliate sales; technology, covering the satellite group; and programming.

The programming department is one of the smallest areas, but it is one of great interest for many people who would like to work in cable. HBO's programming is a mix of theatrically released films from movie studios, HBO's own made-for-pay movies which come out of its Premiere Films division, and original programming, approximately 25 to 30 percent of the total mix. Original programming encompasses specials, concerts, comedies, plays, sports, documentaries, and series— whatever HBO produces or contracts to be produced for its service (plus any non-movie programming it acquires).

HBO's Film Acquisitions department keeps track of what exists in the world of theatrical movies (or, as it's called, "product"), and they compile information so HBO film buyers can make their choices. Actually, about five people negotiate and acquire the studios' movies for HBO. Once they've reached an agreement, the Business Affairs department works out the details.

In some cases, HBO will commit money to a film before

it is completed, helping defray production costs. These "pre-buys" entitle the service to certain benefits such as exclusive cable rights for a period of time. "On Golden Pond" and "Sophie's Choice" are two examples of HBO pre-buys.

In original programming, HBO does very little production itself. The network does produce its own sports programming, on-air promotion pieces such as coming attractions, and some "intermission" material. Sports has several producers, associate producers, directors, and assistant directors on staff. Producer/writers and some support staff handle the on-air promo material, much of which involves editing pre-existent footage.

For the rest of original programming, HBO typically licenses material or has programs produced for it by financing all or some of the production costs for an outside producer or production company. Producers come to HBO (or vice versa) with a program idea, and the network provides money for the show to be executed, usually maintaining approval on the personnel and talent involved. Occasionally, the network will acquire a program after it has already been completed by an outside producer—but only occasionally.

Development of programming takes place on both the West and East Coasts. About thirty people, including support staff, work in original programming. Programming executives are assigned to each show, and they approve the overall show budget. HBO production managers for the programs follow the day-to-day technical and financial aspects all the way through the production. HBO's Premiere Films division operates on the same principles, with development people reading scripts and financing provided for production.

HBO owns a studio in Manhattan, HBO Studio Productions, which it uses for some of its own production and post-production work. Outside clients use the studio as well.

HBO has also become actively involved in producing movies for theatrical release. Silver Screen is one venture the company is involved with that finances film production. In addition, HBO is a partner in Tri-Star Pictures, a full-scale movie studio it started with CBS and Columbia Pictures in 1983.

HBO's programming is transmitted via satellite to cable systems, which in turn send it to subscribers' homes through

cables. The programs, on 1-inch videotape, go out to HBO's facility in Hauppauge, Long Island, for the uplink to the bird. That facility runs twenty-four hours a day to transmit HBO's and Cinemax's signals. Approximately ninety people work there, including twenty program supervisors who oversee the technicians.

If you are interested in producing a program for HBO, consider what these executives say about what they look for and how you might go about it. And, remember, your relationship with them is likely to be as an outside producer with a contracted program deal, not as a staffer.

What HBO seeks is programming "people are willing to pay money for, so it must be different in some way from what's on broadcast networks and basic cable," explains Stephanie Pressman, Director of Original Program Planning. "But it must be broad enough in appeal for HBO's diverse audience. One of the traditional ways we've accomplished that is through 'live' concert events or comedy—they're taped, but there's the element of a 'live' event."

A new direction, continues Pressman, "is in treating themes with greater realism. For example, we're doing a dramatic series set in a prison, which is grittier and more realistic than it could be on broadcast television."

Lynn Klugman is Director of East Coast Production at HBO. To propose a program to the network, she suggests that the producer or production company without an agent "can call the programming developing department and find out what person is responsible for development in certain areas. Comedy development, drama development, series development—the terminology differs from company to company. Try to get that person on the phone, mention the type of show that you have in mind, and see if that is what they're looking for."

It's important, she reflects, for producers to know who is looking for what type of show: "They have to do a little homework themselves. That's the first step."

If there is interest, the development person may request a two- or three-page treatment, or, if it is completed, a script, along with a potential budget and cast breakdown.

However, notes Klugman, in this process, "there is nothing written in stone. The idea may be something that just

catches someone's fancy." And, as at most of the pay-cable services, the development people will want to have input as to the staffing and talent on the show. At this point, there will be conceptual meetings, and it then goes to Business Affairs for the arrangements to be completed.

For producers, "it's not as easy as it was five years ago for someone to come in off the street," Klugman remarks, "because the cable people working in both development and production jobs are far more sophisticated now than they were five years ago. Many have come over from broadcasting. It's not as loosely structured as it was, but it is not impossible. Because what potential suppliers have to realize is that [services like HBO] are programming twenty-four hours a day . . . The programming has got to be different and there's a quantity involved."

For the less-established producer, it helps to come in with a commitment from a star or director: "If you have surrounded yourself with good people," advises Klugman, "you have a better shot."

Mal Albaum, a production consultant for HBO (and previously, full-time staff), agrees that cable has its own programming philosophy. But in terms of preparing for a job in technical production, he notes that cable "is the same as working in any other part of the broadcasting business. The skills are the same; you're just applying them to a different end result. Commercial networks run commercials; we run intermission material. But other than that, it's the television production business.

"So you don't prepare yourself for cable. People send me résumés and say 'I want to get into cable. I've decided I could make an important contribution to the cable business.' Well, except from a programming point of view, there's no such thing."

In Albaum's view, the production community "is becoming more freelance and less employee [oriented] . . . And that's not good in terms of career. Because there's no job security. And there's no career path. You just have to be lucky and involved in projects that are successful."

To join up with HBO's staff in the production and programming areas requires experience. "You need a portfolio," states Lynn Klugman. However, in this area, "school helps.

When I look at the résumés on my desk, and someone has come out of a degree program in graduate school, I will look at that very seriously in relation to other experience that they have had after that . . . I don't negate the school background. It can give you some very good training and it can save you two or three years on the job in entry-level positions."

Program developers, explains Stephanie Pressman, tend to have backgrounds as producers or have worked in script development at other networks or studios. Pressman advises those with the background to send a letter and résumé to the particular department head.

"Basically, everybody keeps résumés and will see people from time to time so they have somebody when they need to fill an opening," Pressman adds. "Don't be concerned with looking for a particular job at a particular time."

Before leaving the areas of production and programming, let's bring back Marty Callner, the director we met earlier, who established himself as a top cable director during his years on-staff with HBO. Callner was a director with the company before going on his own and forming Callner Shapiro Productions. He still produces and directs shows for HBO.

Cable offers opportunities, feels Callner, because it generates so much programming. "There are a lot of production companies that are in business today because of cable," he asserts.

Callner's advice for those who wish to pursue the director's craft is applicable to every area of the business, not only cable. He suggests going to work with a director, getting involved on a daily basis. "I have people who started with me as runners who, within a few months, started directing certain projects," he points out.

The opportunities are in Los Angeles, believes Callner, and "if you come here with the proper attitude, you can still get in and make it . . . The old-fashioned techniques still work: hard work, dedication, good attitude, and a willingness to learn by observation."

There's that word attitude again. We asked Callner for his definition of a good attitude. His answer: "An eagerness to please, an eagerness to learn and not complain. A bad attitude is someone who complains. A good attitude is someone who really feels lucky to be there." The right kind of

person is "not just someone who will do whatever it takes. It's someone who [works as if] it's their pleasure, it's their sex, and it's the most important thing in their life."

To get a start, he advises putting an ad in the *Hollywood Reporter* for a gofer job, and "knock on doors. Keep knocking. It's all timing in this business. If you just continue, eventually you will get in if you have something. Persistence. Persistence. It doesn't fail. Directors love persistence. They know then that you will be there at 3:00 A.M. doing [your job]. Persistence shows a good attitude."

Beyond programming and production, there are hundreds of other people who play a part in HBO. The Research department devotes half its efforts to market research, the other half to audience research (how subscribers feel about the movies shown on HBO, etc.). The Media Relations department generates publicity for HBO's programming, while other people handle corporate and affiliates' public relations (affiliates being the cable systems carrying HBO). Another department schedules programs, keeping track of availability of programs, expiration dates on HBO's contracts to air the shows, and so on; a minute-by-minute log is also kept of exactly what is shown.

Moving right along, there is Human Resources, the controller's group, and Information Services (which handles data processing on the general ledger, billing, compensation, etc.). There's a small staff in International, dealing with world-wide joint ventures for HBO. Some fifty people work in the Legal department. And don't forget the Technology department, which keeps an eye on the future and new technology.

That's not quite everybody, but you get the general idea.

There are also jobs at Home Box Office in marketing, be it market research, consumer research, the marketing of programming—anything to do with more ways to get to the consumer. That might also include consumer promotions such as licensed dolls based on HBO's original program characters.

In terms of entry-level positions, there are a number of entry administrative jobs in marketing as well, where there is more turnover and a lot of activity going on. An auditor who assists affiliates and keeps track of affiliates' subscriber

numbers only needs a finance or accounting B.A. degree, and that job may lead to one on a regional sales force.

Someone with publicist experience and good contacts in the entertainment field might move over to cable in HBO's Media Relations division.

The Scheduling department has entry jobs, such as Program Log Coordinator. In the administration area, Contract Administrator (following up on contract details) is an entry-level position. The producer/writers of the on-air promos need to have experience, but a secretary may move up to become a production assistant in this area.

The possibilities for upward mobility in the company vary among these jobs, but clearly there are avenues for the newcomer to pursue. You might get experience in sales and marketing by working at a cable system. And someone with experience in a different industry may see areas in which his or her skills are transferable. Experience is a definite preference for most jobs at HBO today.

Production, Affiliate Relations, and Sales
Certainly, not every cable network operates in exactly the same way as Home Box Office. Consider how several departments function at other cable services.

Some of the networks, notably the basic cable channels, do a large percentage or most of their own production work. The Nashville Network, for example, headquartered in the city of the same name, produces the majority of its programming in-house in its own elaborate video facility. The network has three studios, two mobile units, and two editing rooms. According to Vice-President and General Manager David Hall, roughly 130 people are involved in daily production.

The kind of people TNN looks for to fill its production jobs, says Hall, are those "with experience, but preferably not at the [broadcast] network level, because those people have preconceived ideas of what it takes to do things and how many people it takes."

Hall's advice for the person looking to a future in production with a cable service is that "if you understand efficient production, it helps to be multitalented, capable in two or three tasks, such as producer/director. The bulk of our shows

have producer/directors or associate producer/associate director types."

At The Disney Channel, a pay service that operates out of Burbank, California, the Sales and Affiliate Relations division is divided into two departments employing forty people: National Accounts and Regional Sales (with five regional sales offices). Managers in these departments report to directors, who report to Angela Schapiro, Vice-President of Sales and Affiliate Relations.

As Schapiro explains, National Accounts works with major MSOs to sell The Disney Channel service to them, and develops marketing plans for introducing the channel or for ongoing marketing. The plans are then handed off to the regional offices for implementation with the local systems. Some thirty MSOs are national accounts; the other MSOs and independents are handled by regional offices. The Disney Channel is currently in 1,500 cable systems.

The regional managers and senior representatives have backgrounds in either cable or program service, notes Schapiro. However, she adds, "we are bringing in people at entry-level as coordinators, who don't necessarily have a cable background." Their job involves follow-up functions such as training the cable operators' consumer sales reps with product knowledge of the channel and making sure the systems get the marketing materials. "It's a good position to learn about the business and Disney, and eventually get promoted," says Schapiro.

As you've probably surmised, marketing is the desired background for this area, and, offers Schapiro, "we look for people who are self-starters who know how to go out and sell." There is the potential for upward movement, as she points out that they are promoting from within.

For someone who wants to be in cable, Schapiro sums up, "this is a great area to be in because, not only does it expose you to the workings of The Disney Channel, but you are also out there meeting MSOs and cable operators, and learning how their business functions. You are really getting an education at both ends of the business."

One department that you won't find at the pay cable services is advertising sales. At basic cable services, staffers are needed to sell ad time to sponsors. The USA Network, which

has its headquarters in Glen Rock, New Jersey, has just such a staff.

As USA's President and Chief Executive Officer, Kay Koplovitz explains that the people working in that department primarily have previous experience in advertising sales. Most, she says, have some radio and TV sales backgrounds; a few have experience in print advertising. To work in this group, states Koplovitz, "you have to have expertise and training, and you have to be able to sell in Madison Avenue terminology."

Tele-Communications, Inc.

Cable programming services are likely to be what the TV viewer thinks about at the mention of cable. But for the person interested in understanding the cable field, there's a great deal more to think about.

Needless to say, without the cable systems, there wouldn't be much point in having cable programming services. Tele-Communications, Inc. is one of the largest MSOs, with owned systems or partnerships in systems reaching 2.8 million cable subscribers in 500 communities.

A little over 200 people work at the company's corporate office in Denver, primarily the top executives and those in Finance, Legal, and Operations.

As Carolyn Baker, Director of Shareholder Relations and Assistant to the Chairman of the Board, explains, outside of Denver, the company is broken down into eleven group offices of twenty to thirty people apiece, each with its own management, accounting, and marketing. A group might consist of five states, further broken down into three or four districts, and, finally, the systems.

TCI's chairman, Bob Magness, had owned several cable systems before forming TCI in 1970. Over time, says Baker, the company has built both new franchises and acquired existing systems. The larger systems might have thirty to fifty people employed, the smallest, just three or four.

As Baker describes it, in an average system with 20,000 subscribers, you would likely find an entry-level technician who climbs the poles and strings the wire, three levels of technicians above him (who may take advantage of a company course sponsored by the engineering department, which

trains staffers to move up). There's also a chief engineer with an FCC license and some management experience or training. In addition, there is the clerical support staff: secretary, bookkeeper, and someone to input on the CRT to the Denver computer. Then there will be the office manager and engineering director or manager who oversees the technicians.

At the district level, she continues, they are "all system people, except their experience, education, and expertise are probably higher because they're directing many systems. The technicians are doing more planning rather than stringing wire for people at the system level." There's also an accounting person and probably someone in marketing as well.

Baker describes the group level offices as "mini-headquarters . . . There's a Group Manager and his staff, an Account Manager and his staff, and a Marketing Manager. The experience and education increases."

Local Origination and Access

This picture of the cable business is not yet fully colored in. There are the premium and basic programming services, the MSOs, and the independent cable systems all working toward increasing the reach and clout of cable television. But the programming that originates at the local system level is another significant aspect of cable. That's the local origination and access programming mentioned earlier. The 1984 *Broadcasting/Cablecasting Yearbook* estimates that 3,250 systems originate programming in their own studios, for an average of twenty-three hours weekly.

Sue Buske, Executive Director of the National Federation of Local Cable Programmers, estimates that there are about 1,000 different entities producing local programming on cable systems. She calls them entities because, aside from the cable system, they run the gamut of being a public library, school district, or local university, to nonprofit corporation or museum.

Both local origination and access provide all types of opportunities to get into the business and learn about it, to transfer skills already-acquired in other fields, or to bring video into play at a job in another industry.

The cable system that offers its own programming may have staff producers to create the shows or may purchase

the programming from outside. Buske sees entry-level jobs for those with some production training, and notes that someone right out of college with a degree in communications or broadcasting might be able to come in as a producer or assistant producer at a local origination operation.

In access programming, individuals can produce and air programs on virtually any subject they like, and no experience in video is needed to take advantage of this cable time allocated to the public. Working for the cable operation on the access side are access coordinators, facilitators, and technicians. This typically requires a different set of skills than producing local origination programming for a system, points out Buske.

"It's not TV production skills primarily," she explains. "It's the people skills, the ability to deal with the public, to be able to teach and show how to produce a program." And, these staffers "have to be able to speak and write well. They have to have some good basic management skills if they want to move forward to higher-level positions."

There are numerous entry-level positions in a larger access operation, she adds, and there are successful people working in access who hadn't had any production experience when they entered the field. "They had the people skills and solid management skills," Buske comments. "They learned the production on the job. You can train people in production skills, but you can't train someone to deal with the public if they don't have the inclination.

"There are people with all kinds of experience: teachers, nurses, retirees—it's all over the ballpark," relates Buske. "You will find people with an enormous diversity of skills plugging in at the entry-level jobs." She estimates that half of the people involved are new to the field, and some are moving over permanently after whetting their appetites producing access shows of their own.

In this area of cable, you can break in through a volunteer job. "There are a lot of skills to transfer and that's why you see people who have been volunteers ending up getting entry-level positions," Buske says. "They took the training and started producing shows. They already had another set of skills [with which] they earned a living, and they decided they wanted to make a switch."

When a local channel is run by an organization, the video-related job may be at the organization itself. For example, explains Buske, if the group behind it is a school district or college, the person in charge is usually on staff there. "It could be a member of the faculty or someone handling audio/visual," she observes. "It differs from one situation to another. Some colleges will bring in someone brand new to train the students and make sure the productions are done well. Most of the time, it's someone already on staff.

"The field is growing rapidly because there are more and more of these local cable channels being activated all over the country. Some cable systems have many of them; they are managed by different entities . . . I think we will continue to see that kind of growth."

And it suggests a number of possibilities for those working in organizations and institutions to become involved in local cable programming through their present jobs.

The person who starts out in a small cable system might go on to a larger operation, and "the larger the city, the more facilities and the more challenge," says Buske. An access facilitator at a small operation might move up to become access coordinator/manager and then access manager in a medium-size community. Producers may move over to a cable programming service. For others on the cable system side, however, there are some limitations to take into account.

"The problem," reflects Buske, "is that there is not as much upward momentum once you get to the top management position in some of these jobs as there is in other fields. Let's say you are working in a nonprofit situation and you are management at an access channel in a small town. You can move to a larger town, and once you have mastered that, you can move up to a city. Then where do you go? You can work at the corporate level, but there are very few cable companies who have anybody at the corporate level who deals specifically with local programming."

She estimates that it takes seven to ten years in the field before running into that "logjam." And to prove her point, at the annual NFLCP convention in 1984, one of the workshops was titled "Is There Life After Community Programming Management?"

But what someone's goals are, and how they parlay their

skills into new challenges is an individual matter. And this certainly doesn't detract from the possibilities local origination programming offers someone who wants to get a foot in the door of the video industry, to learn and get that valuable hands-on experience.

For the immediate opportunities, this area—like so many other fields in video—is constantly looking for technicians to repair and maintain the equipment, Buske says. Singling out a hot job in the field, she chooses that of being the executive director for an access corporation in a large city, such as in Chicago or Staten Island. There are nonprofit corporations running such operations, sometimes set up by the city, sometimes evolved out of the community and then recognized by the city to be the recipient of funds allocated for access.

"It's a big job and it's the best-paying job in the field," Sue Buske notes. "Those jobs are $50,000 to $75,000 a year, and very challenging from a management and political perspective."

The NCTA

"Cable is the most high-powered, energetic area I have ever worked in and everybody I know says the same thing," remarks Sylvia Marshall, Director of Human Resources for the National Cable Television Association. "You have to have unbelievable energy on an everyday basis just to operate in cable. It's never slow."

The NCTA is the leading trade group in cable television. For those interested in the field, the association holds an annual convention, with exhibition booths and workshops. If you are trying to break into cable, you may want to take advantage of the Careers Center and annual Job File listing. In addition, you can write away to the NCTA for their handbook *Careers in Cable* (see the appendix for the NCTA's mailing address).

Echoing the comments made by other executives, Marshall picks marketing and sales as the biggest growth area for jobs. "Just about every company I know is focusing very much on that and on increasing subscribership," she relates. "The whole area of customer service is growing and there's a lot of focus in terms of servicing the subscriber better."

To fill those jobs, she notes, the industry may look to

people in other fields with related skills or graduates with MBAs or Business Administration degrees. The person without a college background might start by getting in-service training as a sales rep. Those jobs are hard work for little pay, Marshall comments, but if an individual holds out through the difficult times, they're a good way to pursue a career path in cable.

From there, one might move into market management, promotional work, or public relations, depending on the area of interest. "But it's a great way to know the industry and to know what services it has to offer, to get in on the ground floor," she feels.

Along with the high energy level, Marshall suggests that the skills of handling computers and data processing are particularly helpful in today's cable business. Writing skills are always valuable, she adds, even at lower-level jobs. And the technical person who adds a business degree to his or her credentials is likely to have an edge.

One other thought from Sylvia Marshall is that "more women should go into technical areas. Two-thirds of cable is technical and most of [those people] are men. It's an industry that started as a 'family business' and it was a role-oriented business. Men did certain things and women did certain things . . . It's beginning to break, and there is not nearly the amount of resistance as there might have been five or ten years ago. It's an area that many women have never delved into."

The Alphabet Soup

Several other new methods of program distribution are currently available or planned for the near future. They are STV, MDS, SMATV, DBS, and LPTV. These additional distribution methods either compete directly with cable or are offered in areas that presently are not served and/or may never be wired for cable.

Unlike the other buzz initials represented by the alphabet soup, STV (subscription television) probably has already seen its heyday. Transmitting on an unused local broadcast channel, STV sends its scrambled single channel of programming, usually movies, to home antennas.

Although there were over 1.3 million STV subscribers in January 1983, that number shrunk to under 750,000 the following year. The reason is that millions of new homes were wired for cable; STV apparently cannot compete in an area once consumers have cable with its many channels of programming.

MDS (multiple distribution service) is also a single-channel service but it uses microwave to reach homes and apartment buildings within about 20 miles of the transmitter. MDS typically serves areas not wired for cable. The programming is usually one of the pay cable services such as HBO or Showtime.

Because receiving antennas must be in a clear line of sight to the transmitter, MDS systems are frequently plagued by interference. Piracy has also hampered the growth of MDS, because its unscrambled signal can be received by relatively easy-to-build antennas.

Although there are currently under a million MDS subscribers, that number may expand as a result of a decision by the FCC, which authorized an expansion of the system. Under the ruling, new systems, offering four or five channels could be offered in MDDS, (multichannel, multipoint distribution service). But even with these additional channels, MDS will face a difficult struggle competing in its most viable marketplace, the cities, which are quickly becoming wired for cable.

Some city dwellers have been able to receive several cable programming channels without cable wiring through SMATV (satellite master antenna television). With SMATV, mini-cable systems have been established in apartment buildings and housing developments through the installation of satellite earth stations. The individual SMATV system makes agreements with cable programming services to offer a selection of channels to its subscribers.

An advantage enjoyed by SMATV operators is that they are exempt from federal cable regulations as well as the local rules governing local cable franchises.

Because of the economics and technology of cable, STV, SMATV, and MDDS, there will always be millions of homes that will never be served by these distribution methods. DBS

(direct broadcast satellite) is a system designed to reach the estimated 15 to 20 million homes outside urban areas that cable will never reach.

Using special satellites, DBS can distribute several channels to homes equipped with relatively small earth stations. (Yes, quite a few people have gone out and bought dishes in the past. But their TVROs are very large and receive—some would say steal—signals from the birds used by companies such as HBO and CNN to reach cable TV systems.)

DBS satellites are more powerful than the ones used by cable programming networks. Because the birds are more powerful, smaller dishes—only about a yard in diameter—can receive DBS signals. The consumer is equipped with a decoder box to descramble the system's channels and is charged for installation and a monthly subscription fee.

Since the startup costs for DBS are so enormous (to build satellites, maintain ground facilities, build and install home dishes), the technology has not yet taken off.

Cable programming services, which are interested in cracking the rural market, have been talking about banding together to start their own DBS systems. And many are also interested in making their channels available to DBS systems that prove viable in the future. In another area, large corporations are investigating the possibilities of using DBS for their own needs, including videoconferencing.

Many observers, noting the millions of homes that will never be served by cable, regard DBS as a technology with a future. But it is still unclear as to when DBS will actually get off the ground.

Also looking closely at the more sparsely populated parts of the U.S., as well as those not yet wired for cable, are the developers in LPTV (low power television). The technology of LPTV is not new; it's basically what has been used for years for broadcast television transmission. The difference is that LPTV stations are limited to using less powerful transmitters than traditional broadcast stations, and therefore, can only serve a much smaller geographic area.

In 1982, the FCC gave its approval to LPTV. Actually, what they did was allow translator stations (stations that had only been rebroadcasting the signals of full-power stations) to originate their own programming. Some 4,000 already ex-

isting translators could rise to LPTV status just by notifying the FCC. And, it was estimated that 4,000 new stations could be on the air as a result of the ruling.

Because of the green light given to program origination, the commission was deluged with applications—well over 32,000—for LPTV stations. To help award the licenses among competing applicants in the same area, the FCC resorted to a lottery system.

Although LPTV stations cost a fraction of what is required to establish a cable franchise or a broadcast station, it remains to be seen how these new operations will pay the bills. While the local programming that an LPTV station can offer may provide the community with a valuable service, it may not generate the advertising support required to keep the station in business.

Therefore, some LPTV developers are examining other options in setting up and programming their stations. One approach is to include a free daytime schedule, supplemented and supported by a pay service at night. This pay service would offer movies and other forms of entertainment of the type currently found on cable.

LPTV entrepreneurs are even turning to satellites to create networks for distribution of programming to LPTV station groups and affiliates (sounds like the big boys). This programming is often drawn from basic cable birds and the broadcast syndication market.

Which of the ingredients in this alphabet soup will still be with us in the years to come is open to debate. It even has the analysts on Wall Street somewhat baffled. We advise you to stay tuned to your trade publications and the business press so you can hear the magic words "Soup's on" when it happens!

Head-Ends
In looking to the future of cable, we asked two veterans of the business what they see on the horizon.

USA Network's Kay Koplovitz agrees that "a lot of work has to be done with customer service. Marketing has opportunities because marketing is always a challenge."

On the technical side of cable, "there will be an introduction, on a large scale, of pay-per-view technology," she be-

lieves. Further, "DBS will mature in the second half of this decade. It will be a competitor in the marketplace for broadcast, cable, and STV. It will be another form of distribution. Its primary market is where cable does not exist, but it's potentially a competitor."

In Ted Turner's view, "Satellite technology is pretty much mature now, and I don't see any great technological breakthroughs." He also mentions DBS as a growth area, and his comment brings up the possibilities of DBS systems carrying the programming of services such as his CNN: "It will give people who don't live in densely settled areas an opportunity to get cable programming where there is no cable."

Turner's advice to the person who wants to prepare him- or herself for a career in cable is that "people should be service-oriented. Cable is a service business." While there are, of course, the manufacturers in cable who make the hardware, he adds, "the cable operations business is service-oriented and that's dealing with lots of customers and trying to keep them happy."

And, finally, we had to ask the most famous name in cable whether an entrepreneur, someone with vision, could still do today what he did back when "cable wasn't cool." Make of it what you will, but we like the sound of his answer. "Sure."

CHAPTER 6

Corporate Video

I t's almost time. The studio is ready for the big taping, with lights, cameras, and audio double-checked and set to go. Technicians stand by, talking and joking with one another, as the producer and director nervously confer over in a corner. The tension level is high: slip-ups will mean serious consequences.

A dark-suited young woman enters to announce that He's on His way. Everyone assumes their positions. Suddenly, there's a flurry of activity by the door, a group of men and women practically running to keep up, as into the room strides the Chairman of the Board.

He may have blue eyes, but we're not talking about Frank Sinatra. This is the Chairman of the Board of a Fortune 500 corporation, ready to videotape a message that will later be seen by all the company's employees. And he has arrived at his corporation's video studio, a facility boasting state-of-the-art hardware. Hundreds of thousands of dollars were allocated to purchase this equipment in order to help the company better communicate with its own personnel and the outside world.

Corporate video is an area that has significantly expanded the opportunities for jobs in production. The phrase corporate video (or television) is actually an umbrella term covering the use of video use by corporations, associations, educational institutions, hospitals, the military—any video done for a par-

ticular organization's own purposes and institutional use. It is also referred to as industrial television or private television.

And creative corporate-video professionals are perfecting and expanding its applications in hundreds of companies and organizations across the country. These entities are involved in everything from banking, retailing, and manufacturing to publishing, utilities, government services, and medicine.

Some specific examples of video's effectiveness in business are offered by the International Television Association (ITVA), the leading organization for private television professionals:

Adolph Coors increased its Halloween beer sales 50 percent using video to give buyers a preview of point-of-sale materials and radio and TV commercials that would be used for the special promotion.

Neiman-Marcus reduced shoplifting by 50 percent with a store-produced tape showing salespeople how to detect and respond to shoplifting.

The University of Colorado Health Science Center provided patients with a video presentation on the hospital's services and patients' schedules and rights. Research showed that the tape was responsible for reducing patient anxiety and increasing positive patient response to the institution.

These are only a few examples. But even with all the activity already underway, companies and organizations have just begun to scratch the surface in discovering ways to use video.

Corporate video is distinct from other segments of the industry because it is a case of video operating in a nonvideo environment. The company's main business probably has nothing to do with television, and the video department is simply one among many. One result of this fact: because video typically does not generate direct profits for a company and may not be well-understood by management, it has been up to the people who run the video operation to prove the department's value.

But you can see the rapid growth that has occurred. One index of video's acceptance by corporations has been the expansion of the professional association, the ITVA. Today, the association has over 6,000 members in more than seventy professional and student chapters in the U.S. and Canada.

There are also chapters in other countries around the world. It has only been in the last decade that corporate video has gained its current prominence. Companies and other organizations have long maintained audio/visual departments to create slide shows, film presentations, and the like to train and communicate with employees; they have also used television since the 1950's for closed-circuit broadcasts. But it took several specific advances in video technology to enable this medium to gain more widespread acceptance in the business world.

To begin with, video had long been a costly investment for an organization. Without a clear idea of the return on their outlay, it's easy to see why companies would have been reluctant to allocate the funds. Video was an unproven tool. Further, this expensive equipment was difficult to operate for anyone but a well-trained engineer.

The breakthrough was the introduction of inexpensive, portable, small-format videotape recorders in the late 1960's; Sony came out with a ½-inch reel-to-reel videotape recorder. Relatively easy to use, it began to gain a foothold in AV departments at corporations, hospitals, and schools. The resulting black-and-white programs were primitive by today's standards but it gave many a chance to see the potentials of videotape. Spurred on by aggressive marketing on the part of hardware manufacturers, enthusiasm for the medium grew.

When the ¾-inch U-Matic videocassette recorder reached the market, the field opened up further. The ¾-inch videocassette used in this machine proved to be a convenient means of distributing programs throughout organizations; the tape was enclosed in a plastic housing (like an audiocassette) and all the threading was done by the machine. In addition, this format, along with new cameras, provided images of a far superior quality to what the old ½-inch tape could deliver.

With the cassettes, organizations began establishing private TV networks. The definition of a corporate TV network differs from that of the other networks we've discussed in this book. These networks are simply setups of videocassette recorders and monitors for playing back programs, distributed throughout the organization's locations. Duplicates of a video program can be sent to all the branch offices, spread-

ing the corporate message. Today, many of the newer networks use Beta and VHS systems.

In addition, over time there have been dramatic improvements in camera technology that have made broadcast-quality cameras affordable to corporate users. Setting up a video department can still run into considerable money, but for the dollars, companies can now produce elaborate, high-quality programs. And they are making those programs for everything from training, corporate communications, and public relations, to sales promotion, and press information.

There are several other reasons why corporate video grew and continues to expand. In the increasingly complex world of business, there is a seemingly endless stream of information that must be gathered, analyzed, and disseminated—and must reach employees in numerous and distant locations. Video can help.

Further, it is no secret to anyone that Americans are now used to getting their information from television. It makes sense to take advantage of a medium they respond to at home in the office as well. In fact, the first generation brought up with television has grown up and joined the business force. It's logical that they will have a positive reaction to using video in order to communicate with their colleagues.

And let's not forget the simple fact that it's fun to be on television. Other people enjoy it; why shouldn't corporate executives?

While many video operations are still to be found within companies' audio/visual departments, there is a trend toward setting up separate video operations. Many corporations have the type of video gear you would expect to find in a commercial video facility or even a TV station. A growing number of private TV groups now use 1-inch videotape recorders—the standard for production in broadcasting—as well as many of the same camera models used to shoot broadcast news.

On the postproduction side, private television operations have acquired everything from the low-end, simpler editing systems, to the high-end computerized versions. Private TV is currently taking a close look at electronic graphics and animation systems, and a number of organizations have already replaced the old press-on letters for titling with electronic character generators.

Many organizations that have not yet experimented with video are trying to learn more about how it can help them. If your company doesn't operate a video department now and you are in a position to suggest they start one, there are some immediate steps you can take to find out more about the subject.

Pick up the trade publications that cover corporate television. Follow the articles about video's use in industry in the consumer business press. Speak to colleagues in other companies that already have video operations. You may want to attend a local ITVA meeting or its annual convention, or even the National Association of Broadcasters Convention.

The big question facing a company looking into a video operation of its own is usually what it will do for the corporation. Although few companies expect their private TV operation to turn a clear profit, they will only establish a department if there are tangible goals that can be achieved by doing so.

The goals may vary. If a company's employees are disbursed in offices across the country or around the world, video can offer a convenient means of communicating complex information. They may be searching out more effective tools in sales promotion or for training new employees, or looking for a better way to update their people on new policies. If they manufacture products to be sold at the retail level, they may see the value in creating point-of-purchase programs to promote the product or explain its use.

Another possibility is using a studio for speaker training. With more company executives appearing on television these days, there is a growing need for the kind of TV coaching that was once thought necessary only for entertainers and political candidates.

Whatever the purpose, some companies will choose to start small by hiring one or two staff members who may do all their production work at outside facilities. Others will invest in equipment, expanding as the video department proves its merit over time.

Building a full-blown operation complete with studio and computerized editing is not the best path for all companies or organizations. If there are a number of commercial facilities nearby, many executives may decide to keep their equip-

ment purchases down. In other companies, usually those with the larger budgets, convenience and long-term economic savings will win out, and they opt for building and staffing a complete broadcast-quality studio. All of this is weighed against how much production they anticipate doing.

When considering what type of operation your company might set up, you should recognize a key fact. The production standards for private television are set by what people are used to seeing on broadcast television. Your department will have to be able to produce high-quality programs.

Therefore, if the company is not going to invest in equipment for its own department, it must be willing to pay the rates charged by good outside facilities. Often, a look at the hourly editing rates at a commercial facility will lead companies to appropriate funds for a simple editing system. That way, they can shoot elsewhere, do some rough editing in-house, and finish the program at a postproduction facility.

Videoconferencing

Videoconferencing (also called video teleconferencing) is another aspect of video technology that has made its way into the private television world. Anyone interested in private television should become acquainted with its possibilities. Many people are very familiar with teleconferencing, or audio-only conference calls. With videoconferencing, executives in locations spread out around the country or the world can both see as well as hear one another in video meetings.

During a typical videoconference, the person or group addressing the other participants is at one site, and their image is sent via satellite, AT&T long lines, or microwave to the other meeting locations. The various participants can see the speakers on video monitors or large-screen projection television; usually the speakers do not see the rest of the participants. Through audio hookups, all the participants can trade questions and comments. Two-way video in which everyone sees everyone else can certainly be arranged, but currently is less common due to the added expense.

The potential uses for videoconferencing are just beginning to be tapped. Companies are taking advantage of it for product introduction and training, stockholder meetings, high-level executive meetings, and company-wide addresses

by corporate management. Another use is for video press conferences, such as the one held by Johnson & Johnson to reveal a new tamper-resistant Tylenol package to the media, in a thirty-city videoconference.

Given its potential, videoconferencing is still very much in its early stages. According to a survey of in-house communications managers conducted by the research firm of Frost & Sullivan, nearly half the managers in this study expect that their firms will use such conferences in the future. Including both video and audio-only teleconferences, the research firm predicts a $3.4 billion teleconferencing services market by 1992.

Interactive Video

Another buzz word in video, especially in private television, is "interactive." If you grew up as part of the baby boom, your first interactive video experience was probably while watching "Winky Dink" as a youngster. With your special crayon and plastic screen, you could become involved with the TV show, although the "technology" was primitive, mechanical as opposed to electronic. Many who grew up on "Winky Dink" are now interacting with TV programs through the use of videodisc technology.

The arrival of the optical (LaserVision) videodisc player, from companies such as Pioneer and Sony, marked the real beginning of interactive video. The disc contains 54,000 frames, each of which can be called up on the TV screen and "accessed" within a matter of seconds. This capability is called random access. Random access allows the viewer to "interact" with a program, deciding what part he wants to watch at any given moment.

While there have been some consumer videodiscs which have offered interactive instructional and entertainment programs, most of the production has been for industrial and professional applications. One reason is that professional LV players can access faster than consumer players. In addition, it has been the corporations in America that have recognized many of the benefits of videodiscs, and used them for training, sales, and information retrieval.

The first major company to go videodisc was General Motors, which installed a network of professional players at its

dealerships across the country. GM financed the production of videodiscs that trained its employees, along with other programs that customers could use to help make buying decisions. Today, Ford and Toyota both include interactive discs in their operations. Another major user of interactive video is the U.S. Army, which has found it a helpful way to train recruits in everything from jeep repair to tank warfare.

There are new interactive disc-based systems that have hooked up to the power of personal computers. Digital Equipment Corporation, the computer giant, offers a training system that includes one of their PCs and an industrial player. Called IVIS, it enhances the capabilities of the videodisc in accessing information. And there are many more companies joining the ranks of organizations experimenting and adopting interactive disc technology.

Industrial players are also showing up in places where the average consumer can go interactive. The largest installation of these players and programming is to be found at Disney's Epcot Center in Florida. Epcot's information network includes special kiosks, hooked up to banks of LV players in a central location. In addition, many of the exhibits feature interactive videodiscs so visitors to learn about different subjects. These disc-based systems, and others currently in use, don't even require a keypad for interactivity. Instead, the participant simply touches the screen in the appropriate place.

Banks, department stores, and travel companies, among others, are using interactive video for point-of-purchase presentations. And interactive videodiscs became part of the arcade game industry, when the Dragon's Lair game started to get heavy play back in 1983.

Interactive videodiscs, whether for the industrial or consumer players, call for special production techniques, which become especially challenging during editing. Because these discs require coding and data entry, producers working on these projects make sure they have a working knowledge of computer language. This helps them in mapping out the disc on flow charts that guide the preparation of these nonlinear programs.

Because interactivity with videodiscs is fast, the technology has even found applications in the production process.

To many, the most efficient way of editing is to access the material from videodisc players (instead of VTRs), because they can move to any point almost instantly. Such a system was introduced in 1984 by Lucasfilm in their new EditDroid video-based editing system.

Job Opportunities

Many people are attracted to private television because they prefer the corporate atmosphere. They like to put on the suit, grab their attaché case, and head off to the office. Of course, instead of finding sales projections in that attaché case, you'll probably find scripts and studio shoot diagrams. And frequently, the private TV manager will wind up taking off the jacket and rolling up the shirtsleeves during a long day in the studio or editing room.

Just as the type of video equipment varies among corporate organizations, so does the "corporateness" of the atmosphere. You would be safe to assume that a Fortune 500 company's video department is likely to be more buttoned-up than one at a university. That's not to say that one is more professional than the other. But anyone analyzing corporate television should not overlook the fact that the organization itself can have a greater effect on the working atmosphere than whether the operation has 1-inch VTRs and CMX editing.

Unlike some of the other fields in video, corporate video cares a great deal about college degrees. It is preferable to have advanced education in any video-related field, but at least some kind of college credentials is expected in most corporate environments. There are enough people who want to work in private television to make the absence of a higher degree an easy means of weeding out job applicants.

The number of people you might find working in a private TV department starts with one and moves up from there. The ITVA conducts an annual salary survey of its professional media communication members and, in 1983, the survey received 1,399 responses, which were broken down into thirteen categories (plus one for "other").

The categories were: manager, supervisor, one-person operation, producer/media director, director, writer, media

131

specialist, production assistant, engineer, technician, sales, videographer, and professor/instructor. Not all of these positions exist in every operation.

Most of these job titles are familiar ones. The ITVA does provide job description outlines for all of them. Examples:

A supervisor advises and works with users in planning how to get the most out of audio/visual media, including content and organization of programs. That person coordinates production schedules and directs or oversees direction of all company media programs.

The producer/media director will evaluate and interpret the company's audio/visual needs, analyzing the audience and determining program objectives. He or she writes treatments, makes up budgets, writes and/or directs programs or assigns someone to handle those functions, is responsible for getting the programs completed, and evaluates their results.

A media specialist in a smaller operation may perform many other functions along with acting as the overall specialist in all media and their uses and operation. This person may analyze media problems and determine the best medium to use, set up media programs, and troubleshoot equipment problems.

Not surprisingly, salaries in private television vary according to responsibility and the size and type of organization and region. Large corporations pay better than nonprofit organizations. Those people working in corporate video in places like New York usually earn more than their counterparts in smaller cities. And the salaries in a video department will be closely related to the importance management places on its private television operation.

Because the manager is the one in charge, let's focus on what that job entails.

All but the most free-form private TV operations require their managers to know about budgeting and creating business plans for the operation. Managers will also be asked to be creative in the artistic sense. Coming up with ideas for shooting a program, writing scripts, and overseeing the production and editing may all be part of the job.

On bigger projects, the manager will have to hire outside talent, including everything from actors and announcers to

lighting specialists. They hire and fire the staff, and work with personnel and upper management on evaluating and rewarding the people who work for the firm's video department.

Another requirement of the job is keeping up on the latest equipment developments by reading the trade magazines and attending industry shows. As a manager, you want to be ready when a senior corporate executive calls you in and says, "J. D., I've been reading about this DBS thing. They say it's going to impact on corporate communications. What is it and should we be getting into it?"

When you put it all together, the corporate TV manager's job combines the tasks of both the video facility manager and the producer.

As the prestige of corporate TV has increased, so has that of the department's manager. Private TV managers can become company vice-presidents and share in all the attendant perquisites. However, stop right there if you're thinking of parlaying a VP of TV into a top job in another area. Although managers may rise to a position such as head of the corporation's communications department, a move entirely out of communications is difficult at best, as things stand now. Private TV is for those interested in video; it's not a stepping stone to the CEO spot.

Profiles in Corporate Video

One person who has seen the view at the top in corporate television is Nathan Sambul, President of the communications consulting firm of NJSambul and Company, and editor-in-chief of *The Handbook of Private Television*. Prior to setting up his own firm in 1979, he managed the highly sophisticated video network at Merrill Lynch in New York, where his first job was as a production assistant.

The advantages of working in corporate video, says Sambul, start with "a great deal of flexibility. Once you get past the fact that you're working for an individual company and you're going to be doing programs on that company's product or service, the amount of creativity is extremely high. For the most part, you usually don't have twenty-seven people above you who are all experts in video telling you how to design programs."

Sambul agrees that the prestige of the video department has increased in the eyes of business. "I think I was one of the first AV managers in the New York area, maybe even the country, that actually became an officer of the company," he recalls. "So, obviously, Merrill Lynch thought enough of its AV department to make its manager an officer."

As with other areas of video, competition for jobs in corporate video has increased. Corporations do not tend to take volunteers, but some do have student intern programs, and there's always the production assistant entry-level job. "That's how most people start," states Sambul. "The industry is such that it's very fluid. It's not surprising to find people starting as P.A. freelancers, who then get brought on to be full-time P.A.'s [and] then get promoted to director positions."

As always, hands-on experience is preferred. To acquire it, Sambul advises, "If you're going to school, get as many different projects as you can accomplish under your belt and then have copies to show that you have done them. Try to get the internship, try to get the low-paying or free jobs as a P.A. gofer as you're going to school."

But once you get in, private television is an exciting field. "It's a lot of fun, and if you're looking for mental stimulation, this is the area," Sambul states. And people do stay within the field, he observes, "if it's any indication by the people I notice at the parties. I see the same faces at the parties. My face included."

* * *

Stephen Mulligan is the 1985–86 President of the ITVA and the Audiovisual Communications Director at Allstate Insurance in Northbrook, Illinois. He developed Allstate's AV communications network, which now boasts a 1-inch broadcast-quality studio. His department handles multimedia presentations and produces some eighty video programs a year in areas such as training, public service announcements, and product introduction programs. Mulligan's post also involves consulting on communications needs, and hiring and training staff.

Mulligan, too, stresses the creativity of working in corporate video. "We get involved in such a variety of projects,

programs, and media, and each one is a whole new challenge," he comments. "I think we do more of a variety of programming than, say, the local [broadcast] affiliates here."

Corporate video "has changed a lot in the past five years," agrees Mulligan. "In the economic crunch, many corporations realized that video was a good resource-user. For example, rather than flying an expert around the country, they can put together a good program with that expert or resource at a savings." Organizations also realized that video "presents a uniform message," he says. "The same message goes out to everybody; it's not subject to interpretation through levels of management. That's very important."

A recent and positive twist on the corporate video professional's job is the expanding audience that may see his or her work. Generally, viewership had been limited to a company's employees. With more programming distribution outlets opening up, corporations are finding they have a broader reach for certain kinds of company-produced programs.

Mulligan relates that Allstate has been producing programming to help charitable and other nonprofit institutions raise funds; some of these programs have found wider distribution. Their public service announcements have been on cable and network television. A documentary they created for the National Down's Syndrome Society ran on cable and was picked up by PBS, and a program about nursing appeared on a number of cable systems. Opportunities such as these add another level of challenge and satisfaction to the corporate video professional's work.

A video department such as Allstate's is large enough to hire people for specific functions such as editing or audio, says Mulligan; smaller facilities are likely to look for more of a generalist. He cites audio and video technician as jobs that can help one break into the field, with writing being another skill that may open some doors.

Mulligan agrees that having a college degree is important in this business. However, he laments, in terms of academic training, "the one problem with the young people is that they are just geared toward broadcast. They don't have any concept of a corporation. It's a very different place to work. In broadcast, the main business is broadcast. In a corporation, the

main business is insurance, automobiles, refrigerators. It's not video. You get an attitude problem. Interns have to adjust. They are not the center of attention."

Mulligan himself had a journalism degree when he got into the field, but found he was having difficulties without a better understanding of business. He went back to school for an MBA. Schools, he feels, should "of course, concentrate on the technical part, but also throw in some business courses."

Like other corporate TV executives, Mulligan advises the job-seeker to go to the head of the corporation's video department, rather than the personnel department. Personnel, he observes, understands the corporation's main business, not video.

Mulligan and others also suggest joining the ITVA as one means of pursuing a job. The association has a job exchange at its conference and is trying to establish one country-wide. Mulligan's company hires through the organization, and "it's a good place to meet people and get to know the field," he sums up.

*　*　*

One of the most interesting aspects of private television is seeing how video is finding new applications. At the law firm of Fisher, Gallagher, Perrin & Lewis in Houston, video is being used to make pretrial presentations to the opposing side and create programs for the courtroom.

The company has spent $300,000 on video equipment and has a broadcast quality facility with the new ½-inch broadcast Recam equipment, two cameras, and a computer-controlled editing system. There is no studio; instead a conference room is set up for taping conferences, depositions, or interviews with witnesses.

David Eatwell, who got his training in the Armed Forces, has the title of Consulting Video Producer at the firm. He heads up a department consisting of himself, a full-time assistant, some part-time students, and one or two freelancers who come in on an as-needed basis.

Eatwell does much of the production work himself for the more complicated location shoots. His assistant handles

videotaping of depositions or new client interviews. They both get involved in the editing process.

The firm represents plaintiffs in product liability or severe personal injury cases. Often, the cases require communicating extremely technical details to a jury, and Eatwell explains that video can effectively illustrate such complex ideas as how a piece of oil field equipment works. And video can help the firm avoid having the case go to trial at all.

As Eatwell describes it, in the pretrial stage, they will produce a short documentary with depositions, photographs of evidence, case histories, and other relevant footage, and send that off to the defending attorneys and their client. The "brochures" show what kind of presentation Fisher, Gallagher is going to use in court, and may convince the defense counsel that the opposition has a good chance of winning. After seeing the tape, they may prefer to settle out of court.

Getting one's first video job in private television is especially beneficial, Eatwell feels, "because you have to learn all aspects of production, planning, editing, equipment operations, and maintenance." He does much of the technical work himself and trains his staff to do it as well. And "if you're really good, you're going to be in demand. You can move up very rapidly."

In Eatwell's view, corporate TV is more demanding than broadcasting might be in certain areas. "I've rarely had someone working for me for more than a year before they began to take on their own projects totally—which means planning them, writing a proposed treatment, and presenting it, whether it's to a board of directors or our own people."

Eatwell feels it is important for newcomers to enter corporate TV "with an understanding of television as a medium for communication, persuasion, and instruction, rather than television as entertainment, drama, and art."

Perhaps that's why he emphasizes that there is a need "for people who understand media and instruction systems design. That is someone who understands the scripting process and the graphics design process, things like that, but also understands how to write a learning objective, how to design a training piece. I don't think there are any bachelor degree programs that really cover that."

* * *

As a private television professional, you won't be able to own the corporation—but how about buying the video department? That's what Jane Strausbaugh and her partner did at Hutzler's department store in Baltimore.

As Strausbaugh explains, when the company, which has eight branches, recently moved the Baltimore store to a smaller location, they weren't quite sure where to put the video department Strausbaugh was running. Her boss, the VP of Personnel, asked her if she would be interested in buying the equipment and going on her own. She and her partner purchased some of it, rented the rest with an option to buy, and leased the studio space.

The two formed their own company called Videomakers, Inc. They now produce training tapes and sales promotion and corporation communication video programs for Hutzler's and other outside clients.

Strausbaugh was the one who originally proposed to Hutzler's that they build a studio for company use. The story is fairly typical of how a small video operation might get its start.

Strausbaugh had been working in the Hutzler's training department, which had a ½-inch black-and-white portapak since the early seventies, primarily used for behavioral feedback training. Her own interest was in film and still photography, but she says she became so fascinated with video, she went back to school to get a Masters in communications. While at school in 1977, she proposed to the department store that they build the video studio for training and corporate communications.

She recalls that "it took a number of attempts before the proposal was accepted, so it wasn't quite as simple as writing it up and getting it through." The go-ahead came in 1979. By 1980, the operation was up and running, and all the branch stores then acquired playback equipment.

The studio Hutzler's agreed to build featured ¾-inch VCRs and in-house editing. Strausbaugh had the title of Video Communications Manager and her partner was Associate Producer. They were the only two people in the video operation and did everything themselves.

At first, Strausbaugh relates, they spent most of their time producing training tapes. They soon added merchandising tapes and videotaped fashion information, as well as producing vendor tapes to promote specific merchandise in the stores.

After the first two years of operating the video department, Hutzler's began using it to generate revenue, taking on assignments from outside clients. These customers were not limited to retailing. The producers' audience grew further when the department store leased time on cable to show fashion programs.

Strausbaugh says her experience in the corporate video department was "excellent. I feel like it spoiled me for doing anything else. I like working in a small setup like this where you can control the entire process. It's much more creative; you learn every phase. I think it gives you a lot more confidence [in that you can] walk into pretty much any video situation and feel at home."

Although there are still many filmmakers who are wary of video, this was one film person who made the switch to video happily. Says Strausbaugh: "I found out that there weren't a lot of opportunities in film. Video was much more practical. It's a lot less expensive to use, easier to distribute, and more commercial."

* * *

This is a book about breaking into video, not breaking out of it. But we're aware that some people will start to consider a transfer in departments once they've reached the top of their company's video operation. We did say that such a move is difficult. We didn't say that it's impossible.

One person who made the move is Meg Gottemoeller, Chairman of the Board of the ITVA, and currently Vice-President, Trade Information Products, at Chase Manhattan Bank in New York. Her department develops and markets reference publications and database products on world trade for Chase customers. It also provides internal and external communication support to the global Trade Group.

Before making the switch in 1980, Gottemoeller set up and ran Chase's television network, producing programs screened for the company's 30,000 employees in seventy loca-

tions world-wide. She joined Chase after three years in Merrill Lynch's video department as senior producer. Prior to that, she had set up a video operation for a Philadelphia insurance company.

As Chairman of the ITVA, Gottemoeller has obviously kept in close touch with corporate video. At her company, the present video operation is a 1-inch studio with simple editing capabilities. The department produces tapes for marketing, training, and to communicate management information. Right now, adds Gottemoeller, they are beginning to explore videoconferencing and other ways of sending messages to employees.

The department has an engineer and a few producers and managers on staff, but typically hires freelancers to handle production.

"I think that's the correct way to go," asserts Gottemoeller, "to keep it lean and hire whatever you need for production. Unless you're such a big facility that you're producing five days a week, I think it's much more cost-effective to hire what you need when you need it, and hire the best."

Gottemoeller believes there are numerous advantages to working in corporate video. "You're not going to become a millionaire working for a corporation, but you're remarkably free at a remarkably young age, generally, to do some really creative things." And you won't be faced by the economics influencing an area such as broadcasting: "You don't have to find an audience of 20 million people to be a success."

But as Gottemoeller points out, "within a corporation, your head hits the ceiling pretty soon if you're doing video. You can go from corporation to corporation, and bigger and bigger networks or studios, but if you're going to rise in the corporation, eventually you have to broaden your general management background."

Gottemoeller believes her video background was a help in getting her current job. "If you've been developing marketing videotapes, you know how to look at benefits and define goals, issues, and objectives," she says.

"In addition, you're not afraid of technology. One of the problems in a corporation is that traditional executives were not raised with computers and are having a hard time adapting to the new order of things. The people who have a video

background are not afraid of machines, not afraid of technology."

And Gottemoeller finds herself using her knowledge of video in other areas, such as computers and electronic mail.

Looking ahead to future opportunities in private television, Gottemoeller comments, "I think people who are smart are studying the whole next generation of technology. They are getting into interactive disc and learning how to program [that], and are computer-literate, understanding some of the interfaces between video and computers.

"They aren't looking to come into a field where they point a camera and do a simple program; those kinds of things are going to get relegated to the training department pretty soon. The real exciting work is [in understanding] new distribution methods like cable and [video] teleconferencing, and new programming methods like interactive video. That's where the really interesting jobs are going to be."

* * *

To get into videoconferencing—a subject of interest to many private TV users—a corporation often turns to outside suppliers for help. One of the many firms providing videoconferencing services is Atlanta's VideoStar Connections, the largest independent networker of videoconferences in the U.S.

Among its services, the company will book satellite time, arrange satellite facilities from the conference origination point, provide satellite receiving stations at the various meeting locations, and provide the two-way audio and large-screen video displays in the meeting rooms.

VideoStar's President, Ken Leddick, has been watching the field grow, and observes that, in his firm, "we've been experiencing more than 100 percent growth every year for the past three years."

The scope of the field is expanding as well, says Leddick: "We're having more international applications now than we ever had . . . About eighteen months ago, people started using Canadian sites almost as frequently as U.S. sites, and now they seem to be using sites world-wide."

VideoStar actually handles all types of closed-circuit satellite networking for a variety of clients. They may provide closed-circuit feeds for news, sports, or political events. At

the 1984 Democratic and Republican Conventions and the Summer Olympics, VideoStar provided transmission services for Cable News Network, and Canadian and Brazilian television, among others.

Then, of course, there's corporate video. In early 1984, VideoStar's services were called upon for one of the most elaborate corporate videoconferences staged to date when Southwestern Bell, one of the newly divested phone companies, held a videoconference to celebrate its birth.

Through this videoconference, 60,000 employees at fifty-seven "receive sites" in five states enjoyed a gala with celebrity entertainment, plus presentations outlining the company's future. With two-way audio, Southwestern Bell was able to involve all the receive sites in a joking applause contest to choose whether they wanted to hear more speeches or more singing. VideoStar had the job of booking the fifty-seven sites and outfitting all of them with downlink equipment (to receive the signals).

Some companies are using videoconferencing frequently enough to consider establishing their own private network. VideoStar set up this kind of system for Palo Alto-based Hewlett-Packard. Recalls Leddick: "They decided to put in permanent satellite receiving stations at fifty-two of their offices around the country. We did that for them and we maintain the network and provide satellite transponder time for it. They have a studio in Palo Alto with a satellite uplink there that they put in on their own. And they use closed-circuit video to their own offices around the country multiple times per week now."

VideoStar offers some rough numbers on the subject of cost for videoconferencing. A two-hour videoconference with 200 people at each of three locations might cost about $20 to $30 per person. If the conference runs two full days and has ten locations with 500 people at each one, figure it at $5 to $10 per person. The higher the attendance, the more cost-effective it will be. A modest setup can be arranged in just two days.

A Prospectus

With the variety of jobs and new applications for technology, it's easy to see why corporate video is now such an exciting

area. The individual interested in learning more about it should follow the same steps as any company considering establishment of their own department.

There is coverage of corporate video and related areas in video trade magazines, which often include listings of private TV operations. Then there are the reports in consumer business publications.

One of the best ways to become involved is by attending trade association meetings. You can call the ITVA's headquarters in Dallas to find out if there is a chapter in your city and who runs it. Membership (for a fee) is open to everyone. As a member you will receive newsletters, job information, a membership roster, and all types of materials related to the field.

At ITVA meetings, you will learn more about the kinds of things that concern or interest corporate video professionals. Since the meetings are usually held either at a private TV operation or outside video facility, they give you a chance to get a close look at a professional video setup. Once you're there, you can discreetly get the names of organizations in your area with private TV operations.

As we've seen, private television has some special attractions for someone considering a career in video. Many newcomers have the opportunity to do a range of jobs. If you have invested time and money in your education, you may find that private TV managers are more impressed with the Masters degree than their counterparts at video facilities or broadcast TV stations.

There can be a great deal of flexibility and creativity on challenging projects. And in a corporation or organization with its own equipment, you can get more hands-on experience than is possible at a production company, which is unlikely to have in-house hardware.

We can expect private television to become an increasingly significant area of the video industry. And in the corporate world, we will be seeing how video is integrated with all the other advancing technologies which are changing the way we live and work.

This offers a unique challenge for the video manager of the future. The video department manager can influence the extent to which the corporation maximizes its use of the new

technologies. And just because the word video is in "videoconferencing" and isn't in "information retrieval" doesn't mean the video department automatically will or will not become involved in these areas. By being there with the answers and expertise at the right time, the private TV manager can expand the responsibilities of the video department.

Home Video

The most explosive and fastest growing segment of the video industry today is home video. Also known as consumer video, the business is comprised of two major components: hardware, including videocassette recorders, cameras, and videodisc players; and software, programming on videocassettes and videodiscs. Also part of the mix is blank videocassettes, which consumers use to record programming off the air or with their own cameras.

Although the videodisc has not lived up to expectations, the VCR and videocassette have outperformed even the most optimistic projections of the industry itself. And as far as the future goes, there appears to be no end in sight.

Stop and think about these dazzling statistics from the Electronic Industries Association's Consumer Electronics Group, the leading source of information in this field. At the beginning of 1984, the EIA/CEG predicted that VCR sales for the year would hit 5.5 million. The trade group reassessed the estimate when they saw that in just the first four months, more VCRs moved off the shelves than in all of 1982. Projections for 1984 VCR sales were upped to seven million, but the final count was actually closer to 7.5 million.

VCRs were in almost 20 percent of the homes in this country by the end of 1984. That's especially impressive when you consider that the owners of these 16 million machines had probably never heard of home video just a few years

ago. At this rate, VCRs could be in half of America's homes by the end of 1989.

On the software end, the numbers are equally glowing. According to information provided to the EIA from a video research company, The Fairfield Group, over 22 million prerecorded videocassettes reached dealers' shelves in 1984 to be either sold or rented, up from 11 million in 1983. A Fairfield Group study also indicated that total revenues at the retail level for sales and rentals are expected to hit almost $3 billion in 1985. And the study projects that figure could reach $4.1 billion by 1986. That's a lot of cassettes!

Perhaps one of the most startling facts behind the figures is that they address an industry that really didn't exist until recently. Almost half of the 13,000-plus stores specializing in cassette software did not open for business until three years ago. The motion picture studios, the primary suppliers of programming on cassette, are earning hundreds of millions of dollars from this new revenue source. Finally, most of the homes that will have VCRs by the end of 1985 did not own a machine in 1983.

With this kind of stupendous growth and a future that promises more of the same, the demand for home video is both creating new business and having an impact on the established segments of the video industry, including production companies, facilities, and cable. Producers and video houses are being called upon to help keep the pipeline supplied with software. On the other hand, cable is now assessing the competition posed by widespread rentals and sales of prerecorded videocassettes.

On the retail level, aside from creating the video specialty shop, consumer response to home video has moved the equipment into department and appliance stores, audio and camera dealers. Videocassettes are beginning to show up in book and record shops, supermarkets, and the lobbies of local movie theaters.

Home video's phenomenal growth is creating new jobs by the thousands. Some of these positions call for people with backgrounds in programming and marketing. To fill the ranks, the industry is drawing recruits from the motion picture industry, broadcasting, the record business, advertising, publishing, and packaged goods companies. On the retail side,

home video has opened up perhaps the greatest number of entrepreneurial opportunities in the video industry. And most of the people working in the home-video industry hold jobs that, once again, didn't exist five years ago. They are being joined in the business every day by people who may be the first to hold their new positions.

The Home Video Story

Whether you want to plug into the programming, production, marketing, distribution, or retailing end of the business, it's crucial to have an understanding of the brief history of home video.

As you'll recall from our discussion of facilities and broadcasting, the first videotape recorder was introduced in 1956. It cost about $100,000 and you needed a trained engineer to run it. Over the years, the size and price of VTRs was drastically reduced, and in the late 1960's, Japan's Sony introduced a small, lightweight black-and-white recorder using ½-inch videotape on reels. The recorder was packaged in a console with a small TV set and tuner so the consumer could record off the air.

But the machine didn't catch on with the public. Instead, it was adopted by industrial video and audio/visual operations, as well as video independents, who used it with a small camera in the legendary portapak setup.

In 1972, there were two other tries at a home-video system. Sony introduced a ¾-inch tape format, called the U-Matic, that recorded in color. The tape was housed in a plastic case and called a videocassette. The Cartrivision system, which used ½-inch tape in a cartridge, also appeared that year, complete with a range of prerecorded programs. However, Cartrivision went out of business the next year because of the system's high price and its poor image quality.

Although Sony's U-Matic failed to capture the imagination of the public, because of its performance it soon found its way into industrial television applications. And, as we have mentioned in other chapters, ¾-inch VCRs were instrumental in the arrival of electronic newsgathering in broadcasting.

Building upon the technology behind the U-Matic and studying their market research, Sony finally struck on the product that would take video home. In late 1975, the com-

pany introduced its Betamax videocassette recorder. The unit recorded on a ½-inch videocassette, using the Sony-developed Beta recording format. The original model was a console containing a VCR and a TV set, priced at $2,200. Within a year, the VCR was liberated from the console, and for less than $1,200 a consumer could buy a VCR with a built-in tuner/timer (for recording off the air) and one-hour recording capability.

Sony heavily promoted the use of the Betamax to record TV shows at home that you would otherwise miss. The public responded to this application of the new equipment and the word "time-shifting" entered our vocabulary.

Time-shifting includes taping a show when you're away from your TV, as well as the ability to tape one show while watching another (of course you can also tape the show you happen to be watching at the time). Recording off the air is the leading force behind blank videocassette sales, which soared to 92.5 million units in 1984, up from 65 million in 1983, according to the EIA/CEG.

After Sony sold 100,000 Betamaxes during the product's first full year, other VCRs, including JVC's VHS (Video Home System) arrived. All these VCRs were manufactured in Japan. However, these machines used a variety of recording formats; cassettes of one format could not be played on VCRs of any other format. And so the word "incompatibility" took on a whole different meaning.

After about a year, only Beta and VHS were left. VHS, like Beta, uses a ½-inch videocassette, but the overall size of the VHS cassette is slightly larger. On the other hand, the first VHS machines could record for two hours on a single cassette, giving them an advantage over Sony's Betamax.

Watching the action closely on either side of the Pacific were the leading consumer electronics companies in Japan and the United States. Meanwhile, Sony and JVC, each hoping for victory for their respective formats, began searching for allies in the rising format war. Both used a two-pronged attack. First, they licensed their technology to other manufacturers, who then built their own machines. Second, they began manufacturing VCRs for other companies and put that firm's brand name on the machine. (A note: companies that

build VCRs for other firms are called original equipment manufacturers, or OEM's.)

As other Japanese companies were choosing up sides, Sony signed up Zenith as the first U.S. brand to join the battle. Sony began manufacturing Beta machines which carried the Zenith name.

As the story goes, one that could fill its own book, each camp was hoping to enlist RCA, the largest consumer electronics company in the U.S. RCA decided to go with the VHS format when consumer electronics giant Matsushita, JVC's parent company, said they would build a machine that could record for four hours. And the Japanese company did it by adding another recording speed, a slower one that enabled a VHS machine to double the recording time of JVC's first device. Signing up RCA was a big coup for VHS, and the tide started to turn.

With RCA's sales clout on the retail level, VHS started to gain over Beta, a surge aided by the arrival of companies like General Electric and Magnavox in the VHS army.

Although Beta expanded its recording time on a single cassette, first to two hours and later to three, it has never been able to overtake VHS. Today, as things stand after further increases in recording times on both sides, VHS offers a maximum of eight hours on a cassette to Beta's five.

Since the late seventies, a number of Japanese companies have been manufacturing VCRs under licenses from either JVC or Sony. And dozens of American companies have been selling VCRs under their own brand names, which are manufactured for them by OEM's in Japan (however, recently Taiwan and Korea have started exporting VCRs to our shores).

The format war has even had its share of shifting alliances as well as companies fighting on both sides. Zenith began 1984 by announcing it was forsaking Beta in favor of VHS. And you'll find the NEC and Sears names on both Beta and VHS machines.

As far as the battle between Beta and VHS goes, according to *Television Digest* newsletter, a leading source of information on the consumer electronics industry, about 83 percent of the home VCRs sold in 1983 were VHS (although in 1984, Beta sales began to rebound).

Once heralded as the new product that would move video into millions of homes is the videodisc player. Despite the millions of dollars spent on research, manufacturing, and marketing, the videodisc player never caught on. One of the major reasons is that these machines can play back material, but don't record.

The programming for videodisc players is contained on videodiscs, which resemble audio records. Although the players can't record, they can move to any point on a disc faster than a VCR can perform a similar function with a videocassette. This capability is called random access, and is the major attraction of videodisc technology.

The first system introduced was the optical or LaserVision (LV) format, which arrived in the late seventies. It uses a laser to scan the videodisc. The second system, which debuted with great fanfare from RCA in 1981, was the capacitance or CED format. The CED system was cheaper than the LV unit because it used a mechanical stylus resembling the type found in a record player. The manufacturers of both formats made agreements with programmers to make an array of titles available on videodiscs (which cost less to buy than cassettes).

With the price of VCRs declining sharply and the rental approach to videocassettes taking over, consumers saw no reason to buy a videodisc player of either format. Nor did they want a machine that couldn't record. Although optical players are still being sold in the U.S., RCA, which was making the CED machines in this country, decided to pull the plug on their capacitance disc players in April 1984, after investing $500 million (the company promises to manufacture discs for several years to come).

The optical videodisc technology has enjoyed its greatest success in professional applications. Industrial disc players use more sophisticated microprocessors than the consumer LV models. These systems can access any one of the disc's 54,000 frames in a matter of seconds, even faster than the consumer disc players. Random access and the capability for interaction between the viewer and the program have been put to work in training, information retrieval, and point-of-purchase applications.

On the consumer level, there have been a relatively small

number of videodiscs that tap the optical system's interactive feature. There is a limited universe of optical players (still well under a million) and interactive discs are complicated and expensive to produce. However, as more computers move into homes, the possibilities for the LV player may expand. Hooked up to computers, even consumer videodisc players can be used for more sophisticated interactivity in home education and entertainment.

A major reason why VCRs became a mass-market item is the fact that their prices have dropped sharply over the years. The average price of a VCR in 1984 was $470, while in 1980 the price was a whopping $300 more, according to the EIA/CEG.

Japan has been able to reduce prices as they produced more machines, not just for their domestic market and the U.S., but the rest of the world as well. There are over 35 million VCRs outside the U.S., and market penetration is higher in a number of countries than it is in America.

In addition, today's machines are much-improved and you get more for your money. Since the first Beta and VHS machines were introduced, the machines have expanded not only their recording times, but other capabilities as well. Machines can now be programmed to record a number of events off the air over several weeks. Sound has improved enormously with the introduction of stereo, followed by "Hi-Fi" models offering near-digital audio quality. VCRs are now also sleeker, smaller, and more attractive than the early machines.

Although the first models, and most still sold today, are tabletop units, portable VCRs are gaining a share of the market. Portables are getting smaller all the time and include almost all of the features you would find in the tabletops.

And the technical breakthroughs keep coming. Besides recording off the air and playing back prerecorded cassettes, VCRs can also be used to create home-video movies. A wide range of video cameras is available, many producing high-quality pictures in a variety of lighting situations. And they have shrunk in size and weight since the early models; there are even video cameras today that you can hold in the palm of your hand.

Although video cameras and VCRs have continually become lighter and easier to use, many consumers were waiting

for the day when the two pieces would be combined into one. Manufacturers have responded to this demand with a new piece of home video gear called the camcorder.

Sony led the way in 1983 when it debuted its Betamovie, a VCR and camera in one piece, using Beta format cassettes. In mid-1984, JVC and Zenith introduced VideoMovie, a camcorder that records on a mini-VHS cassette. A camcorder using a full-size VHS cassette will debut by late 1985.

Kodak, hoping to expand its business beyond photography, introduced a camcorder in late 1984, which uses a completely new videotape format. The Kodak camcorders record on an 8mm videotape cassette, about the size of an audiocassette.

According to Allan Schlosser of the EIA/CEG, "The opportunities for selling hardware are enormous. We are in the middle of a video boom now." The interest on the retail level in consumer electronics is reflected by the fact that the Consumer Electronics Show, which the EIA/CEG runs twice a year, has become the largest trade show in America. As Schlosser points out, at the June 1984 CES held in Chicago, "We had almost 100,000 people, and half of the people who came were retailers."

For those interested in selling video hardware, the CES is the main event. Although hardware is the show's main focus, those people on the software side should also invest the time and money to attend the gathering. The CES is held in January and June, usually in Las Vegas and Chicago, respectively. It provides a wealth of information on the home-video business, not to mention the opportunity to make contacts in the industry.

The Software Business

As VCR sales began to grow, a new business began to take shape: the software industry. Although initially a large share of the prerecorded cassettes available were adult or X-rated titles, once the movie studios started releasing their movies on cassette, the balance started to change. This was a significant factor in the growth of home video. Today, Hollywood studios including 20th Century-Fox, Paramount, and Disney all have home video software divisions. These programmers compete in the marketplace with a number of independent

software companies such as Vestron Video, Embassy Home Entertainment, and Karl Video.

Another key factor in the home video success story has been the move to release most films to the home-video market closer to the time that they debut in theaters. Many films are now available on videocassette within a few months after theatrical release. The studios have been doing this to cash in on some of the advertising and promotion of a feature when it opens in theaters. And to really maximize the impact of these multimillion dollar advertising campaigns, there are some programmers who are examining simultaneous release of movies in theaters and on videocassette.

However, while this may delight consumers, not everyone is pleased with these developments. Movie theater operators are still debating the effects of cassette release of films shortly after they have played on the silver screen. And, many are convinced that simultaneous release of movies to theaters and home video would destroy the movie theater business as we know it. Further, because movies don't usually play on cable until six months after they are released on cassette, home video is having its effect on pay-TV services.

At the beginning, most of these cassettes were sold to consumers outright, carrying price tags of up to $80 or more. But as more VCRs reached the home, video software retailers were able to make cassettes available for rental for a few dollars a night. Although purchase prices dropped over time, today, the majority of cassettes are rented as opposed to purchased. Most of the business is in movie titles from the major studios, followed by adult films, children's programs, how-to instructional tapes, and music-video releases.

As the VCR universe and the number of titles grew, so did the number of outlets selling and renting videocassettes. And they were expanding beyond the big cities to Main Street, USA. According to the Video Software Dealers Association, the leading trade group for video software retailing, about 30,000 stores across the country are today selling and/or renting videocassettes. There are an estimated 13,000 retailers that specialize in this business.

Videocassettes have moved into record and book stores all over the country, mass-merchandising operations such as Sears and K-Mart, and convenience stores including 7-Eleven.

Even U-Haul, famous for renting trucks and trailers, is now renting videocassettes. Prerecorded software will be showing up in the future in supermarkets and drug stores, if they are not already there in parts of the country. And they will not just be sold or rented over-the-counter either. A retailer can get into the business by purchasing a videocassette vending machine that takes care of the transaction automatically.

In addition to attending the CES, another way to get your feet wet in software is to attend the Video Software Dealers Association Convention, which is held during the late summer. The VSDA is a trade organization that represents the interests of 1,000 regular members who own a total of 5,000 video stores. The VSDA also offers associate membership status to programming companies and manufacturers in home video. According to the group's spokesperson, Bill Silverman, most of the members are video software specialists and about 60 percent of them also sell hardware.

The VSDA membership includes dealers, software programmers, and distributors. The organization works with A.C. Nielsen to produce on-going statistics on a national scale that track everything from sales and rental activity to consumer preferences for certain types of titles.

The Cherry Hill, New Jersey, association also encourages dealers to set up local and regional branches of the VSDA, publishes a monthly newsletter, and operates a toll-free anti-piracy hotline to cut down on illegal activity in the video software market.

* * *

We are asked many specific questions about the opportunities in home video from amazingly diverse groups of people. Production companies and video facilities are clamoring to find out when original production for home video will really take off. People who work in the publishing and record industries and advertising and marketing ask where they can apply their skills. Small businesspeople want to know how to open a video store.

If these are the questions on your mind, you'll be particularly interested in the comments from programming executives and retailers in the pages that follow.

CBS/Fox Video

In 1977, Twentieth Century-Fox became the first major studio to release its movies to the home-video market. In 1982, they formed a home-video joint venture with CBS, an alliance now known as CBS/Fox Video. Today, CBS/Fox is one of the top software programming companies in terms of total market share for its product.

In addition to releasing recent Fox theatrical films, the company also markets Playboy-produced titles, acquisitions from production companies, music videos, documentaries and news shows from CBS, made-for-home-video (original) productions, and movie classics under a separate label called Key Video.

Larry Hilford is President and Chief Executive officer of CBS/Fox Video, and a veteran of broadcasting, cable, and home video. According to Hilford, "on a title-by-title basis, about three-quarters of our releases are movies. On a unit basis, it's well over 90 percent." But, he adds, "We hope that will change and we'll have more original programming."

The company is a world-wide operation, employing 700 people around the globe. Duplication of the CBS/Fox videocassettes sold in the U.S. is handled by the company's duplication operation in Farmington Hills and Livonia, Michigan.

Like most software programming companies, CBS/Fox uses independent distributors to get its cassettes to retailers in the United States. Outside this country, it varies, and in many cases, they have salespeople who go to retailers directly.

As Larry Hilford reflects on the size of his in-house staff in New York, he explains, "There are not very many jobs here," pointing out that, "just because the number of VCR homes may double in a year doesn't mean our staff is going to double."

Because it is a new field, notes Hilford, there is no one thread that runs through the backgrounds of all the people who work at CBS/Fox: "In terms of sales and marketing, our people come from all over the place: hard-goods distribution to music distribution." He says that the people in the industry are relatively young, and "came in at its formative stages."

CBS/Fox has released several original productions in the information and how-to category. Because that market is still small, the company has been for the most part developing the ideas and producing these programs themselves. But, Hilford adds, "We do talk to people on the outside and we have a department that relates to acquisition and production of material," usually in the information category.

Hilford says that people usually come to them with ideas for informational programming or a finished product (and occasionally ideas) in music and entertainment. The finished programs and the ideas are evaluated on a case-by-case basis, and in some situations there could be financing provided for an original production.

His advice for would-be producers of original programming is to have an "awareness that [home video] is different, different from broadcast and cable. The fact that you can start and stop the machine and review makes it much closer to being truly interactive." The people who run into trouble, notes Hilford, "are the ones who assume that home video is identical to the broadcast and cable process. Programs tend not to work when they are produced the old way."

As to what the future will bring, Larry Hilford believes that the production area is going to expand, but slowly. He expects there are going to be increased opportunities in sales and marketing, as well as finance and cassette duplication. CBS/Fox's president notes that home video is a growing field but one that is changing as it grows. Reflects Hilford, "Whatever form it's going to be in five years will no doubt be quite different than it is today."

Vestron Video

The final months of 1983 were exciting ones for Vestron Video, the largest independent software programming company. During the fall, Jon Peisinger, the company's president, had the pleasure of ringing the company's gong (literally) and announcing that Vestron had won the home-video rights to Michael Jackson's high-budget music video "Thriller."

As a company that is not linked to any major studio, Vestron has had to be very creative in the way in which it acquires titles. Consider how they signed the Jackson deal right under the noses of all the majors.

In October 1983, according to Peisinger, Vestron jumped in when they heard that Michael Jackson's "Thriller" video was running over budget. Vestron became part of a deal with cable's Showtime and MTV to provide additional financing. Each participant received some highly desirable rights for their own means of distribution to release "Making Michael Jackson's Thriller." The program included a short film about the production of the "Thriller" video, the "Thriller" piece itself, and several other Jackson videos.

"Making Michael Jackson's Thriller" reached dealers' shelves just two months later. By mid-1984, the cassette was the second best-selling home video title and had grossed over $9 million.

Vestron Video was started in 1981 after Austin Furst, the former president of Time-Life Films, acquired the consumer rights to the Time-Life Library of films, concerts and how-to's. Using these titles as his springboard, Furst went into business as an independent program marketer. And Peisinger, who worked under Furst in Time's home-video operation, joined him. Today, Vestron is one of the top ten home-video programming companies, ranking higher in market share than some studio-backed operations.

Peisinger received his preparation for the home-video business while working in marketing for several record companies. To say that he enjoys his job and the home-video industry is an understatement. Proclaims Peisinger, "I can't wait to get out of bed in the morning because I know that each day is bringing more exciting opportunities."

But even Vestron's president reflects that he is constantly surprised by how fast the industry is growing, noting, "I look at some of the benchmarks in unit sales. A year ago, the biggest films would do 50,000 units. Now, over the last two or three months, we have seen two, three, four films hit the 100,000 unit mark. That's in a one-year period and it's doubled." He observes that if that rate is projected out two or three years, as the marketplace doubles and doubles again, "it's going to be a terrific business."

Peisinger believes that the home-video industry is going to create more possibilities for a diverse range of programming. "This is going to allow [home video] to position itself more as the record or book industry as a medium for original

[material]," he predicts, "rather than being an ancillary distribution outlet for product created for other mediums."

For those who want to work in programming, Vestron's president says there are opportunities for people who have experience evaluating properties and negotiating those acquisitions, as well as for people with production backgrounds. He points out that Vestron's head of development worked in cable but is also a producer and director. Those are skills, according to Peisinger, "that we are using more and more, not only in our own productions, but also for the trailers [we create] for promotion."

On the marketing end, Peisinger says that in original programming especially, home video needs people who can create a campaign from the ground up. That takes skills in merchandising, promotion, and marketing tie-ins.

He points out that marketing people must know about, and be sensitive to, the distribution channels that the industry is using. That means understanding the difference between the needs of video dealers, record stores, mass merchandisers, and booksellers.

Vestron's president sees the talents of people from the record, book, and toy business as being very well suited to home-video software marketing. As in the case of those businesses, he says, home-video marketing must take into account what he calls "the heat of the projects," needs oriented to the "now." Particularly in children's programming and promotion, in which Vestron is active with its Children's Video Library line, there is a demand for people who have dealt in licensing characters.

Commenting on the retail business, Peisinger believes there are great opportunities for aggressive and creative merchandisers. These are people who "have the wherewithal and resources to take advantage of this growing business," he states, and who can "expose and educate their customers as to what home video has to offer."

Video Retailing

There are three types of retail operations that specialize in video software: the independent, the affiliate, and the franchise.

Simply put, a franchise is a store connected with a large

chain, which is owned by an individual but operated in accordance with the chain's policies.

Like a franchise, an affiliate uses the name of a larger chain; however, once set up, affiliate retailers can operate as they see fit. While both types of stores pay an initial fee for use of the chain's name and a start-up inventory, only the franchise operation pays a percentage of their revenues to their namesake.

Independents have to think up the names of their stores, set up the operation on their own, and answer only to themselves. An independent video store is your basic privately owned store. (There are other differences among the three, which we'll soon explain in depth.)

Before cassettes reach these retailers, they pass through the hands of a distributor, also called a wholesaler. Noel Gimbel is president of Sound Video Unlimited, one of the largest video software distributors in the U.S. Starting as a record retailer fifteen years ago, Gimbel moved into record store franchising and subdistribution, and then expanded into video. He was one of the first to move into video software distribution, and his Niles, Illinois-based company now maintains seven offices around the country.

Gimbel describes the role of the distributor as that of "a middleman, a rep of the manufacturers," which in the video business means the software programming companies. When a new cassette title is about to be released, his company canvasses several thousand dealers for pre-orders. Sound Video Unlimited then calls their orders into the programming company, which tells its duplicator the size of the order. After the cassettes are duplicated, they are shipped on a specified day to the distributor, where the order is broken down and shipped to those dealers who have requested cassettes.

Sound Video also has a division that helps people establish video retail operations. Gimbel estimates that it costs about $50,000 for an independent to start a video store: $35,000 for inventory and $15,000 for setup expenses.

He advises people who want to open a store to find one main distributor and use another as a secondary source. As he explains, "Most independents are not big enough to command any respect if they split their business by two or three

distributors. If you put your eggs in one basket, you become more important to that supplier."

In Gimbel's view, the people now going into the video retailing business are different than those in the past. The original dealers were either movie buffs, or people who found out it was a profitable business from their friends. Then there were those who, according to Gimbel, "were in love with their VCR," saw the people lining up for movies in video stores, and decided to go into the business too.

Today, things are different. "What you are seeing now are the independent entrepreneurs, the small businesspeople," he remarks. Gimbel agrees that in the near future, "you are going to see the mass merchandisers getting into it."

To Noel Gimbel, the independent route is clearly the way to go. He claims that most of the franchise and affiliate companies, which provide an inventory as part of their fee, "put in what they have in stock. They don't have as good a pulse of the marketplace to give you the hot product right away."

According to Gimbel, when you deal with your own distributor in setting up a video store, "he is not interested in what he has in stock." Instead, "he is interested in helping someone get into business. If I give someone 100 tapes and only eighty are rentable, then I really haven't helped them that much."

Another problem Gimbel sees with franchising is that, in his opinion, in most cases, "they don't give you a lot for your money. With McDonald's, they give you a nice site location, they have the name, and they have a formula," not just for the food, but for making money.

He goes on to explain that video store retailing is an inventory control business, not a specific brand business, such as fast-food operations. So even though video franchises provide advertising support, it can't have the same impact, according to Gimbel, as that of an outfit such as McDonald's.

But Gimbel concedes that a franchise may be right for some people. It can make the new retailer feel more confident and may be able to get the store owner better deals. And, even with its limitations, there is that national advertising. On the other hand, Gimbel remarks that with an affiliate,

you can get the name and the setup without having to pay the ongoing fee required by franchisors.

Sound Video's president sees the video retailing business growing dramatically in the next four or five years. In his view, individual dealers will grow and thrive, despite competition, if they have a good location and put in the effort and money. But, Gimbel cautions, an initial inventory costing $35,000 will have to grow to about $100,000 or perhaps $150,000 worth of cassettes. The reason he gives is that video is going to become more like books, with a vast array of titles for rental and sale. The outlets will resemble a library or bookstore more than today's video store setup.

Those entering the business must treat it like one, says Gimbel: you can't just put the money into it and have your family run it unless they are good businesspeople. Retailers must have an eye for merchandising, states Gimbel, claiming that "the old tacky stores just don't do anymore. The entertainment business is a little pizzazz and a little show business. They have to be creative."

The Independent Store

One person who Gimbel believes has been creative with his store is Dave Miller, owner and founder of Video Hotline, an independent store in the Chicago suburb of Winnetka, Illinois. The shop, which is managed by Miller's brother, is mainly devoted to renting videocassettes. It also sells cassettes and some records. Because he handles both records and videotapes, Miller has been quick to create merchandising tie-ins with titles such as "Thriller" and "Flashdance."

Dave Miller started his store in a 300-square-foot space, the size of a little candy store. Within one month, he claims his operation was in the black.

The story of Miller's move into video retailing is a small-screen drama unto itself. Miller says that he had about thirty jobs over the years, always working for someone else, and he wanted his own business. While employed by the Cook County Probation Department, he first learned about the video store business from a probationer, who opened up five video stores in the course of a year.

At the time, Dave Miller was renting videocassettes as a

customer at a local store, where he saw that business was thriving but the customers were treated badly. "So I thought they should be easy to beat," he recalls, and he decided to open his own independent operation.

He started by talking to distributors, looking for store space and fixtures, and deciding what accessories he would carry. Miller went to the Consumer Electronics Show and talked to people, read trade magazines, and "did a lot of brainstorming late into the night," he remembers. The video store owner-in-the-making also visited many dealers, where he observed and sometimes found people who were willing to share what they knew.

Dave Miller had already ruled out the possibility of becoming part of a franchise operation. He admits that the franchise route may be an option for someone who has second thoughts about going it alone. He also mentions that a franchise chain, because they are buying for many stores, can get the retailer a discount. But Miller felt that he wouldn't be getting enough for his money, and he describes himself as the kind of person who would rather figure things out for himself.

When Miller set up his store in 1980, it cost only $35,000. However, he adds, because he is handy, he was able to do a lot of the work himself. Miller stresses that today, "it could take $50,000, $60,000, or even $80,000 to start and be competitive, especially in an area where there are established video stores."

While Video Hotline sells hardware such as VCRs, it doesn't keep them in stock. Instead, the store takes individual orders from customers. According to Miller, although "it's basically the norm for the independent to sell hardware, it's a risky business because of the strong competition," and the fact that new models are coming out all the time. Further, he explains, independents have less money for advertising than the video store chains and other outlets like department stores. But he does stock blank video and audiocassettes, video games, computer diskettes, telephones, and video accessories.

Miller puts most of his money into his video software inventory, which does not include any videodiscs. With the death of CED and the small number of LaserVision players

in consumers' homes, "it's such a tiny percentage of business," says Miller, "so it's not worth handling."

Business has thrived for Video Hotline, and in February 1984, Miller moved a few doors down, where he now has 1,500 square feet. One of the key factors in Video Hotline's success has always been its location. Dave Miller's store is located next to a McDonald's. The two businesses complement each other, he says: "We draw a tremendous amount of traffic and so do they."

Another reason for his success, he believes, has been the attitude of the people working in his store. Recalling the rude service at the store from which he once rented cassettes, Miller demands that his staff treat customers politely, stating, "We make sure that every transaction has a 'thank you.' I am adamant about that."

A third important factor in making it in retailing for Miller has been maintaining a good stock of titles. "We have up to thirty copies of any one title, especially the hot titles. People want to know that you have more than one copy of the titles," Miller explains. But stocking such a large number of copies, he notes, makes his operation a bigger investment now.

Video Hotline is open seven days a week, twelve hours a day. Ten to fifteen people work in the store at any given time, including several members of Miller's family. To Dave Miller, owning a video store is an enormous challenge because of the fast pace of the business and changes that occur on a daily basis.

The competition is very stiff where he is located, with six other video stores in a 2-mile area. Although Video Hotline is number one, according to Miller, he says it's hard to stay on top. For people starting out, his advice is to find an untapped territory. Notes Miller: "There are still areas throughout the country that don't have any video stores . . . The funny thing is that everyone seems to congregate in one area."

The Affiliate

Video Station is the largest affiliate network in the video-store business. Based in Los Angeles, Video Station, Inc. is a publicly traded corporation that sells affiliate packages to would-be video-store entrepreneurs. This affiliate package includes

use of the corporate name, logo, and trademark, some train ing, a startup inventory, and a protected territory. For all this, Video Station charges a one-time fee for the use of the name for five years.

Video Station has 550 affiliates in the U.S. and Canada, and they are in all fifty states as well as Puerto Rico, Guam, and even Samoa. The first one opened in 1979. Video Station, Inc. also includes a distribution company called Coast Video. Coast provides the startup inventory for affiliates, which are not obligated to buy from it once they are off and running. The distribution company also sells to independent stores across the country.

Video Station's president is Gil Padilla, whose own back-ground is in credit and financial management. He heads a staff of forty people at corporate headquarters. New affiliates are sometimes brought to headquarters for training, or they can be trained in their own store or other stores.

According to Padilla, the price for one of his company's affiliates varies, depending upon what the particular owner wants in his or her store. But he says the average store cost is about $42,000 to $49,000.

Video Station also provides assistance in location selec-tion, advice on the choice of titles for the initial inventory, information on the type of business forms and inventory con-trol that should be used, as well as on-going reports on soft-ware releases. Padilla explains, "We have an open dialogue to answer any questions they may have," but "it is not a formal arrangement."

Unlike franchise operations, affiliates don't "dictate that [store owners] do certain things. We have an arm's length relationship with the stores," asserts Video Station's president. "But," he adds, "they must treat the logo, trademark, and name with a certain standard."

Commenting on the software end of the business, Padilla observes that movies are number one by a large margin in the retail stores. However, he sees that changing, pointing out that the industry is only about five years old. "The format is open to anything and everyone," he notes. He believes that consumers are interested in using video, and they are "open to anything that has always been a pleasure to them." To

Padilla, that would include how-to programs and conversions of books to video.

Padilla says that Video Station is in the process of reevaluating the concept of the affiliate network. One of the main reasons, he explains, "has been the dramatic demand for national advertising." This, he notes can't be provided by the affiliate chain because there is no way to offset the cost. Therefore, Video Station is looking closely at the franchising approach, which Padilla points out also has problems with national advertising, "because what's doable in Wyoming may not be doable in Texas."

Looking to the future, Padilla sees a need to create a national network with regular support services in advertising and merchandising, and standardization of the quality of the store identity and store management. "That's what made McDonald's," he states. "A hamburger is a hamburger, but there is only one way that McDonald's will let you make it."

The Franchise

Then there are the franchises. National Video is the largest video-store franchising company in the U.S. Based in Portland, Oregon, the company was started in 1981. The cost of a National Video franchise is typically $85,000, according to the company's founder, Ron Berger.

For that initial investment, what the new video-store owner receives includes the following: the right to use the National Video name and logo; assistance in site selection supported by market studies in a protected territory; fixtures, product displays, and promotional materials (which are provided on an on-going basis); an inventory of software for startup; training at the company's training center near Chicago, followed by field support by a National Video coordinator, who helps in the store opening; national advertising support; and the on-going expertise of the National organization.

In addition to the initial franchising fee, National store owners are required to pay a monthly royalty, which is basically 4.9 percent of gross sales of nonhardware items. The franchisee must also contribute an advertising fee of 3 percent of his or her gross sales, which goes toward newspaper, radio,

and TV advertising, newsletter production (a monthly publication focusing on National's activities and the video industry), and decor kits for dressing up the store. Finally, the store owners agree to spend a certain percentage on local advertising.

According to Ron Berger, most of the people buying National Video franchises already own a number of other franchises, such as McDonald's. That's been a change, notes Berger, who says initially most of National Video's franchisees were mom-and-pop operators, people who had been working for other people, and "wanted to control their own destiny." Although National still gets that kind of franchisee today, Berger explains, "There seems to be an investor out there who is a believer in franchising, and goes out there and develops a management group that then manages a number of franchises for them."

Ron Berger is a veteran of retailing and franchising, and he and his wife currently own three National stores. After working in a photo store and later for a major photo franchise operation, Berger opened his own retail camera store in New York. He decided to give up the Northeast for the Northwest, and started a camera shop in Portland. In 1974, he launched Photo Factory, which grew over the next five years to become the country's largest franchised camera chain (although it later went out of business).

Then Berger discovered video. After checking out some stores in Portland and Los Angeles, he did market research to find out more about the video-retailing business and also to identify the keys to its success. The results led Ron Berger to pursue the video franchising concept in earnest.

Like many interested in the home-video business, Berger made the trip to the Consumer Electronics Show in January, 1981. In a hotel suite he had booked there, he sold his first three National Video franchises for $10 apiece. By the second half of 1984, National Video had sold 705 franchises, of which 100 are in Canada, one is in the Virgin Islands, and another in Japan.

Some sixty people are part of the corporate operation at National today. The management team includes Berger as chairman; a president who spent twenty-five years in fran-

chising, concentrating on the food industry; a national merchandising manager with twenty-five years at Montgomery Ward, where he headed up the national marketing and merchandising for home electronics; and a training manager based in National Video's training center in Schaumburg, Illinois, who handled training for B. Dalton books.

Berger discusses the main advantages of breaking into the video-retailing business as part of a franchise chain. As he notes, in this arrangement, your chances of failure are reduced. According to Berger, the failure rate for independents is far higher than that of franchisees.

The reasons why the success rate is better with a franchise, says Berger, is that companies like National have a national identity, "so there's customer acceptance of your product or service." In addition, franchise store owners can buy everything from video software to computers to plastic sacks at a savings. An operation such as National sets up volume buying arrangements with many suppliers (and at National, dealers order software through a distributor such as Commtron or East Texas Periodicals, and get the benefit of National's discount).

Berger also mentions the national advertising campaign as a major benefit, which pools the resources of hundreds of stores "to develop more of a national identity and create clout." Finally, of course, there is the expertise of the franchisor.

"So you go into a franchise to avoid being a jack-of-all-trades," is the way Ron Berger sums it up. He points out that if a retailer tries to do everything by him or herself, "you're not an expert at anything. And there's no way an independent is ever going to buy as well, theoretically, than the franchisor's purchasing agent. There's no way you're going to advertise as well as the franchisor's advertising staff, market as well as his marketing staff."

Ron Berger concludes with the following observation: "McDonald's is successful because there is a consistent level of quality and service. Whether you like it or not, the fact is when you pull up [to a McDonald's], this is what you are going to get, this is how clean it's going to be, and this is the approximate price. That is what franchising is all about."

Coming Attractions

What comes next in home-video programming and retailing will no doubt be profoundly affected by how many more VCRs reach consumers' homes in the next few years. When VCRs will be in half of America's homes is still a guess because no one can predict with accuracy the exact rate of sales. The numbers may wind up exceeding everyone's wildest expectations.

The enormous sales of VCRs reflect the fact that the machine is no longer just for the affluent. Current prices are low and still dropping. One other event that could bring more VCRs home is the arrival of even cheaper models, now that Korea and Taiwan are exporting them to the U.S. With those two countries in the marketing mix, the time of the $250 machine could soon be here.

Here are some other things to look for in the near future: With more VCR homes, programmers will be able to offer additional kinds of video software that is tailored to special audiences. And this will bring more print media organizations into home video. Book publisher Simon & Schuster, for example, plans to get into the business by transforming some of its book titles into videocassette releases. As a result of moves like this, consumers, who can already act as their own TV programmers with the thousands of titles available, will have even more choices.

Since many people are spending an increasing amount of their time watching their VCRs, the companies that advertise on TV to sell their products are taking note of the trend. They know that many consumers are fast-forwarding past the commercials on the programs they record off the air. The public is also spending its TV time watching prerecorded cassettes instead of broadcast TV. All of this is a cause for concern in corporate marketing offices as well as on Madison Avenue. So don't be surprised to see advertiser-supported videocassettes appearing in the future.

The demand for more programming to meet the needs of the home-video marketplace will mean more work for producers, directors, and video facilities.

More titles to stock will present even greater challenges for retailers. Therefore, it's easy to see why the video store

of the future will probably look more like a record shop or a library. Also, video stores will require more capital to get off the ground and stay competitive.

Meanwhile, in Hollywood, the movie studios are being fueled by the additional revenues they are receiving from home video and cable. And they are considering strategies that would increase their slice of the video pie.

The studios say there could be even more production if they could promote sales over rentals and/or get a piece of the cassette rental action. They won't be able to do that unless the First Sale Doctrine in federal copyright law is repealed. The doctrine prohibits the studios from getting additional royalties once a cassette is sold to a dealer. Repeal appears unlikely because it would probably drive up rental prices, something that consumers, and therefore politicians, will not like.

Therefore, studios may decide to push harder to sell cassettes, by lowering prices and developing new marketing approaches. Paramount has already led the way with $39.95 price tags for some of its blockbusters (and, subsequently, even lower prices). Actually beyond the studios' control, but factors that could also bring down the price of movies on cassette, is cheaper blank tape and faster duplication processes.

Finally, and most importantly, there is the consumer acceptance of this new technology. The public has always been willing to buy machines, priced within their means, that provide greater flexibility. The mass acceptance of the automobile is based on the freedom the car provides. Home video, in its own way, is fulfilling a similar need. With cars, you can go where you want, when you want. With home video, you can watch what you want, when you want. It's not surprising that many people are as attached to their VCRs as they are to their automobiles.

It is consumers who will decide the course of the home-video industry. And from all indications, America is having a love affair with the VCR.

Appendix

Hardware Manufacturers

The following companies sell professional video equipment in the United States. Many of these companies either offer training courses or can refer you to other companies or organizations that can give you hands-on instruction on their equipment.

Although space does not permit the listing of all companies in the hardware field, provided below are firms in some major equipment categories including cameras (C), editing systems (E), and graphics/character generator/animation systems (G).

Ampex (CEG)
401 Broadway
Redwood City, California
94063
(415) 367-4161

Aurora Systems (G)
185 Berry Street
San Francisco, California
94107
(415) 777-2288

Robert Bosch Company (CEG)
PO Box 31816
Salt Lake City, Utah 84131
(801) 972-8000

CMX/Corporation (E)
3303 Scott Boulevard
Santa Clara, California
95050
(408) 988-2000

Chyron (G)
265 Spagnoli Road
Melville, New York 11747
(516) 249-3018

Computer Graphics Lab (G)
405 Lexington Avenue
New York, New York
10174
(212) 557-5130

Convergence Corporation (E)
1641 McGaw
Irvine, California 92714
(714) 250-1641

Digital Graphic Systems (G)
2629 Terminal Boulevard
Mountain View, California
94043
(415) 962-0200

Dubner Computer Systems (G)
158 Linwood Plaza
Fort Lee, New Jersey
07024
(201) 592-6500

EECO (E)
1601 East Chestnut Avenue
Santa Ana, California
92701
(714) 835-6000

Grass Valley Group (E)
PO Box 1114
Grass Valley, California
95945
(916) 273-8421

Harris Broadcast (C)
PO Box 4290
Quincy, Illinois 62305
(217) 222-8200

Hitachi Denshi America (C)
175 Crossways Park West
Woodbury, New York
11797
(516) 921-7200

Ikegami Electronics (C)
37 Brook Avenue
Maywood, New Jersey
07607
(201) 368-9171

JVC Company of America (CE)
47 Slater Drive
Elmwood Park, New
Jersey 07407
(201) 794-3900

Lyon Lamb Video Animation
(G)
4531 Empire Avenue
Burbank, California 91505
(818) 843-4831

MCI/Quantel (G)
3290 West Bayshore Road
Palo Alto, California 94303
(415) 856-6226

Montage Computer
Corporation (E)
52 Domino Drive
West Concord,
Massachusetts 01742
(617) 371-0485

NEC Broadcast (C)
130 Martin Lane
Elk Grove Village, Illinois
60007
(312) 640-3792

Paltex/Datatron (E)
2752 Walnut Avenue
Tustin, California 92680
(714) 836-8833

Panasonic (CE)
1 Panasonic Way
Secaucus, New Jersey
07094
(201) 348-7000

Panavision (C)
18618 Oxnard Street
Tarzana, California 91356
(818) 881-1702

Philips Television Systems (C)
900 Corporate Drive
Mahwah, New Jersey
07430
(201) 529-1550

Quanta Corporation (G)
2440 South Progress Drive
Salt Lake City, Utah 84119
(801) 974-0992

RCA Broadcast Systems (CE)
PO Box 900
Gibbsboro, New Jersey
08026
(609) 435-2924

Sharp Electronics (C)
10 Sharp Plaza
Paramus, New Jersey
07652
(201) 265-5548

Sony Broadcast (CE)
1600 Queen Anne Road
Teaneck, New Jersey 07666
(201) 833-5200

Sony Video Communications
(CE)
1 Sony Drive
Park Ridge, New Jersey
07656
(201) 930-1000

Texscan MSI/Compuvid (G)
3855 South 500 West
Salt Lake City, Utah 84115
(801) 262-8475

3M Broadcast (G)
3M Center, Building 225–
3N
St. Paul, Minnesota 55144
(612) 733-9073

Thomson-CSF (CG)
37 Brownhouse Road
Stamford, Connecticut
06902
(203) 965-7000

Time Arts (G)
3436 Mendocino Avenue
Santa Rosa, California
95401
(707) 576-7722

United Media (E)
4075 Leaverton Court
Anaheim, California 92807
(714) 630-8020

Via Video (G)
5155 Old Ironsides Road
Santa Clara, California
95050
(408) 980-8009

Videomedia (E)
211 Weddell Drive
Sunnyvale, California
94086
(408) 745-1700

Television Markets: Ten Largest and Ten Smallest

(Source: *Broadcasting/Cablecasting Yearbook*, 1984. Based on Arbitron Television's 209 ADI [area of dominant influence] markets for 1983–1984)

Ten Largest Television Markets
1. New York
2. Los Angeles
3. Chicago
4. Philadelphia
5. San Francisco

6. Boston
7. Detroit
8. Washington, D.C.
9. Dallas–Ft. Worth
10. Houston

Ten Smallest Television Markets
200. Presque Isle, Maine
201. Twin Falls, Idaho
202. Victoria, Texas
203. Bend, Oregon
204. Ottumwa, Iowa–Kirksville, Missouri
205. Helena, Montana
206. Selma, Alabama
207. North Platte, Nebraska
208. Alpena, Michigan
209. Glendive, Montana

Cable Multiple System Operators (MSOs): Top Ten
(Source: National Cable Television Association, September 1984)

1. Tele-Communications Inc. (TCI)
 Box 22595 Wellshire Station
 Denver, Colorado 80222
 (303) 771-8200

2. American Television and Communications (ATC)
 160 Inverness Drive West
 Englewood, Colorado 80112
 (303) 799-1200

3. Group W Cable
 888 Seventh Avenue
 New York, New York 10106
 (212) 247-8700

4. Cox Cable Communications
 1400 Lake Heam Drive
 Atlanta, Georgia 30319
 (404) 843-5000

5. Storer Cable Communications
 Box 61–8000
 Miami, Florida 33161
 (305) 899-1000

6. Warner Amex Cable Communications
 75 Rockefeller Plaza
 New York, New York 10019
 (212) 484-8000

7. Times Mirror Cable Television
 Box 19398
 Irvine, California 92713
 (714) 549-2173

8. Continental Cablevision
 Pilot House, Lewis Wharf
 Boston, Massachusetts 02110
 (617) 742-9500

9. Newhouse
Box 4871
Syracuse, New York 13221
(315) 455-5826

10. Viacom Cablevision
Box 13
Pleasanton, California
94566
(415) 828-8510

Cable Networks

Here is a list of some of the leading cable networks. Whether the service is basic (B) or pay (P), often determines the range of jobs available at the cable network, as explained in the cable chapter.

Arts & Entertainment Network
(B)
555 Fifth Avenue
New York, New York
10017
(212) 661-4500

Black Entertainment Network
(BET) (B)
1050 31st Street, NW
Washington, D.C. 20007
(202) 337-5260

Christian Broadcast Network
(CBN) (B)
1000 Centerville Turnpike
Virginia Beach, Virginia
23463
(804) 424-7777

Cable News Network (CNN),
CNN Headline News,
WTBS (B)
1050 Techwood Drive, NW
Atlanta, Georgia 30318
(404) 827-1500

C-SPAN (Cable Satellite Public
Affairs Network) (B)
400 North Capitol Street,
NW
Washington, D.C., 20001
(202) 737-3220

The Disney Channel (P)
4111 West Alameda
Burbank, California 91505
(818) 840-7803

ESPN (Entertainment & Sports
Programming Network)
(B)
ESPN Plaza
Bristol, Connecticut 06010
(203) 584-8477

Financial News Network (B)
2525 Ocean Park
Boulevard
Santa Monica, California
90405
(213) 450-2412

GalaVision (P)
460 West 42nd Street
New York, New York
10036
(212) 502-1300

Home Box Office (HBO) and
Cinemax (P)
1100 Avenue of the
Americas
New York, New York
10036
(212) 512-1158

The Learning Channel (B)
1200 New Hampshire
Avenue, NW
Washington, D.C. 20036
(202) 331-8100

Lifetime (B)
1211 Avenue of the
Americas
New York, New York
10036
(212) 719-8950

Modern Satellite Network
(MSN) (B)
5000 Park Street, North
St. Petersburg, Florida
33709
(813) 541-7571

MTV (Music Television) and
VH-1 (Video Hits 1) (B)
1133 Avenue of the
Americas
New York, New York
10036
(212) 944-5397

The Nashville Network (B)
2806 Opryland Drive
Nashville, Tennessee 37214
(615) 361-0366

Nickelodeon (B)
1133 Avenue of the
Americas
New York, New York
10036
(212) 944-5521

The Playboy Channel (P)
100 Crossways Park West
Woodbury, New York
11797
(516) 364-2222

Spanish International Network
(SIN) (B)
460 West 42nd Street
New York, New York
10036
(212) 502-1300

Showtime/The Movie Channel
(P)
1633 Broadway
New York, New York
10019
(212) 708-1600

Trinity Broadcasting Network
(TBN) (B)
PO Box A
Santa Ana, California
92711
(714) 832-2950

USA Cable Network (B)
208 Harristown Road
Glen Rock, New Jersey
07452
(201) 445-8550

The Weather Channel (B)
2840 Mt. Wilkerson
Parkway
Marietta, Georgia 30339
(404) 434-6800

International Television Association (ITVA) Chapters

A good way to break into corporate video is by attending a meeting of a local chapter of ITVA, the leading professional organization of private TV. Listed below are the locations of the chapters in the United States and Canada.

Because the chapter presidents often change, we suggest

you first contact the ITVA's national headquarters to find out the name and phone number of the current chapter contact in your area. That person can tell you the date and location of the next local meeting:
International Television Association
Three Dallas Communications Complex
6311 North O'Connor Road
Irving, Texas 75039
(214) 869-1112

In addition, check with the ITVA if you don't see your area listed. Because the ITVA is a growing organization, new chapters are established throughout the year.

Local Chapters (by state)
ALASKA: Anchorage
ARIZONA: Phoenix
ARKANSAS: Little Rock
CALIFORNIA: Los Angeles, Sacramento, San Diego, San Francisco, Santa Barbara
COLORADO: Denver
CONNECTICUT: Connecticut
FLORIDA: Miami, Orlando, Tampa Bay
GEORGIA: Atlanta
HAWAII: Honolulu
ILLINOIS: Central Illinois, Chicago, Rockford, Southern Illinois University (Carbondale)
INDIANA: Ball State University (Muncie), Indianapolis
IOWA: Des Moines, Eastern Iowa
KANSAS: Wichita
LOUISIANA: Baton Rouge
MARYLAND: Baltimore
MASSACHUSETTS: Boston
MINNESOTA: Twin Cities
MICHIGAN: Detroit, Mid-Michigan, Saginaw Valley
MISSOURI: Kansas City, Mid-Missouri, Springfield, St. Louis
NEBRASKA: Lincoln, Omaha
NEW JERSEY: New Jersey
NEW YORK: Central New York, Long Island, New York City
NORTH CAROLINA: Piedmont, Raleigh/Durham/Chapel Hill

OHIO: Cincinnati, Cleveland, Columbus, Dayton
OKLAHOMA: Oklahoma City, Tulsa
OREGON: Portland
PENNSYLVANIA: Kutztown, Lehigh Valley, Philadelphia, Pittsburgh
SOUTH CAROLINA: Palmetto
TENNESSEE: Nashville
TEXAS: Austin, Dallas/Ft. Worth, Houston, San Antonio, Texas Tech
VIRGINIA: Richmond, Tidewater
WASHINGTON, D.C.: Washington, D.C.
WASHINGTON: Seattle
WISCONSIN: Milwaukee
CANADA: Edmonton, Montreal, Toronto

Home-Video Software Companies

This is a list of some of the companies that make videocassettes available for the home-video market. These companies, also known as home-video programmers, sell their cassettes to retailers through distributors.

CBS/Fox Video
1211 Avenue of the Americas
New York, New York 10036
(212) 819-3365

Embassy Home Entertainment
1901 Avenue of the Stars
Los Angeles, California 90067
(213) 556-7416

Family Home Entertainment
7920 Alabama Avenue
Canoga Park, California 91304
(818) 888-3040

Karl Video
899 West 16th Street
Newport Beach, California 92663
(213) 659-4653

MCA Home Video
70 Universal Plaza
Universal City, California 91608
(213) 508-4308

MGM/UA Home Video
1350 Avenue of the Americas
New York, New York 10019
(212) 408-0662

Media Home Entertainment
116 North Robertson Boulevard
Los Angeles, California 90048
(213) 855-1611

Pacific Arts Video
PO Box 22770
Carmel, California 93922
(408) 624-4704

Paramount Home Video
5555 Melrose Avenue
Hollywood, California
90038
(213) 468-5583

RCA/Columbia Pictures Home
Video
2901 West Alameda
Avenue
Burbank, California 91505
(818) 954-4950

Thorn EMI/HBO Home Video
1370 Avenue of the
Americas
New York, New York
10019
(212) 977-8990

Vestron Video
1011 High Ridge
Stamford, Connecticut
06907
(203) 968-0000

Walt Disney Home Video
500 South Buena Vista
Burbank, California 91521
(818) 840-5167

Warner Home Video
4000 Warner Boulevard
Burbank, California 91522
(818) 954-6486

Video Store Franchises and Affiliations: Top Ten
(Source: *Video Store*, August 1984)

Franchises
1. National Video Inc. Portland, Oregon
2. Adventureland Video Salt Lake City, Utah
3. The Video Connection Malibu, California
4. Video Biz Inc. Los Angeles, California
5. Sounds Easy International Orem, Utah
6. Video Exchange Lakewood, Colorado
7. Neighborhood Video Centers Anchorage, Alaska
8. Video Paradise Inc. Westboro, Massachusetts
9. Video Update Maplewood, Minnesota
10. Video America West Bountiful, Utah

Affiliations
1. The Video Station Santa Monica, California
2. Network Video Sarasota, Florida
3. Video Depot West Covina, California
4. Video Biz Inc. Los Angles, California
5. Discount Video Sandpoint, Idaho
6. Video Studio Stores East Windsor, Connecticut

7. Mr. Video Indianapolis, Indiana
 (tied for 7th position)
—. Video Cross Roads Yorba Linda, California
9. Home Video of the Bay Area San Francisco, California
10. Halldorson Discount Video Chico, California

Magazines

Here is a list of the magazines covering various areas in the video industry. They can be valuable sources of information for the latest industry news, interesting applications of video, listings of companies in their particular fields, and the names and dates of upcoming conventions.
(Note: Magazines for the consumer are noted with an asterisk [*]. All others are oriented to the trade or for the professional.)

ADVERTISING AGE
740 Rush Street
Chicago IL 60611
(312) 649-5200

AD WEEK
820 Second Avenue
New York NY 10017
(212) 661-8080

AMERICAN
CINEMATOGRAPHER
1782 North Orange Drive
Hollywood CA 90028
(213) 876-5080

BACKSTAGE
330 West 42nd Street
New York NY 10036
(212) 947-0020

BILLBOARD
1515 Broadway
New York NY 10036
(212) 764-7300

BROADCAST ENGINEERING
PO Box 12901
Overland Park KS 66212
(913) 888-4664

BROADCASTING (Also THE
BROADCASTING/
CABLECASTING
YEARBOOK)
1735 DeSales Street NW
Washington DC 20036
(202) 838-1022

BROADCAST
MANAGEMENT/
ENGINEERING (BM/E)
295 Madison Avenue
New York NY 10017
(212) 685-5320

CABLEVISION
600 Grant Street
Denver CO 80217
(303) 860-0111

CHANNELS OF
COMMUNICATIONS
1515 Broadway
New York NY 10036
(212) 398-1300

COMMUNICATIONS DAILY
1836 Jefferson Place NW
Washington DC 20036
(202) 872-9200

DAILY VARIETY
1400 North Cahuenga
Boulevard
Hollywood CA 90028
(213) 469-1141

EDUCATIONAL-INDUSTRIAL
TELEVISION (EITV)
51 Sugar Hollow Road
Danbury CT 06810
(203) 743-2120

HOLLYWOOD REPORTER
6715 Sunset Boulevard
Hollywood CA 90028
(213) 464-7411

INTERNATIONAL
TELEVISION
One Park Avenue
New York NY 10016
(212) 725-5742

LPTV
4121 West 83rd Street
Prairie Village KS 66208
(913) 642-6611

MILLIMETER
826 Broadway
New York NY 10003
(212) 477-4700

MULTICHANNEL NEWS
300 South Jackson Street
Denver CO 80209
(303) 393-6397

ON LOCATION
6777 Hollywood
Boulevard
Hollywood CA 90028
(213) 467-1268

PAY-TV NEWSLETTER
Paul Kagan Associates
26386 Carmel Rancho
Lane
Carmel CA 93923
(408) 624-1536

PUBLIC BROADCASTING
REPORT
1836 Jefferson Place NW
Washington DC 20036
(202) 872-9200

SATELLITE
COMMUNICATIONS
6530 South Yosemite
Street
Englewood CO 80111
(303) 694-1522

SATELLITE WEEK
1836 Jefferson Place NW
Washington DC 20036
(202) 872-9200

SMPTE JOURNAL
862 Scarsdale Avenue
Scarsdale NY 10583
(914) 472–6606

TELEVISION/BROADCAST
COMMUNICATIONS
4121 West 83rd Street
Prairie Village KS 66208
(913) 642–6611

TELEVISION DIGEST
including CONSUMER
ELECTRONICS
(Also TELEVISION
FACTBOOK)
1836 Jefferson Place NW
Washington DC 20036
(202) 872–9200

TELEVISION/RADIO AGE
1270 Avenue of the
Americas
New York NY 10020
(212) 757–8400

VARIETY
154 West 46th Street
New York NY 10036
(212) 869-5700

VIDEO *
460 West 34th Street
New York NY 10001
(212) 947-6500

VIDEO BUSINESS
325 East 75th Street
New York NY 10021
(212) 794-0500

VIDEO MANAGER
701 Westchester Avenue
White Plains NY 10604
(914) 328-9157

VIDEO MARKETING
NEWSLETTER
1680 Vine Street
Hollywood CA 90028
(213) 462-6350

VIDEO NEWS
7315 Wisconsin Avenue
Bethesda MD 20814
(301) 986-0666

VIDEO RETAILER
100 Lafayette Drive
Syosset NY 111791
(516) 364-3686

VIDEO REVIEW*
350 East 81st Street
New York NY 10028
(212) 734-4440

VIDEO STORE
1700 East Dyer Road
Santa Ana CA 92705
(714) 549-4834

VIDEO SYSTEMS
Box 12901
Overland Park KS 66212
(913) 888-4664

VIDEO TIMES *
3841 West Oakton Street
Skokie IL 60076
(312) 676-3470

VIDEO WEEK
1836 Jefferson Place
Washington DC 20036
(202) 872-9200

VIDEODISC MONITOR
PO Box 26
Falls Church VA 22046
(703) 241-1799

VIDEODISC & OPTICAL DISK
UPDATE
520 Riverside Avenue
Westport CT 06880
(203) 226-6967

VIDEOGRAPHY
50 West 23rd Street
New York NY 10010
(212) 645-1000

VIDEOPLAY*
51 Sugar Hollow Road
Danbury CT 06810
(203) 743-2120

VIDEOPRO
902 Broadway
New York NY 10010
(212) 477-2200

Associations and Trade Shows

Valuable resources for people breaking into the video industry are the many trade groups and associations. Some of these organizations sponsor trade shows which we encourage you to attend if you have an interest in that area of the field. In addition, these associations often publish newsletters or jour-

nals, that may be available to nonmembers. A number of them have chapters that hold local meetings. In the list that follows, we provide the names of associations in the video world along with information on the conventions or conferences some of them offer. Although most trade shows are sponsored by associations, there are others associated with publishing companies, for example. These shows are listed alphabetically along with the associations.

AMERICAN WOMEN IN RADIO &
TELEVISION (AWRT)
1321 Connecticut Avenue
NW
Washington DC 20036
(202) 296-0009
Annual conference and
publication

AMERICAN SOCIETY FOR
TRAINING & DEVELOPMENT
(ASTD)
600 Maryland Avenue
Washington DC 20024
(202) 484-2390
Annual conference and
publication

ASSOCIATION FOR EDUCATIONAL
COMMUNICATIONS &
TECHNOLOGY (AECT)
1126 16th Street NW
Washington DC 20036
(202) 466-4780
Annual conference and
publication

ASSOCIATION OF INDEPENDENT
TV STATIONS (INTV)
1200 18th Street NW
Washington DC 20036
(202) 887-1970
Annual conference and
publication

ASSOCIATION OF INDEPENDENT
VIDEO & FILMMAKERS
(AIVF)
625 Broadway
New York NY 10012
(212) 473-3400
Publication

AUDIO ENGINEERING SOCIETY
(AES)
60 East 42nd Street
New York NY 10017
(212) 661-8528
Annual conference and
publication

BILLBOARD VIDEO MUSIC
CONFERENCE
Billboard Magazine
1500 Broadway
New York NY 10036
(212) 764-7427

CABLE TELEVISION
ADMINISTRATION &
MARKETING SOCIETY
(CTAM)
219 Perimeter Parkway
Atlanta GA 30346
(404) 399-5574
Annual conference and
publication

CABLE TELEVISION
INFORMATION CENTER
1500 North Beauregard
Street
Alexandria VA 22311
(703) 845-1705
Publications

COMMUNITY BROADCASTERS OF
AMERICA (Low power TV)
1830 Jefferson Place NW
Washington DC 20036
(202) 463-8701
Annual conference and
publication

CORPORATION FOR PUBLIC
BROADCASTING (CPB)
1111 16th Street NW
Washington DC 20036
(202) 293-6160
Annual conference and
publication

ELECTRONIC INDUSTRIES
ASSOCIATION/CONSUMER
ELECTRONICS GROUP (EIA/
CEG)
2001 Eye Street NW
Washington DC 20006
(202) 457-8700
Consumer Electronics
Shows in January and
June and publications

INDEPENDENT MEDIA
PRODUCERS ASSOCIATION
(IMPA)
1100 17th Street NW
Washington DC 20036
(202) 466-2175
Annual conference

INSTITUTE FOR GRAPHIC
COMMUNICATION (IGC)
375 Commonwealth
Avenue
Boston MA 02115
(617) 267-9425
Various conferences

INTERNATIONAL ASSOCIATION
OF BUSINESS
COMMUNICATORS (IABC)
870 Market Street
San Francisco CA 94102
(415) 433-3400
Annual conference and
publication

INTERNATIONAL ASSOCIATION
OF INDEPENDENT
PRODUCERS (IAIP)
National Press Building
Washington DC 20045
(202) 638-5595
Publication

INTERNATIONAL RADIO & TV
SOCIETY (IRTS)
420 Lexington Avenue
New York NY 10170
(212) 867-6650
Publication

INTERNATIONAL TAPE/DISC
ASSOCIATION
10 Columbus Circle
New York NY 10019
(212) 956-7110
Annual conference and
publication

INTERNATIONAL TELEVISION
ASSOCIATION (ITVA)
6311 North O'Connor Road
Irving TX 75039
(214) 869-1112
Annual conference and
publication

MDS Industry Association
1725 N Street NW
Washington DC 20036
(202) 639-4410

National Academy of
Television Arts &
Sciences (NATAS)
110 West 57th Street
New York NY 10019
(212) 586-8424
Publication

National Association of
Broadcasters (NAB)
1771 N Street NW
Washington DC 20036
(202) 429-5300
Annual convention

National Association of
Television Program
Executives (NATPE)
310 Madison Avenue
New York NY 10017
(212) 661-0270
Annual convention and
publication

National Cable Television
Association (NCTA)
1724 Massachusetts
Avenue NW
Washington DC 20036
(202) 775-3550
Annual convention and
publication

National Computer Graphics
Association (NCGA)
2722 Merrilee Drive
Fairfax VA 22031
(703) 698-9600
Annual conference and
publication

National Federation of
Local Cable
Programmers (NFLCP)
906 Pennsylvania Avenue
Washington DC 20003
(202) 544-7272
Annual conference and
publication

National Institute for Low
Power Television
17 Washington Street
Norwalk CT 06854
(203) 852-0500
Conference and
publication

National Audio-Visual
Association (NAVA)
3150 Spring Street
Fairfax VA 22031
(703) 273-7200
Annual COMMTEX
conference and
publication

Radio-Television News
Directors Association
(RTNDA)
1735 DeSales Street NW
Washington DC 20036
(202) 737-8657
Annual conference and
publication

SIGGRAPH (Computer graphics)
PO Box 72177
Chicago IL 60690–2177
(312) 644-6610
Annual conference

Society of Motion Picture &
Television Engineers
(SMPTE)
862 Scarsdale Avenue
Scarsdale NY 10583
(914) 472-6606
Annual conference and
publication

VIDEO EXPO/NEW YORK AND
SAN FRANCISCO
Knowledge Industry
Publications
701 Westchester Avenue
White Plains NY 10604
(914) 328-9157

VIDEO SOFTWARE DEALERS
ASSOCIATION (VSDA)
1008-F Astoria Boulevard
Cherry Hill NJ 08003
(609) 424-7117
Annual conference and
publication

VIDEOTAPE PRODUCTION
ASSOCIATION (VPA)
565 Fifth Avenue
New York NY 10017
(212) 734-6633

VIDEOTEX INDUSTRY
ASSOCIATION
1901 North Fort Myer
Drive
Rosslyn VA 22209
(703) 522-0883
Publication

VISUAL COMMUNICATIONS
CONGRESS/NEW YORK AND
LOS ANGELES
Media Horizons
50 West 23rd Street
New York NY 10010
(212) 645-1000

WESTERN CABLE SHOW
California Cable Television
Association
PO Box 11080
Oakland CA 94611
(415) 428-2225

WOMEN IN CABLE
2033 M Street NW
Washington DC 20036
(202) 296-7245
Annual conference

WOMEN IN COMMUNICATIONS
Box 9561
Austin TX 78766
(512) 346-9875
Annual conference and
publication

About the Authors

MARJORIE COSTELLO is editor-in-chief of the leading profes-
sional video magazine *Videography*. Previously she has been
manager of video services for a New York City video facility.
She received her M.S. degree in broadcasting and film from
Boston University's School of Public Communication in 1974.
A graduate of Smith College, she is a native of New York
City, where she currently resides. She has written for *Omni*
and *Video Times* magazines, and is co-author of *How to Select
and Use Home Video Equipment.*

CYNTHIA KATZ is a full-time writer. She is a contributing edi-
tor of *Videography* magazine and has written regularly for
Magazine & Bookseller. Her work has also appeared in *Work-
ing Woman* and *Preview* magazines. She attended Middle-
bury College before earning a B.A. degree in sociology in
1976 from Brown University. In the past, she worked for a
New York City production company, holding several posi-
tions, including producer, script writer, and on-camera inter-
viewer. She resides in her native New York City

Breaking
into Video? ▪ ▪ ▪ ▪ ▪

Printed in the United States
By Bookmasters